Orpen at War

About the Author

Patricia O'Reilly writes fiction and nonfiction, and teaches writing in UCD, the Irish Writers' Centre, literary festivals and elsewhere.

Her novels include *The First Rose of Tralee*, *The Interview*, *Time & Destiny*, *A Type of Beauty*, *Once Upon A Summer* and *Felicity's Wedding*. Her short stories are published in magazines and various anthologies.

Her nonfiction titles are: *Writing for Success*, *Working Mothers*, *Earning Your Living from Home*, *Writing for the Market* and *Dying with Love*.

Patricia has been a freelance feature writer for newspapers and magazines, creator of radio documentaries and plays, and has broadcast scores of *Sunday Miscellany* pieces for RTÉ. She lives in Dublin.

Orpen at War

Patricia O'Reilly

The Liffey Press

the
liffey
press

Published by
The Liffey Press Ltd
'Clareville'
307 Clontarf Road
Dublin D03 PO46, Ireland
www.theliffeypress.com

© 2022 Patricia O'Reilly

A catalogue record of this book is
available from the British Library.

ISBN 978-1-7397892-3-7

All rights reserved. No part of this publication may be reproduced or transmitted in any form or by any means, including photocopying and recording, without written permission of the publisher. Such written permission must also be obtained before any part of this publication is stored in a retrieval system of any nature. Requests for permission should be directed to The Liffey Press, 'Clareville', 307 Clontarf Road, Dublin D03 PO46, Ireland.

Printed in Northern Ireland by W&G Baird.

Author's Note

Orpen at War is a work of soft fiction based on hard fact. I'm aware of the ethical quandary of fictionalising a life, yet also know that fiction can reveal the hidden truths behind the facts and grants creative freedom by allowing the author to take flight and indulge in storytelling. I have, though, taken liberties with events and locations, even creating a few minor characters.

William Orpen wrote the story of the duchess in Ciro's – it was published in the now defunct *Daily Chronicle* newspaper; the story of The Spy and The Refugee has intrigued for more than a century and even made an appearance on the BBC's *Antiques Roadshow*.

This one is for Xavier.

Sir William Orpen

Prologue

January 1917, London

His name was William Newenham Montague Orpen. Billy to his friends.

Pushing through the revolving door, hands in pockets, he strolled across the lobby of Claridge's hotel, making for the Smoking Room – it was the most likely place to find the Field Marshal. He paused at the entrance to the Reading Room, intrigued by the groups of women gathered there for afternoon tea. They were out in force that Wednesday – furs gracing wool-clad shoulders, strands of pearls gleaming in the soft light, and frivolous hats waving an occasional feather as their chatter and laughter rose above the tinkle of silver on china.

And there, most unexpectedly, in the far corner sitting with his back to the wall, was the lean figure of the man himself – Douglas Haig, his long legs stretched out across the carpet. William tweaked his uniform, straightened his shoulders and negotiated the low tables and plush sofas, ignoring the looks of curiosity that followed his progress – apparently men were quite the novelty in the Reading Room, and men in uniform even more so.

'Ah, Lieutenant Orpen,' Haig acknowledged, gesturing to the seat opposite him.

Depending on your viewpoint, Haig was the man variously referred to as the Master of the Field or the Butcher of the Somme, but he was never long out of the news for his divisive military tactics at the front.

Haig ordered two afternoon teas. 'They do a damn fine spread here.'

William would have preferred a Scotch, but he knew better than to make his preference known.

Sir Douglas looked around. 'A rum do, this afternoon tea. The matrons of Mayfair at play while their gallant men do God knows what.' He adjusted his monocle and gave a dry little laugh.

Douglas Haig at GHQ, France

The room was luxurious, warm and scented; the walls covered in gold-coloured silk; deep-seated furnishings were in rich shades of maroon, royal blue and sea green, replete with braiding and fringing.

'I supposed you're wondering why I've brought you here?'

'Well, yes.' William was extremely curious as to the reason for the summons which had arrived a week ago at the barracks by hand in an official-looking envelope. Glancing around, he caught the eye of a young, hatless matron with a sleek bob. She gave him a wide, happy smile. Like so many others she was apparently undisturbed by the fact that the war being fought with Germany had been proclaimed as the war to end all wars and was supposed to be over in a matter of months. It was now well into its third year and showing no sign of ending.

'I hear you've put in a request to go to the front to paint?'

William looked searchingly at Haig. 'I did. Quite some time ago.'

'And, meanwhile, you're stationed at Kensington Barracks? How are you getting along?'

William swallowed. No matter what the purpose of this meeting it would not do to give vent to his thoughts on his military experience. Assigned to clerical duties, he kept boredom at bay by decorating the margins of pages with pen and ink drawings; he had learned nothing about soldiering and never once had to turn out for drill. 'It's interesting.'

'You're still painting? Portraits, I believe?'

So that was it. The Field Marshal was about to commission a portrait. Now that he was on familiar territory, William breathed easier. 'Yes, I'm managing to fulfil some commissions between army duties.'

The trolley arrived; tea was poured, milk added, and plates laden with sandwiches, scones and pastries set within easy reach of the two men. William was pleasantly surprised to bite into a chicken sandwich with a flavour that brought him back to his childhood.

Haig ate at breakneck speed, devouring finger sandwiches, scones with clotted cream and a variety of pastries. Finished, he wiped his fingers fastidiously on the linen napkin and leaned back against the wall. 'I believe you're acquainted with Mrs St George?'

Uneasy at where this might be leading, William had difficulty swallowing the bite of flaked salmon sandwich, dainty as it was. Ingest accomplished, he confirmed that yes, he knew Mrs St George.

'She's a fine woman. That's a splendid portrait. Her husband says you captured her to a T, and he's not easily pleased. Impressive fellow, Howard. Are you acquainted with him?'

William took a sip of tea. Mention of Howard Bligh St George made him even more uneasy. 'Well, yes, of course. He's a distant cousin of my mother. And I met him at the unveiling of the portrait.'

'From what I hear, you made quite an impression on them.' William wondered was it his imagination or was Haig looking at him in a particularly knowing, perceptive way? Could he be aware

of his affair with Evelyn? They had always been circumspect, careful of where they met, but London was a hotbed of gossip. 'She's pleaded your case at the highest level with the result that we're arranging for you to go to the Somme as an official British war artist.'

William drew an excited breath. After months of pleading his case, he was finally getting to the Somme.

Mrs St George

'Your brief is to paint images of the war, so that the people at home can see for themselves what's happening in France.' Haig stood up. 'I'm relying on you to present to the British public the facts of soldiering without the gore.'

William did not relish the thought of telling his wife Grace that he would be leaving the family home to go to the war.

Daily Mail, 30 January 1917

Unique Honour for Irish Artist

Sir Douglas Haig has conferred a unique honour on a distinguished Irishman, Mr W. Orpen RIA, who has been appointed official artist with the Army in France. Mr Orpen joined the Army Service Corps some time ago.

Chapter 1

Spring 1917, The English Channel & Amiens

William stood on the deck of the troopship steaming across the Channel. The sea was cold and choppy, the boat pitching and tossing. With England fast fading behind him, the die was cast. There was no turning back now – not that he wanted to. He plunged his hands deep into the pockets of his greatcoat and gave a smile of satisfaction as he turned his face towards the French coastline.

His fellow travellers were a mixed bunch. He watched them with interest, mentally envisaging how he would go about painting them: officers congregating on the bridge, huddling into the meagre shelter, quiet in conversation; groups of jostling Tommies strung out along the deck, some exuding noisy confidence as they smoked and joked; others quiet, withdrawn, clutching the rails, their features tight with fear of the unknown, he supposed. Officers and soldiers looked terrifyingly young to him.

Suddenly, a raw-boned lad threw his head back, slung his arms around two pairs of shoulders and started singing 'It's a Long Way to Tipperary', the words taken up along the line.

A slender youth leaned over and vomited yellow bile onto his boots. William moved a few steps away, unwilling to be seen watching the lad as he wiped his mouth with the back of his hand before rubbing it along his trousers where it left a long yellow smear, hiding his discomfort behind a defiant chin-jutting stare.

It had been a sunny, gull-soaring morning as they set out from Folkestone in southeast England, but as they crossed the English Channel, the weather changed to whips of stormy winds and lashes of driving rain.

Bracing himself against the rail, the icy air stinging his face, William shrugged further into his gabardine, but still the damp seeped through. In his excitement at being on his way to the war his physical discomfort only served to heighten his spirits. He grasped firmly at the railing and looked out to the vastness of the sea, his eyes sweeping along the horizon.

Only now was he able to admit to the relief of finally getting away. As expected, Grace had reacted dramatically to the news of him 'going to the war in France', as she referred to it, enunciating each word for maximum impact. When he told her that his commission had finally come through, she clutched at her heart, gasped for breath and collapsed onto the couch in the little parlour. Their daughters, looking from their mother to their father, followed the drama with wide-eyed interest – the eldest, Bunnie, white-faced and biting on her lower lip; Kit, knotting and re-knotting her handkerchief; while baby Dickie opened her mouth and bellowed as only she could.

William had stood by helplessly. Emotional scenes had not been part of his childhood, and as an adult he dreaded them, avoiding the intricate discussions that Grace so favoured. And he couldn't handle tears. He crossed the room and gave the tassel of the bell rope a hearty jerk. Their housekeeper took in the scene at a placid glance and sent out for the doctor who arrived within minutes. He dispatched the children upstairs to be looked after by Nanny, diagnosed Grace as being in shock and prescribed bed rest for her.

William made himself scarce by repairing to the Savile Club.

When they disembarked in Boulogne, he was thrust into a whole new world of men in khaki and humming dialects. The docks were shrouded in driving sleet, with men, horses, carts, trucks, bicycles and motorbikes all sloshing backwards and forwards. He watched, fascinated, as the soldiers were herded off the boat, like so many cattle, before being sent to the front. Kill or be killed. That was the way the fighting men were spoken of by the powers in London. William

accepted the edict for what it was, undisturbed by it. Like a fact of life – it was the fact of war. And he was on the point of having his very own Boy's Own adventure.

The harbour master, moustache bristling with self-importance, was overseeing his staff in a loud-voiced way, checking off paperwork in between directing straggles of men hefting goods and yelling orders at the comings and goings of the constant stream of soldiers and personnel.

'It's here, Major. Your motorcar.' It was Green, William's ever-cheery Cockney batman who'd spotted the vehicle further along the docks.

A short, broad-shouldered man stood alongside the Rolls-Royce. 'Afternoon, Major. I'm Howlett. Your driver.'

'I'll look to Captain Aikman and the luggage,' said Green.

In the confusion and excitement William had quite forgotten about his aide.

Howlett ushered William into the back of the motorcar and took his place behind the wheel. 'I'm to bring you to Amiens GHQ to Major Lee.'

'Yes. I believe I'm to liaise with him.' William leaned back, pulling the peak of his cap over his face – effectively shutting out conversation.

As far as the eye could see stretched an endless waste of frozen mud, holes and water, mile after mile of it. In the falling sleet the landscape looked silky soft, almost as if it did not have any edges. What tricks nature played, William thought, as they travelled in silence through the dusk. The distant rumble of artillery was the only sign that a war was taking place.

Some two hours later, Howlett drew up outside an impressive-looking granite building. William waited in the hallway, seated on a stiff-backed chair, as along the corridor doors opened and closed and telephones rang; clerks in uniform, heads bent, clutching files and sheaves of papers scuttled backwards – they were the sounds and

actions of administration that he was familiar with from the months spent at Kensington Barracks.

Finally, he was shown into a room of elegant proportions with two long windows looking out to the street and a large mahogany desk behind which sat a stern-faced officer with neat, centre-parted hair. When he looked up from whatever he was writing, the officer frowned at William, put down his pen and rolled a blotter across the page.

'Well, well,' he said, 'if it isn't Major William Newenham Montague Orpen in person.'

The title of major was still unfamiliar to William. The elevation was

Lieutenant-Colonel Arthur Lee, Censor in France of Paintings and Drawings by Artists at the Front

in keeping with his brief, he supposed. Not that he was interested in military rankings. He had a flash of uneasiness at Lee's attitude, usage of his full name and military title, all of which he interpreted as being falsely ingratiating and, indeed, verging on bullying.

'Your reputation precedes you.' Lee looked enquiringly at him.

When William did not reply, Lee steepled his hands, sat back and cleared his throat. 'We need to get one thing straight from the beginning. I oversee all matters relating to press and propaganda, as well as the work of the official war artists and photographers. You're to report directly to me. Keep me informed of what and who you're painting. And you're to send your completed paintings to me for approval before I forward them to London.'

William was so flummoxed that he remained silent, processing what he'd heard.

Lee continued. 'It takes the burden of administration and the like off you; ensures you have an adequate supply of canvasses; but most importantly guarantees that London receives appropriate paintings.'

William inclined his head but made no comment. He was still standing and seething with annoyance at the bombast of Lee's attitude. There was something about the major that was tugging annoyingly at the back of his mind. Something familiar. They had never met – he was sure of that – but ...?

He wanted to point out that how he worked was his business; that he was used to working alone and without interference. In different circumstances he would have done so, but from his experience of military clerking, he suspected it would be unwise to antagonise the man on whom the ease of his time at the front depended. He needed to have Lee on his side so that he could move freely to research, pursue his ideas and paint the pictures that were already crowding his head.

'I'd like to get to the front as soon as possible. It's the only way I can capture the essence of this war. And that's what I'm here for.' He spoke with what he hoped was matter-of-fact determination.

'Essence! That's a damn foolhardy attitude. You could work behind the lines, away from danger. There are several important army figures to be painted. And we've many artists more expendable than you who can go to the front. For the present, you'll be based in Amiens. It's the place to be – Allied headquarters and a key railway hub.'

'I've the title of official British war artist.' Ignoring Lee's look of annoyance, he continued, 'My brief from both Field Marshal Haig and the British Ministry of Information is to paint authentic war scenes. To do that, I need to be where the action is, not hiding out in a safe town.'

Instead of commenting Lee stepped out from behind his desk and opened the door of an impressive-looking mahogany cabinet. He

removed a bottle and two crystal glasses. He held the bottle to the light. 'Medoc, a particularly good year, I've found.'

William accepted the glass of wine and sniffed appreciatively, as seemed appropriate.

'To the success of your war effort without endangerment.' Lee stood in front of William and raised his glass. 'Too many civilians go into war with too great and too foolhardy expectations.'

'And may your shadow never grow less.' As William replied with the ancient Irish toast, he saw the uneasy flickering of Lee's eyes, the sideways glance of not quite meeting his gaze. He wondered what could be making the major uneasy.

Arthur Lee returned to his desk and gestured for William to sit. 'I hear you painted a portrait of Winston Churchill after his debacle in Gallipoli?'

William was not in the habit of discussing his sitters, certainly not Winston Churchill, whose every move and utterance was examined *ad nauseum*.

'Yes. Indeed. And it was a privilege.' He thought back to the time spent deliberating on how best to pose his subject, followed by the hours of painting the velvety-black background that threw Churchill's shirtfront, face and hands into prominence, capturing the cherubic cheeks and his look of self-conscious politician staring out of the darkness with frown-lines creasing his forehead. Throughout the sittings William felt Churchill was measuring up the situation as he waited to defend himself in court.

On seeing the completed painting for the first time, Churchill was reputed to have said, 'This is not the picture of a man – it is the picture of a man's soul.'

Later William heard that his was Churchill's favourite portrait and was regarded by his wife as the best likeness of her husband.

'I hear you described Churchill as a man of misery. Is that really how you saw him?'

Sir Winston Leonard Spencer Churchill

William had never said anything of the sort; nor would he. He placed his half-finished glass of wine on the desk and stood. 'I believe, and so did Winston Churchill, that I captured his character.'

And capturing the characters of front-line soldiers was what William planned to do.

Chapter 2

Spring 1917, behind enemy lines, northeastern France

It was a cold, overcast morning with a sky as grey as gulls' eggs when William came out from the hotel. Howlett was bent double, turning the crank handle. Motor started, the driver ushered William into the passenger seat, adjusted his cap, put on his goggles and they were off.

William held his canvas case on his lap – it contained sketchpads, sticks of charcoal and pencils. 'We'll drive around, get the feel of the place; hopefully, catch a bit of the unexpected.' After only a few days in France he had come to realise that painting the war was far from simple.

Howlett's driving was heroic as he navigated the yellow-brown mud, curdled in ruts, falling snow and puddles of slush on the pot-holed roads. William tucked deep into his greatcoat, sucked in icy gales of air and watched as the ancillaries of war happened around him – small grey motorcars splashing along; winding columns of loaded mules, their drivers walking beside them; troops with their capes bulging with boxes of long 6.5 millimetre cartridges.

Suddenly, out of nowhere, loomed the raw and ragged ruins of a cathedral. From high up on the belfry what looked like a statue leaned out precariously.

'Look, Major, it's the Madonna. The Madonna and Child. It's said she keeps a watchful eye on the townspeople.'

'Where are we?' William was impressed with his driver's knowledge.

'Albert, I think it's called. It's about halfway between Amiens and Bapaume.' Howlett slowed to a halt.

William stepped from the motorcar and stood, hands behind his back, looking upwards. The statue caught his imagination. He had never seen the like. Stamping particles of snow from his boots and blowing into his fists, he retrieved his sketchbook and a few soft pencils from the motor. Perching on one of the least jagged portions of a wall, his upright knees propping his sketchbook, with a few deft strokes he captured the stark ruin and the statue.

Before coming to France, he had visualised finding vignettes of war around every corner, waiting for effortless sketching and painting. But so far that had not happened.

Less than half a mile out the other side of a village that looked as though it had escaped the war, several ambulances stood in a clearing. They were top heavy, blunt-nosed, painted a grey colour and built like removal vans. The back doors were open, and the sounds of crying, cursing and moaning filled the air. Ignoring the yelps of pain from the injured, stretcher-bearers stoically transferred the wounded from one ambulance to another.

Curious as to what was happening, William walked over to a young man he took to be an orderly. He had a smudge of a moustache, and his face and clothes were smeared with blood and mud. There was exhaustion in every line of his body. He gave William a disinterested glance, as though in the middle of his chaos a man dressed in pristine khaki was nothing to be surprised about.

'Anything we can do?' William nodded in the direction of Howlett standing by the motor.

'Get the bloody generals to stop this mayhem. That's what you can do.' The orderly looked towards an ambulance, its back doors swinging open. Inside was a sprawl of bodies.

'These poor divils fightin' to save mankind are poorly equipped, badly led, half-starved and sadly wasted. I'm in the process of transferring the wounded. Pray God they get to a hospital.' He pointed towards an open wagon. 'Ten dead, on two stretchers.'

The dead soldiers, covered with rags, were bundled one on top of the other. 'What'll happen to them?' William was horrified at the sight.

'They'll be taken to an open pit at the foot of a Calvary. If they're lucky, a priest will conduct, rather than celebrate, the service. Even the clergy have become military. Bless 'em.' The words sizzled from between the orderly's lips. 'These days the reverends are having to be as skilled with guns as they are with the holy water.' With that he shrugged and shouted to an unseen someone, 'For God's sake, get a move on!'

William lit a cigarette inside the shelter of his cupped hands, drawing little solace from the hit of nicotine and trying to make sense of what he had seen. When there was no sense to be made of it, he said, 'Perhaps, Howlett, another half an hour. And then we'll call it a day.'

A short distance along a wet, brown road, they turned into a sloping corner and suddenly they were in a picturesque village nestling into the landscape. Wreathed in mist, it was a serene-looking place of cobbled streets, two-storey stone houses swathed in ivy, and in the square, a fountain with a plump cherub spurted gushes of silvery water. Its sense of tranquillity put William in mind of the remote villages of Connemara that he had visited when staying with Evelyn, but lest the war be forgotten way beyond the horizon, the low booms of distant guns acted as a stark reminder.

'A nice change, eh, Major?'

'Yes. Let's stop here for a while.' As the motorcar came to a halt, a robin, miniscule with head held high, fearlessly negotiated the edge of the fountain. William took a deep breath of the icy, nectar-like air.

'Not sure about this, Major. It's the kind of place that could've Boche hiding out.' Howlett sounded worried and glanced skywards. 'Looks like it'll be snowing again before long.'

Howlett was a worrier. William let his predictions pass without comment, but his sensation of tranquillity was short-lived as three

soldiers in torn and ragged uniforms shuffled out from the doorway of a shop. What the devil were fighting men doing in a place like this?

One of them came forward, freckle-faced and baby-cheeked, cradling his right arm against his body; the flittered sleeve of his uniform exposing flesh lumped from shoulder to elbow in a bloodied mass. With a cigarette dangling from between his lips, he jerked his head. 'That your Rolls, Major, sir?'

William gave a sketchy nod. That he was being driven around war zones in a Rolls-Royce had already raised many an eyebrow – eyebrows he considered better ignored.

A man with a cigarette

As he drew closer to the soldiers the stench of their wounds mixed with blood, sweat and dirt came at him in waves. And yet despite their injuries, they held themselves straight and had about them an air of suffering dignity.

'How are you?' William felt foolish asking what was a ridiculous question, but in the circumstances, it seemed the only one to ask.

A herring-thin man, who looked too old for battle, gave a half-hearted salute. 'We're wounded. Badly enough, Major.' He hauled a grubby blanket around his shoulders while blackened blood and pus oozed through the inadequate bandaging on his thigh. 'But we're all right. Could be worse.'

Confirming Howlett's prediction, fat snowflakes several shades lighter than the pewter-coloured sky stung William's cheeks, and he tasted cold in his mouth. 'How can you say you're all right?' He shook his head in disbelief, 'you couldn't be much worse.'

The freckle-faced boy spoke in a youthfully sturdy way. 'Likely you don't know, but the trenches are the most dangerous places for a soldier to be. They're full of rats and lice, stinking baths of mud, and water as high as our waists. And so, Major, sir, it's good to be anywhere else.'

The third man had a long, bony head and a narrow jaw. A grubby-looking bandage slipped down his forehead. He pushed the bandage up to his hairline, speaking of how they spent hours crouching in the mud 'like animals', trying to sleep in ditches full of water, watching for the moment to kill or to be killed. 'Trench foot, do ya know of it?' His voice was firm, emotionless.

William said yes, that he'd heard of it.

'Pray God, you'll only hear of it, Major. Blisters, open sores, infections, gangrene. Then amputation. Poor buggers. I tell ya, despair takes over.' His long nose curled under at the tip.

'But us lot are all right. For now. We look out for each other.' The boy spoke optimistically. 'We won't be going back to the trenches.

Leastways not for a while. Maybe never. If we've luck on our side.' His companions nodded.

William remembered a conversation overheard between a group of sleekly turned-out officers – since docking at Boulogne he had heard such a variety of discussions and wide-ranging opinions that he'd forgotten the where, when and why of most of them.

The story was that front-line soldiers who were too injured to fight, but not bad enough to be hospitalised, were granted a few days furlough, usually spent hanging around on the edges of villages, hoping to have their wounds treated, and if lucky, be given a hot meal or two. Medical care depended on the unlikely availability of doctors or nurses, or increasingly locals who were courageous enough to ignore the repercussions if caught by the Germans. As soon as the men were considered well enough to fight, they were sent back to the trenches.

A man in a trench

'You a fighting man yourself, Major? Have you seen much action?' It was the soldier with the bandaged forehead, his tone sardonic.

William admitted that he was not a fighting man, 'I'm here to draw and paint what I see.'

'You an artist, Major, sir?' the youngest asked.

'Official like?' Now the soldier sounded more interested than sardonic.

'Yes, War Office official from London.'

'Paint us, sir. You can paint us. We're the real McCoy.' The young lad had an irresistible Cockney perkiness, assuring William that he would not find anything better to paint and telling how he

was writing down what he saw, so he would never forget. To confirm and give credence to what he was saying, he patted at a notebook sticking out of the pocket of his uniform.

The lad was probably right. The three wounded men were perfect subjects for a study of the war. In their company William felt a lurch of exhilaration followed by a rush of creativity. This was turning out to be a generous bit of the unexpected – better than he had imagined that morning. Surely there could be no more pertinent images than these three injured soldiers who had sampled the horrors of war but were not in despair. He retrieved his equipment from the motorcar, and with his waterproof cape draped across his shoulders, pencil between his fingers and his sketchbook propped on his knee, as the village furred with snow, he drew a quick sketch of the boy and a separate one of his two companions.

'Thought you'd be paintin' us? Colours, like?' It was the boy come to stand alongside him.

'I will when I get back to my rooms.' William cast an arm wide, embracing men and village. 'I couldn't do a painting of you justice here.'

'Will you be able to remember the colours?'

William met the boy's eyes. 'I will. I won't ever forget.'

Howlett turned the motor around, and leaving the soldiers huddling together in the doorway of the shop, they drove away from the village. Though still early evening, the snowflakes fell grey on grey, and the road stretching away in front of them was a sea of greyish white, full of angled, insubstantial shadows. Another mean night of black ice and savage wind loomed.

'I'm going back a different way, Major.'

'As you wish. Personally, I can't wait to get into a warm bath with a hot toddy.'

'Missing home comforts already?'

Chapter 3

Summer & Autumn 1898, Vattetot-sur-Mer; Autumn 1901, London; Winter 1916, London

Howlett had hit the nail on its proverbial head: despite the thrill of being at the front, nothing had prepared William for the constant discomfort of his living conditions. The hotel was chilly, the bathwater lukewarm, the food appalling and the weather cold enough to freeze the nose off a brass monkey. Already he was missing the comfort and ease of the life he had left behind, and indeed, wondering how long he'd survive this war. When he thought of Grace it was with blurred affection and an appreciation of her home-making skills.

They had met in France during the summer of 1898. William had joined Augustus John, the newly married Rothensteins, and several other artists on a painting holiday in Vattetot, a small village nestling between the fishing port of Fécamp and the resort of Étretat.

He first heard mention of Grace when Alice Rothenstein came running along the beach, arriving breathless with excitement to where he and Augustus John had set up their easels. Alice's hair was flying, and her skirts bunched up. She waved her hat, bent over, gulped and announced, 'Grace is coming on Friday.'

Augustus John merely raised his eyebrows and added another brushstroke.

Out of a sense of politeness rather than curiosity, William asked, 'Who is Grace?'

'Alice's sister,' Augustus John supplied.

As Alice ran back along the sand, she was joined by William Rothenstein, who put his arm around her in a proprietorial way and drew her to him in a lingering kiss.

'Young love,' said Augustus John in his mocking way.

'They're married.'

'Just as well. Or Papa Knewstub wouldn't allow Grace near us. Likely they're on chaperone duty.'

'What's she like? This Grace?'

'Gives the word "pulchritude" a new meaning.' With that Augustus John returned to his brushstrokes.

It was a strenuous working holiday. William Rothenstein was deep in the planning stages of setting up of a gallery in London with the aim of exhibiting the best of rising young artists. Augustus John was fulfilling some commissions, and William was working on *The Play Scene from Hamlet* for entry to the Slade competition, although he had not yet settled on its centrepiece.

From the beginning William was as taken with Grace's vivacity, her fair-haired looks and luminous grey eyes as he was with her air of self-confidence. Feeling unusually gauche around her, he skirted her with circumspection – although when he thought he was unobserved, he sketched her wearing the long white summer dresses and wide bonnets tied with chiffon scarves that she favoured. He was intrigued at the way she held her small pouch bag in front of her – like a shield, he thought.

'Why don't you ask her to sit for you?' Augustus John, the self-appointed leader of the group, came on him unexpectedly and was peering over his shoulder at the half-finished canvas on his easel.

'Most likely she wouldn't.'

'You won't know until you ask.'

William didn't like Augustus John's smug look, and much as he would enjoy having Grace sit for him, he didn't want to ask her for fear she might refuse.

In the mornings the group rose early and breakfasted in the cottage's miniscule courtyard strung with climbing pink roses. They sat on benches set alongside a refectory-style table, enjoying freshly ground coffee and chunks of crusty bread smothered in apricot preserve. Afterwards, they gathered easels, palettes, brushes and boxes of paints, and set off for their morning's work.

Frequently Augustus John laid a proprietorial hand on Grace's arm, whispered into her ear, and the two of them would disappear together.

William was used to approval and welcome wherever he went – he put it down to his Irishness. He was somewhat unnerved to discover that their group was looked upon with suspicion by the local men and women, mainly because of their swimming. The daily swim heralded the end of the morning's work. The majority of the group were strong swimmers, and they needed to be as the steep beaches and the waves coursing through the stormy channel created a dangerous undertow. Each day at noon, released from the discipline of their art, the artists craved the excitement of physical activity. They undressed gaily without thoughts of modesty. Augustus John swam naked and afterwards ran unclothed along the beach. His antics attracted the attention of the locals who threatened 'to take action against those pagan ways'. As there was no sign of this action being taken, the artists persisted with their high jinks, and Augustus John's nudity continued.

On a morning with the sun high in the sky William walked as far as the village. Unusually for him, he wasn't in the humour to draw or paint. The village was a place of stone buildings with tiny windows and steeply pitched roofs set against gently rounded hills. It was quiet – deserted, except for a group of girls in pinafores and boys in short pants, playing what looked like a game of noughts and crosses in the dust.

His nods and smiles at them were met with indifference. He danced a few hornpipe steps that drew their attention, adding a joyous

'whoop' when he saw a mule standing placidly in a small field. As the children watched, their game on hold, he jumped over the small hedge of blossoming hawthorn, easily caught the mule and hoisted himself on its back. Holding on by its tail and yahooing Wild West style he rode the animal around the field.

That the children did not have a word of English was no deterrent to their enjoyment of his antics. Jigging up and down, giggling and chattering, pushing and shoving at each other they laughed at the spectacle of a man riding their mule. They were joined by a group of women of varying ages dressed head to toe in black, carrying wicker baskets of crusty loaves and ripe tomatoes. Eventually, a few of the local men, drawn by the sounds of jollity, straggled out from the small café, foregoing their games of chess.

When William jumped down from the mule with a final 'Yahoo', there were smiles all around and a scattering of clapping. A young man wearing the fisherman's blue of the locality gestured him to a game of boules. Good at all forms of sport and always competitive, William won easily. Jacques, for that was the man's name, bought him a brandy. In pidgin English, non-existent French and lots of gesturing, they managed basic communication. When William admiringly fingered the cloth in Jacques's shirt, he was treated to the history of the local clothing industry. From then on, the villagers viewed William as one of their own, with the children following him about as though he were the Pied Piper of Hamelin himself.

Over lunch a few days later, William suggested visiting Yport. 'There's a tailor in the village who makes clothes for the local fisherman.'

He was rewarded by clapping hands from Grace and a dismissive nod from Augustus John, who slouched back in his seat with an air of distracted annoyance. The enthusiastic agreement from the others put a gloss on the outing.

The tailor was a wizened gnome of a man who managed to talk at them without disturbing his mouthful of pins. With high-spirited

gesticulating and laughter, they ordered several suits to be made using the local linen, a material that retained its softness and faded to pale blue when washed, as well as additional pairs of baggy peg-legged trousers that gathered in at the ankles. Afterwards, they celebrated in the village café with several carafes of the local wine.

Sometimes William roamed further afield on his own to paint landscapes. He carried the easily transported tools of his trade – a light easel, an enamelled tin box of watercolours, a selection of big soft round brushes to apply broad swathes of colour, and thinner, pointed ones for detailed work with which he captured the warm intimacy of the Normandy summer.

On one of those breathlessly warm afternoons, as he was contemplating a scene of lush grass sloping towards an ancient cluster of farm buildings and admiring the stillness of the atmosphere, Grace appeared alongside him. For a moment, he savoured her nearness.

'I saw you drawing me.'

He was taken aback by her directness. The more he watched and sketched her, the surer he was that he had found the centrepiece for his Hamlet painting. She brimmed with natural confidence, without the gaucherie of Irish girls or the sophistication of the young ladies he came across in London. In a burst of courage he asked, 'Will you sit for me?'

She tossed her head. 'No. I won't. From what I hear you've plenty of willing models.' Her giggly laugh took the harm from her refusal.

He winced with disappointment as he watched her run back in the direction of the village.

'Forget her,' advised Augustus John later with a cocky look that had William wondering at his relationship with Grace.

That autumn William took a basement studio in London's Fitzroy Street – it was cold and damp with an earth floor and an infestation of rats and mice that gnawed at his canvasses. Emily Scoble moved

in with him. She had run away from home with dreams of becoming an architect. Instead, she became the model for William's *The Mirror, The Bedroom* and *The English Nude,* in which he portrayed her as a symbol of flesh and sexuality, with half-closed eyes and a tousled appearance, posing loose-limbed and relaxed on the crumpled sheets of his big four-poster bed.

'This place is dirty, Billy. Filthy. Needs a good cleaning.' She scrambled up from the bed after a few hours of posing. 'And it smells.' She crinkled her nose fastidiously.

The Mirror

William scarcely looked up from his canvas where he was applying finishing touches to the background.

Emily scrabbled among the clothes lying around. She pulled on a pair of the blue trousers and matching jacket that William had got in France, adding one of his brimmed hats to complete her outfit. 'I'm going to have a good clean; otherwise, God only knows what diseases we'll pick up.'

As she set to, muttering in disgust, William ignored her. With a basin of warmish water heated on the stove, some caustic soda and a few rags, discovered behind the sink, she cleaned the visible surfaces and then turned her attention to brushing the floor – from experience knowing to give William and his easel a wide berth.

Finally finished, she threw herself back on the bed, arms above her head, her pert nose sniffing. 'Billy, Billy, there's still that smell.'

He turned from his easel and observed her, with a quirky smile. He liked her; she was easy to be around, and he knew she was fond of him.

She jumped up, stood on her tippy-toes on the bed, stretching up to run her hands along the canopy. 'There's a pile of your socks up here. Yuck.' She pulled them down and fell back on the bed, laughing.

'I throw them up there when they became unwearable.'

He and Emily became engaged, and the following year they went to Cany on a summer painting holiday. Although he missed the warmth of the locals he had befriended the previous summer, William preferred Cany to Vattelot as he found the area's abundance of trees, barns, mountains, hills and valleys to be more artistically appealing.

Their engagement was short-lived. Later, Emily explained why she ended it. 'Billy is too ambitious for me; although his impulsive moods and brilliant application as a painter are attractive. He can't not paint. Even when he's ill, he positions himself under the skylight to go on working.'

William was not upset by Emily's announcement. If anything, he was pleased, as shortly afterwards he received a letter from Grace urging him to *keep woollen things next to your innards*. With that touch of encouragement, he made her the central figure in *The Play Scene from Hamlet*, his much-lauded picture that won the painting prize in the Slade's 1899 summer competition.

His profile was on the rise. His paintings were selling, and he had several commissions for portraits. He began to court Grace seriously, treating her as a precious commodity: taking her out for tea, bringing her to the theatre, sending her gifts of flowers and colourful silk wraps. When he proposed marriage, she accepted. He immortalised her in *Grace by Candlelight*, *The Lady in Black* and *The Coral Necklace*.

His ever-practical mother, Annie, journeyed from Dublin to London to meet Grace. She pronounced herself impressed that her son's wife-to-be was the daughter of a well-respected painter. 'She's a

pleasant girl; she'll make you a good wife. She knows about the life of an artist. Her father has good contacts in London's art world, and he'll support you.'

They married in August 1901 and moved into a fine house in South Bolton Gardens, the fashionable end of Chelsea. As William's happiness was Grace's main concern, his life was more pleasant than he imagined life could be. He enjoyed being fussed over, cared for and having his every wish pandered to.

Domesticity suited Grace: she blossomed within the confines of their home, furnishing the house with taste and style, pouring over a manual titled *Hints on Household Taste* by Charles L. Eastlake. After a few unsuccessful attempts to include William in discussions on the merits of this versus that, and his patent boredom at anything relating to household matters, she left him to his devices while she got on with hers.

Grace Reading at Howth Bay

Portrait of Grace

'This looks nice,' he said, looking around their elegant drawing room with its muted yellows, powder blues and petal pinks. The furniture was of good quality, smart too – a well-upholstered sofa and comfortable side chairs. Grace gave a confident nod as she accepted his praise, and he sensed her eyes on him as he wandered around the room. 'I'm impressed with your taste, and the capable way you've gone about choosing and buying.' He sat into the sofa, sinking deep into its cushions. 'It's very comfortable,' he complimented. 'I better watch out or Mr Eastlake will be looking to employ you.' She laughed happily in her giggly way.

The idea of fatherhood had him bemused. 'Are you sure?' he asked Grace, running his fingers through his hair in delighted bewilderment when she told him she was carrying their child.

She reached over and stroked his chin. 'But of course I'm sure. Perhaps it will be a son who'll follow in your footsteps? How Papa would love that.'

Mary Robson, or Bunnie as she was known, was born in 1902. Christine Grace Violet, called Kit, came along four years later. While William appreciated the ease with which his home accommodated him and was fond of his wife and daughters, he grew bored with domesticity and what he referred to as the 'trivia' it involved. As his

absences grew more frequent and longer, Grace did not complain. His mother had been right when she recognised that Grace would make a good wife, who would understand the dictates of his painting.

Grace showed little interest in his life outside of their home, but when she had learned that he was interested in a posting to the front, she had confronted him, stamping her feet in rage. 'Endangering your life, Billy? And what about your commitment to your family? In case you've forgotten we've a one-year-old baby. We should have gone to Dublin, to conscription-free Ireland, not put our lives in danger for a cause that has nothing to do with any Irishman.'

William was taken aback at her attitude. 'I've publicly committed to support the British war effort. England has been good to me. And if my studio manager wasn't in such a hurry to get out of London, I'd be able to keep the studio going properly.'

Grace's face flushed red; she crossed her arms and glared at him. 'I don't want you going to war, Billy.'

'I'll be remaining in London for now. I've several commissions.'

'It's likely those portraits won't go ahead. Not with the war and everything.' She spoke in a dogmatic way – motherhood had given her a confident voice. She was no longer the joyous young girl he had married. She had become a woman on continuous edge: fierce in her determination to have her own way and to protect the family.

Instead of the cancellations Grace forecast, William had received several more requests for portraits, and Evelyn's fundraising auctions were an unqualified success. His work, lauded for the grand manner of his portraiture, was being compared to that of John Singer Sargent. Between his commissioned work and the auctions William was busier than ever.

In December 1915 he was commissioned into the Army Service Corps, reporting for clerical duty at London's Kensington Barracks in March 1916. There, as he half-heartedly carried out his clerical duties while hoping to get to France, he came to know the meaning of stultifying boredom.

He did his bit to preserve the peace at home. Sunday afternoons, settled in his favourite armchair, collar loosened and boots kicked off, he listened to his daughters show off their musical prowess – Kit breaking away from the duet she was playing with Bunnie, filling the room with the melancholic notes of 'Molly Malone', both girls innocently beautiful in their lace-collared, velvet dresses.

Grace sitting upright, smiling, nodding in time to the notes, holding the baby on her knee. The child was frilled like a meringue in a concoction of white muslin and woolly wraps. From Grace's every gesture William knew she was happy, enraptured with the afternoon of familial domesticity. He loved the girls and remained fond of his wife, but increasingly he was finding such occasions claustrophobic.

He became expert at feigning interest, and while seemingly engrossed in the antics of his daughters, he sneaked glances at the newspaper that lay on the side table. *Zeppelins Rain Death from the Sky* screamed the headline, and he thought of how apt D.H. Lawrence was with his description of Zeppelin warfare as 'war in the sky'. The Zeppelin campaign was raging over Britain – Big Ben was silenced, its clock stopped, the streets of London were in darkness, and for weeks Grace hadn't mentioned anything about him going to France.

His sense of complacency was short-lived. A week before the Christmas of 1916 William sat with his wife and daughters around the large oval dining table lunching on slices of spiced beef, rich gravy and mashed potato. The scene was perfect and the atmosphere one of happy family life.

The ringing of the front doorbell was unexpected.

Grace rose from the table and went out into the hall. William continued eating, paying no attention to Bunnie, who swiftly and mischievously transferred her potato to Kit's plate. He remained oblivious as Kit threw a spoonful of potato back at Bunnie. As his eldest daughter squealed her annoyance, William heard a familiar voice.

He found his father in the hallway divested of coat, scarf and hat, holding a plate with an assortment of coins. 'What's this?' he was asking Grace. He had never lost his legal curiosity.

Grace gave a little laugh. 'Billy insists it's to help out artists who are less fortunate than he.'

Arthur Orpen shook his head and poked his index finger through the coins. 'Typical. A plate of coppers. I don't think any starving artist will have a full belly on the largesse of my son.'

'We're pleased to see you, Father. It's been too long.'

William was warmed at the affection between Grace and his father. Initially, Arthur Orpen had opposed the marriage, considering his son could have made a better match. But he had developed

Portrait of the Artist's Parents

a soft spot for Grace during her weeks of devotedly nursing his dying wife. After the funeral, Grace insisted on remaining in Dublin to ensure his comfort and to make certain he would be well cared for.

'I'm not here on a social call, William,' Arthur said. 'I've come in person to put a stop to your latest nonsense.'

Suspecting what this 'latest nonsense' referred to, William wanted to get his wife away from his father. 'Grace, could you take the girls? And ask Ruby to lay another place.' He eased his father in the direction of the dining room. 'Some luncheon? The beef is delicious.'

'Tea will do. I am not staying.' Arthur sat into the chair opposite his son. William tidied up his cutlery, pushed his plate away and leaned forward, elbows on the table. He had always been uncomfortable when his father laid down the law, and sitting opposite him, he was acutely aware of the older man's curdling annoyance.

Arthur Orpen was in full spate. 'Your mother would turn in her grave if she knew what you were up to. She was always soft with you. Giving into you. But this? Going to war. It's a ridiculous idea. You've a wife and family now. And you're Irish. Not English. This is not your war. Are you listening to me?'

William couldn't but listen. 'Where did you hear that? And from whom?' It was not generally known that he was looking for a commission to paint at the front. He wondered who was doing the talking.

'I met Mr Keating in the Shelbourne hotel. With the outbreak of war, he returned to Ireland. He told me that he felt it was impossible to continue as your studio manager. I believe he tried to persuade you too.' Orpen senior gave a little sniff. 'Obviously not successfully, but I'm grateful to him for alerting me to your plans. Pulling strings. Using your contacts to get to France. Your attitude is one of lunacy.'

Lunacy, his father had said. After experiencing the war first hand over a few weeks William was inclined to agree with him: from the little he'd seen this war was lunacy.

Chapter 4

Spring 1917, Amiens & behind enemy lines, northeastern France

As William was leaving the hotel, stepping on to the narrow side street, one of the few porters with a smattering of understandable English caught up with him. 'Major Orpen, There's a telephone call for you.'

William moved back into the lobby.

'Major Lee wishes to speak to you.'

William waved a jaunty hand at the porter. By his counting this was the third time Lee had telephoned. He handed the man a few francs. 'Tell him you can't find me.'

He jumped into the motor, laughing. 'Off we go, Howlett, as quick as you can.'

Away from the streets of Amiens, the landscape underwent a radical change. The ice on the road, tossed up by the army's movements, lay in hard twisted sheets, so bad that trucks slid from side to side and the few horses they saw had to be led rather than ridden.

William clutched a sketchpad and a soft pencil, itching to capture the nothingness of the landscape, but dithering as to where to begin? Never before had he experienced such a primitive urge, and never from the time he began drawing as a young boy had he felt so ineffectual – it was as though the war was eluding him, playing its own desperate game of hide-and-seek.

When he'd opened his sketchbook after returning from the picturesque village, he expected to have the boy soldier and his companions leap from the pages, begging to be painted. But they had not. He'd looked over the drawings with critical eyes, concluding they were without life and not worth painting. As yet, he had not completed

one painting to his satisfaction. In the circumstances, Major Lee was the last person he wanted to talk to.

Thomas Tertius Aikman invited those he considered to be his equals to call him TT. He was a tidy figure of a man, all bustling business and a great one for the *Financial Times*. He was waiting for William on his return that evening.

Brisk and to the point, he asked, 'Have you been sending your work to Major Lee?'

'Not yet.'

'Why?'

'Has he been asking?'

'Of course he has. You're to telephone him. He says he's tried to contact you on several occasions.' Aikman looked closely at William. 'As you likely know?'

William did not make the telephone call. A few evenings later as he was finishing a particularly meagre meal, Lee telephoned again. Realising he could not dodge the issue any longer William took the call. After confirming that he was indeed speaking to William Orpen, official war artist, the major asked, 'Why are you behaving this way?'

'What do you mean?' William was instantly on the defensive.

'I haven't seen any of your drawings or paintings.'

'I haven't sent any.'

'Why not?'

'There aren't any completed to my satisfaction. Nothing is ready for viewing.'

'What have you been doing all these weeks?'

'Preliminary work, looking around, getting the feel of the situation. Little Orps is extremely busy,' William answered flippantly. When on the defensive he had a habit of referring to himself in the third person.

But the situation he was finding himself in was far from flippant. No matter how hard he tried, no matter what sketches he made, with the exception of some of the officers, he was dissatisfied with the finished product. He could not capture in paint what he was seeing in reality. Scenes that had seemed so exciting when imagined from the safety of London did not materialise – daft anyway to have ever thought he could paint battles as an observer on the sidelines. He drew several Tommies, singly and in groups, and painted glum sights, using ochre and burnt orange, moody green and sludgy brown to little avail. He was not getting to the kernel of the war.

'Looking around! Indeed! You artists are as intractable as a herd of cats. Don't you know you're to report to me, keep me informed and show me what work you've been doing? You're being paid – and handsomely – for your services.'

William was glad this was a telephone call rather than a face-to-face meeting. The last thing he wanted was an argument. 'The weather is appalling – it's freezing. Perhaps when the damnable snow and sleet stop –'

'Your behaviour is appalling! You could be painting officers in comfortable settings. But no. You want realism. From now on, you're to report weekly and let me have your completed canvasses.'

William's grip on the receiver tightened. Last heard of Major Lee had left Amiens and was based God-knows-where? William replaced the telephone on its cradle and sat thrumming his fingers on the table.

Next morning, he telephoned his friend Philip Sassoon, private secretary to Field Marshal Haig. Unusually, he was connected immediately. Straight to the point, he said, 'If the War Office wants me to carry out my work in a professional manner, I have to paint in my own way and at my own pace.' He was beginning to wonder what had impelled him to come to France.

Philip said he understood and that he would pass on the message. Later, William heard that Lee had received a rebuke from General

Headquarters and the seed of hostility was sown in the Major's Intelligence (F) Section, GHQ. Over the following weeks it manifested itself in a myriad of niggling ways that William ignored.

Late afternoon William sat in the bar of the hotel, a glass of red wine in front of him. He was faced with an unsurmountable quandary – he was unable to paint the war as he wanted to, and he refused to submit a canvas that did not meet his standards. His early sense of adventurous excitement was diminishing, eroded by worry, and the constant sounds of shelling and cannon fire had him on edge.

Another sip of wine, followed by a deep sigh when suddenly out of nowhere came a fleeting thought: a solution? Perhaps? It felt right. But before he could capture it, it fluttered tantalising out of his reach and executed some elusive manoeuvrings before settling. He had it! He knew what to do. He took a grateful breath. Relief at the certainty that he was, at last, on the right path had him giddy.

Leaving his half-finished glass on the counter, he eased down from his stool.

When he opened the door of the hotel room he had occupied since coming to France he was drawn to the left-hand corner where the window looked out to a narrow street, giving a glimpse of a typical French townscape. Beyond, the world of image, surface and reflection looked otherworldly with the spotlight of late sunshine coming in under the ceiling of cloud.

To the right-hand side of the window was a wall-mounted mirror reflecting green wallpaper scattered with what he thought of as giddy pink flowers. Spread out across a table covered with a red and white checked cloth were the necessities of his life: a bottle of Dewar's whiskey, soda siphons and a couple of glasses, as well as a tin of cigarettes, a matchbox and a pile of books, including a few Hall Caine novels – a writer he favoured, although as yet he had not progressed beyond the opening pages of *The Shadow of a Crime*. He looked around in a satisfied way: he would do a self-portrait with the room

as a backdrop. For now, it was his place, embracing his interests and his background. From boyhood, he had done many self-portraits – he liked the way they touched on his inner self, allowing him to look beyond the outer him, to express and better understand himself.

On his easel, he propped up a stretched, primed canvas measuring twenty-four by twenty inches. As he ran his fingers over its surface, he felt that familiar stirring – he was smiling as he began outlining in pencil the self-portrait that he would call *Ready to Start* – surely it was a good omen to have the title before the painting?

After a few tentative brushstrokes, he felt changed, lighter. He was himself, and yet not himself. His paint brush moved intuitively, as though to an unknown melody, capturing on canvas his feelings about being a man, a husband, father and a lover. As metaphorically he looked himself in the eye, facing what he was, it was as though his flesh peeled away, leaving only the rawness of bone from which to rebuild himself while teetering on the edge of war.

As he continued the process of laying down paint over the under-drawing, his pencil marks fell away and colour took over, leaping and licking around him. He was half-blind with the dazzle of his creativity – feeling the rhythm of his breath matching every brushstroke. A new surety and creativity filled the little room. Time was meaningless, and he had no idea of how long he stood before his easel with colours burning up time, drifting from him like streamers of smoke. Eventually spent and exhausted, the painting was done.

Looking at the finished portrait, he hardly knew who had made it. It was unlike many of his previous self-portraits that showed him as gnarled and knowing with exaggerated features; in this he was a handsome, straightforward artist soldier, wearing the uniform of a major topped with a fur gilet, his face somewhat lost beneath the oversized helmet. The colours were muted, subdued as they should be. Quite perfect. He was dressed, ready for the battlefield, and as he painted himself into the war, his creativity strained for expression.

He turned to his drawings of the Madonna and Child looking out from the ruins of the cathedral, and the three injured soldiers sheltering in the doorway of a shop. A few lines here and a touch of shading there brought the previously inert drawings to life. He executed a few steps of his favourite Irish jig. Hurrah. His creativity had not deserted him. He could do what needed to be done.

Ready to Start. Self-portrait

Next day he was perkily confident as he sat into the motor. 'Good morning, Howlett. Today we drive to capture the mood.'

'What mood, Major?'

'Just drive where your inclination takes you.'

A short distance out from an unknown town, driving northeast, they came on a wasteland of mud, holes filled with water, broken tanks, scattered equipment and a thin line of ragged soldiers. With their grey pallor and dragging shoulders, the men looked exhausted, but with heads up, their marching feet were taking them past little white crosses marking where their comrades had fallen. To William such scenes belonged to a nether world.

'Terrible place, France. Ain't it, Major? Plenty of mood here.' Driving conditions were so bad that frequently Howlett had to stop to wipe globules of mud from his goggles.

His driver's concentration was total, only allowing him a word or phrase here and there. For that William was thankful.

Straggling along by the side of the road, propping each other up were three Tommies, looking as though they had fallen behind the main line of soldiers.

'Stop here.' Before Howlett had a chance to demur, William had jumped out and introduced himself to the soldiers, explaining his reason for being at the Somme. Their eyes were blank, unseeing. 'I've a few questions and hope you've a few minutes to answer?'

They looked at him and then at each other, one of them shrugged and the other two nodded. Leaning against the side of the motor, William passed around his flask.

A tall, broad-shouldered soldier licked his lips appreciatively before passing on the whiskey. 'Well, Major, it's not often we get such treatment. What do you want to know?'

'Have you all been in the trenches?'

Tightened lips and nods confirmed they had been.

'What I want is for each of you to give me a sentence or two about your experiences.' Hearing directly from the fighting men

Royal Irish Fusiliers, 'Just come from the chemical works, Roeux'

their side of the war would bring additional humanity to his paintings.

The Dewar's was passed around again. It was going down well.

The first soldier said, 'I've done two hitches in hell, as we call the trenches. Sometimes we wonder if hell could be any worse.' He looked to the soldier beside him.

That fellow's eyes were heavy lidded, shrewd. He took an extra sip before speaking. 'When we go up the line, we know we'll be doing a few days' shift in the trenches. You've to be in them trenches to know what they're like. Mud and water up to our knees, and if you raise your head over the top, quick as a flash a Boche sniper'll take a shot at it.'

The third man was small and too thin, with sad, moist eyes. 'There are nights when there's no noise but the squealing of rats, some of them as large as cats.' His voice was barely audible.

William thanked them, reclaimed his flask and handed out a few bars of Cadbury's chocolate. The comments from the three were precisely what he wanted – the more he knew of the men, their locations and circumstances the better he could paint their reality.

Back in the motor, Howlett said, 'I'm told it's hell at the front, sir. Sheer bloody hell.'

'Who told you that? How do you know?' His driver was turning out to be well informed.

'Tommies sounding off last evening. Mud, shells, barbed wire, rain, cold, rats, lice, trench foot – like those fellows said. Sounds a God-awful situation.'

William planned to see the war from all sides – from the perspective of the fighting foot soldiers, the enemy soldiers and tank commanders, to the statesmen and generals looking to broker peace. Every now and again he remembered Haig's comment that his paintings should be without 'the gore'. And yet gore was one of the words he would use to describe much of what he had seen so far.

This was a war that had not been entered into lightly. William was familiar with the steps taken in Britain to avert it – how at the eleventh hour King George V sent an imploring telegram to the Tsar that read along the lines of: *I can only believe that a misunderstanding has led to this impasse. I am incredibly concerned that the opportunity to avoid this terrible fate, a fate that now threatens the whole world, could be left untaken.*

If the rumours in the barracks were to be believed, even before the war began, officially it was already too late to stop it. Wasn't it well-known that the German ambassador in St Petersburg was shocked to learn that Russian troops had received the order to attack? Optimism ran high with the generals in England, Germany, France, Austria and Russia that the war would be over by Christmas 1914.

But that had not happened. And now it was spring 1917. In less than three years, the world had changed.

Chapter 5

Spring 1917, behind enemy lines near Arras & Amiens

Dusk was fast falling, and the mud was dark and thick as the Rolls-Royce drew up to the campsite on the edge of where the second battle of Arras was being fought and where William planned to set up base for a few days. The only sign of occupation were flickers of lamp light from inside the tents.

Green and Howlett looked around uneasily. They were reserved in reaction and united in solidarity that their war artist master was not only putting his life in danger but theirs also with his 'antics', as William had heard Green so describe his forays. He was glad TT had remained in Amiens claiming a backlog of paperwork.

William spoke briskly, 'I'll see the officer in charge. Get things sorted. The sooner I start the better.'

Slipping and sliding in the sloppy mud, William made his way towards the biggest tent in the most prime position. Pushing aside the flap, he bent his head and stepped in. A harassed-looking officer with the stripes of a captain, polishing his eyeglasses, sat behind a desk, covered in stacks of files and bundles of papers. Pegged on a board behind him were a series of yellowing ordinance maps.

He looked up with a sigh and a frown. 'Yes...?' He put on his glasses and picked up a slim file with an orange cover.

'Major William Orpen reporting. I'm here to paint.'

The captain looked at him with a frown of incomprehension.

'I believe you've been notified.'

'Notified about what?'

'That I was coming here to paint.'

'Hmm. I wish you luck with it. Anyone who's been in this hell-hole could paint the Somme from memory. It's just a flat horizon-line covered with the bodies of men and mud-holes. And a smell you'll never forget.'

'I'm to paint some of the officers as well as the men in the trenches.'

The captain, a pale man with a thin nose and a nasal voice, ran a harassed hand across his forehead. 'The officers are dining now. I'll have you taken to the dugouts for the men, but it'll have to be tomorrow.'

Between them Green and Howlett organised a basic hut. It was miserable accommodation, but they did their best, as always. They even sorted out nearly warm water for a tin bath that William sank into with gratitude and remained there until the skin on his fingers was pruning – as his old nurse would have scolded. He stepped from the bath onto a wet platform and dried off with a skimpy, damp towel.

As he ate a glutinous mess of a stew-like substance from a tin plate and gratefully mopped up the gravy with a chunk of bread, he tried to plan his timetable of painting, wanting to maximise on each opportunity.

Green materialised beside him holding a tin mug of steaming tea. 'Think we'll be here long, Major? We were wonderin', like?' He looked around, his expression inscrutable. William suspected that such inscrutability was deceptive. Given half a chance, Green backed by Howlett would voice his opinions of the situation, and it would not be positive.

'I want to be in and out as quick as possible.' He noted the look of relief on his batman's face. The war experience was biting into their souls, but while William's impressions of the war so far were different to what he expected, he did not want to jump judgement and have emotions colour his perspective. 'I need enough time to get this down on paper.' His gesture embraced the camp and its surroundings

and away in the distance where the familiar intermittent sounds of canon and gunfire had started their barrage.

Over the next days he settled into a routine – he was pleased with the official portraits of several officers in their makeshift offices. It was capturing the ordinary soldier that had him flummoxed – he could not get used to the sight of shell-shocked soldiers operating in destroyed landscapes. But **echoes from *Ready to Start* drove him on, and several of his studies pleased him.**

Later he wrote in his diary: *I shall never forget my first sight of the Somme battlefields. Nothing but mud, water, crosses and broken tanks; miles of it, horrible and terrible, but with a noble dignity of its own.*

Usually, while William sketched, he was left alone, apart from a few curious stares, but on his last morning at the campsite, feeling a presence at his shoulder he looked around. A young Tommy with a pinched face came up behind him. He was staring vacantly into the distance, his rifle hanging loosely by his side. William nodded at him and returned to colouring, doggedly seeking to capture in paint the flecked white snowflakes resting on the brown oozing mud around a trench he had visited earlier.

'On a break?' he asked the soldier.

'Don't know.'

'It's tough. Must be tough for you all.' William willed him to move away, but he came closer.

'It's not as though every day is full of horrors. It's mostly boredom, interrupted by bursts of terror.' The lad sounded as though he might be from the Manchester area.

'What's an ordinary day like?' The boy's need for conversation was greater than William's wish for solitude.

'Hah. We make tea, lunch on bully beef and chat – while delousing each other. Waiting. All the time waiting.'

'I see.'

'No, you don't see. You can't see. You can't know what it's like.' The fact that there was no raised voice to accompany the pronouncements made the boy's statements all the more real.

'I am trying to capture in paint the actuality of the war.' William knew he sounded pompous.

The soldier threw back his head and laughed – a terrible sound that came from the depths of his being. 'Actuality. Whatever that is. Know this, guv. You can't. Nobody can. And it's the not being able to and the not knowing that gets to us. Night-time the trenches come alive – troops being replaced, carrying parties replenishing supplies.

The Manchesters, Arras. 'Just out of the trenches near Arras. Been through the battles of Ypres and Somme untouched. Going home to Sheffield to be married.'

And groups of us, the expendables – that's us lot – sent out on expeditionary missions to mend wires or conduct trench raids. Trench raids – that's what the brass calls them. We don't all ever come back.'

At last, overnight, the weather changed. Suddenly it was a perfect morning, sharp, dry and sunny. The earlier chill faded to stillness, and the sky was so blue that William felt he could taste it on his tongue. A day tasting of hope.

William was back in Amiens, setting out each morning on what he called his 'painting forays'. He sketched soldiers going about their business – marking details of their buttoned uniform tunics, trousers, leather boots and long putties for detailing and colouring later. In clusters they moved backwards and forwards without apparent direction – some wore the uncomfortable-looking chin-strapped Brodie helmet, while more opted for the trench cap. Webbing equipment criss-crossed their bodies and their 303 rifles were to hand. Invariably, there were some locals hanging around – women carrying loaves of bread, with children hanging out of their skirts, trailing after their men folk, grateful to be odd-jobbing for a few francs.

A solid-looking soldier, square-jawed and with fearless eyes, looked at William's sketch for several seconds before dismissing it with a shrug and a clucking sound. 'As soon as this war is over, souvenirs of the battles will be all the rage. Make a fortune with 'em back home, so I will.'

His stance, attitude and words defied contradiction. The idea of anyone taking from the dead repulsed William, but he wanted to be sure. 'Are you really collecting souvenirs from the dead?'

'Now that'd be telling, so it would.' The soldier wandered off.

The pencil between William's fingers continued to record. Page after page he covered with thumbnail sketches encapsulating what was happening around him.

Each evening at some stage, William would be strung out, unable to witness anything more. That was when he stood up, stretched, packed away his drawing materials in his bag and went walk-about, wandering through the makeshift camp and beyond.

'What are you writing?' he asked a tousle-haired young man sitting by the base of a stumpy tree. The boy was operating his pen with three fingers of his left hand. From what William had seen, the men spent an inordinate amount of their free time writing to the women in their lives – fiancées, girlfriends, sisters, mothers, aunts and cousins.

A Grenadier Guardsman in full kit

The soldier's bony shoulders were bent over a sheet of paper and his blush had his face glowing. 'A letter to my fiancée, Margaret.'

'What happened?' William indicated the damaged hand.

'A bag of gunpowder by my right foot. A spark, I suppose. Wasn't much of a bang but the flames were God-awful terrible. Us nearest had our uniforms charred black, and our hands and faces burnt. Harry got the impact of the blast. He's gone blind.'

'You were lucky.'

'Don't know. Don't know that Margaret'll fancy me like this.'

Without warning, clouds of dirt, lumps of debris and hissing sounds filled the air.

'It's an enemy shell,' the lad yelled, dropping his half-completed letter to the ground and running.

Sharpshooters grabbed their rifles and burst out from behind a wall, firing one after the other – reloading or covering their comrades in turn.

William coughed as a cloud of smoke and dust enveloped him. Beyond one of the earth barricades, he saw a soldier hit, struck down hard. He rushed out from behind the wall and ran to him. It was a head wound, a gruesome sight of oozing blood, fragments of bone and what looked like gristle. As bullets whistled over them from both sides, he looked at William, raised his hand slightly, and then his eyes rolled sideways in death. Something inside William took over, ruthlessly shutting down emotions and feelings. He should walk away. But he could not. He reached forward, grabbed the shoulder of the man's jacket and heaved him over.

He stood by the body as shells hissed over them, the air coming in a whooshing blow, until one shell exploded into the roof of a nearby farmhouse. Orange and black flames shot from the windows – a splash of a blaze, a push of hot wind, a world filled with the quiver of vibrations. The area around him was littered with corpses. He breathed in heat and watched as the flames spread, flattening and crackling the dry grasses.

Over the hiss of fire and screaming artillery shells, bullets whizzed in all directions. Another bomb exploded to William's left, sending up a shower of dirt and rocks. People ran around him and they ran in to him. He tasted smoke. His muscles tensed for flight. He should run for cover, but he faltered, caught between the drama of his surroundings and fear for his life as sweat ran down his back and blood rushed to his head.

Still, he clutched his sketchpad. He opened it, his pencil flashed across the paper, capturing men in uniform wielding sleek rifles, creeping past demolished stone walls and straw-fortified earth barricades; within the curves of stinking, choking smoke, a soldier steeling his nerves, lit a cigarette.

Several thumbnail compositions were rendered in minute and horrific detail.

To his side a soldier spiralled down the rocky precipice until the toes of his brown leather boots caught against a ledge. He landed face down in the dirt, with his hands thrown to the side, his knapsack still strapped to his back. William was not sure what to do. He looked around for help, but all he could see were clouds of smoke and dust. He squatted on a rock and did what he had seen ambulance men do – he reached towards the man, eased back his uniform collar and checked for a pulse in his neck, his index finger running along the soft skin. So soft, like his daughters'. But there was not a throb of pulse or a sign of life. The tip of his finger roamed further, stroking, inspecting, hoping. Still nothing.

He sat back on his hunkers, lit a cigarette and smoked it to the end, all the while, eyes widening, staring at the lifeless body, relieved that it was lying face downwards, that he did not have to look into another pair of eyes, whether open or closed. As if by reflex action, he began sketching the man in conscientious detail, right down to the pool of dark blood oozing around his body. He squiggled his signature uncial at the bottom right-hand corner of the page and sat motionless by the body with his head deep in his hands.

Around him the ambulances lined up and the ambulance corps packed in the wounded. The sun was setting, and in the gathering dusk, the trees grew black. William stood up and took a swig from his water bottle. It was late, time to return to his hotel. News of the killings would have reached the town. He knew that crowds of mothers and children, old men, relatives and friends of those who had come to the camp that morning would surround him, press in, pulling at him, their crying faces like burst tomatoes, demanding news. All he could do was reassure them as best he could with kindly spoken words.

As they drove back to Amiens in the evenings Howlett was in the habit of asking how he'd got on during the day? Had he met

Bringing in a Wounded Tommy

interesting people? Was he pleased with his drawings? But on that occasion William got in first, words tumbling over each other as he recounted meeting the letter-writing soldier, the one with the head wound, and the soldier who died still wearing his knapsack.

As he stepped from the motor outside the hotel several women of varying ages approached him, and he was enveloped in a stream of French questions. How he wished he had even the basics of their language. He smiled at the women, shrugged, folded his arms across his chest, threw them wide, and with palms pointing upwards hoped to convey compassion at the bombing – he did not want to mimic bombs, gunshot or death.

A pale-faced woman with auburn hair, wearing mourning black stepped up from the back. Her eyes were clear and fearless. She waved an embracive arm at the group and spoke to him in hesitant

English. 'I am Madame Brodeur. We know you go to the front, Major, to paint, and we want to know what happened this afternoon – we heard the shelling.'

William looked around – after what he had seen and been part of only a few hours previously the thought of using placatory words was abhorrent to him. These mothers, wives, daughters, sisters, cousins and friends deserved to know what was happening. 'I'll tell you what I know and what I saw.' And so he did, speaking cautiously and slowly to aid Madame Brodeur's translation. Fluently and compassionately she translated his hesitant English to her articulate French. Finished, he bowed towards her. '*Merci*, Madame Brodeur.' The sprinkle of clapping was unexpected, and it cheered him.

Later that evening, out walking, William passed a scruffy-looking youth leaning against a wall, smoking. They locked eyes. The young lad had a fearless look about him that reminded William of the boy who posed for him the summer he was fifteen. His work at the Dublin Metropolitan School of Art – the Met, as it was affectionately known – was being talked about and already he was being tipped as an artist with a future. He knew he was good – there was no doubt in his mind about that: talent was nurtured within the walls of Oriel – but he also knew he could do better.

He had seen a young lad of about his own age hanging around Dawson Street, ragged but with a proud way of holding himself and a bold stare: a street urchin straight from the pages of Dickens, as his mother would later comment.

'Will you pose for me?' William asked him a few days before the school closed for the summer holidays. 'I want to paint you.'

'Wha'? Pose for ya? Paint me?' The lad's curious stare turned to one of cynicism. 'Ya must think I'm daft.'

William hastened to assure him. 'I'll pay you.'

'How much will ya pay?'

'The going rate.' William spoke with more confidence than he felt – he had no idea of what might be a going rate, but the longer he was in the boy's presence, the more he wanted to paint him.

'No funny business?'

'No. We'll do it in my home. In Stillorgan. My mother and father and brothers will all be there.'

The boy gave him a sceptical look, spat into his palm and held out his hand. William took the proffered hand and gave it a hearty shake.

William's father was outraged at the idea of bringing a stranger, a tramp, into the house. But his mother praised her son's innovation, discovered the boy's name was Dessie, calmed her husband and assured him that she would keep a close eye on the proceedings. Among themselves, William's brothers, with a few nudges and winks, wondered if their little brother was involved in more than painting the scruffy-looking model who presented himself at the back door of Oriel on the first day of the Met's summer holidays.

William set up his easel under an apple tree in the grounds. He insisted on Dessie standing in the shallow pond with its floats of water lilies so he could get the right reflections from the sun and shadows flirting through the trees. It was a difficult pose and William was a hard taskmaster, so much so that Annie Orpen took pity on the boy. She protected his privacy with an improvised screen of old sacking and kept him alive with mugs of hot soup. The painting titled *Boy Under an Apple Tree* was an oil on canvas, thirty-six and a half inches by twenty-eight inches. Despite days of work, William never finished it.

William did not know why the young lad in Amiens should remind him of Dessie; he felt a pang of nostalgia for he knew not what. Perhaps it was remembered images of more innocent days? He re-traced his steps with the idea of giving him a few coins; perhaps they could smoke a cigarette together? It would cheer him up. But the boy was gone.

Chapter 6

Summer 1906, Dublin

Perhaps it was seeing the boy that had William remembering the happiness of his childhood. He often said words to the effect that 'one should never forget to be thankful for a happy childhood – like mine, with not a blot of sorrow to it'.

In many ways, without his mother being aware of it, she had altered the course of his life. He frequently thought back to the summer of 1906 when he had first met Evelyn St George.

Around the time of his marriage, he had negotiated a part-time teaching job at the Dublin Metropolitan during the summer. It gave him the opportunity of spending time in Dublin with his parents and catching up with his brothers, sisters-in-law, nieces and nephews.

William was in the habit of rising early, as he liked to breakfast alone and begin the day on his terms, but as he entered the sun-filled breakfast room, Annie Orpen looked up with a pleased smile. He debated backing out as that morning he planned to visit Flossie Burnett. She was his model for 'Nude Study' and 'An Eastern Gown'. She'd posed with abandonment, tempting him from his marriage bed, so he'd brought her to Dublin from London with the excuse that Irish girls were reluctant to pose nude.

William was struck anew by what a handsome woman his mother was: pale-skinned, with dove-grey hair and strong features. While he admired her looks, her imperturbable manner and excellent memory, he did not enjoy what he considered to be her interference in his career, and since he'd arrived home, she was full of ideas.

He picked up a copy of *The Irish Times* and made a production of scanning the front page.

She made short shrift of taking the top off her boiled egg. 'Billy, wouldn't it be a coup for you to paint a portrait of Mrs St George?' Annie was well connected, being related to Hugh Lane and Lady Gregory, and she made the most of her connections.

'Who is she?'

'Really, Billy. You never pay attention. She's an American married to my first cousin, Howard Bligh St George. You know, he's the Connemara land agent.' She sprinkled salt delicately on the egg and plunged her spoon into its centre.

'I know who you mean.' William gave up on the *Times* and buttered a triangle of toast. 'I remember him. He's tall and thin. No sense of humour. I pity his wife, even if she is American.'

'Not everyone appreciates the Orpen sense of humour.' Annie shook her head in mock disgust, although a trace of a smile fluttered around her mouth and her fine blue eyes sparkled. William knew he was the dearest to her of her children. He was aware of the debt of gratitude he owed her – she had persuaded his father to have him attend art college in Dublin and then to go on to the Slade in London.

He watched as she concentrated on poising the tea strainer carefully over the breakfast cup and poured a thin stream of Darjeeling into her cup. She replaced the strainer on its stand, added a touch of milk and a tip of sugar to her cup. That accomplished to her satisfaction, she sat back and looked across the table at him. 'You're primarily a portrait painter. It's what you do best. I've mentioned the success of your portraiture to Howard ...'

William battled to hide his annoyance at her meddling, 'Mother, I wish –'

Undeterred, she continued, 'I'm not talking about those Celtic revival style paintings, your portrait of that Under Secretary, or that one of William O'Brien, although you have Nathaniel Hone looking relaxed. I'm thinking along the lines of something more akin to the one you did of Sir William Nicholson and his family. What did you title it?'

William shook his head and could not help but smile. His mother would make a great hand at running the country. 'It's called *A Bloomsbury Family*.'

Giving her cup a delicate stir, Annie said, 'That setting and interior worked well.'

'Glad you think so.' His voice was jovial.

The cameo brooch at her throat caught a shaft of sunlight and her expression became stern. 'Your career is not a matter for joking. And I do not appreciate being talked down to.'

William looked at his mother with fresh eyes and saw her as a woman of vitality with wide-ranging ideas, a thirst for current affairs, as well as being a competent watercolourist and one of the leading

A Bloomsbury Family

lights of the city in the burgeoning arts and crafts movement. She had given birth to six children and miscarried many others. She had a demanding husband, ran Oriel efficiently, and in Dublin circles she was known as a charming hostess.

'I'm glad you think it works.' He reached across the table and touched her hand. 'It's a nod to a Vuillard interior. Sir William's wife came up with the idea of the family sitting around a dining table and having the cat to the foreground.'

'Howard is familiar with your painting of the Vere Fosters. He was unusually complimentary. That was a commissioned work, wasn't it? Paid handsomely too, I'm sure.'

William groaned. 'It was chaotic from start to finish. I'd to go to their home at Clyde Court in County Louth. All the family, including the children, had opinions on setting, clothing and posing and they wouldn't be budged. Vere Foster insisted on wearing check breeches – his wife and daughter had those hideous confections of headgear. And in the background was the family's favourite donkey.'

Annie laughed. 'A donkey in the drawing room?'

'Yes, all the time I was there it never stopped raining. The dogs and donkeys get into the house at odd times, mostly after tea.'

'Well, there'd be none of that carry on with Evelyn.'

'What does she look like?' William had a horror of having to paint ugly socialites whose husbands insisted on their enhancement.

'She's regarded as a great beauty. An heiress in her own right. Her father is a prominent banker in Boston, I believe.'

Clonsilla Lodge, the St George home in north county Dublin, was a dignified red-brick structure with a sweeping gravelled driveway. As William mounted the steps to the hall door he was thinking over his mother's insistence that he attend the dinner party. In the hallway his attention was caught by the way vase after vase of flower arrangements brought light and life to the dark wood-panelled interior.

A pale-skinned young boy with an abundance of freckles across his nose relieved him of his light cloak and scarf; a butler with a stiff gait escorted him to the drawing room where another youth with a mop of unruly red hair circulated with an ornate silver tray holding pyramid-shaped glasses containing a golden liquid. William took a glass and looked around at the animated guests – none of them familiar to him.

He caught snatches of conversation about America winning the Davis Cup; somebody saying, 'the fastest ocean crossing from New York to Plymouth'; to the other side of him, a florid-faced man braying about 'a new American drink'. A woman in a shiny green dress raised her glass, 'Oh, you mean Coca-Cola.'

William's tentative sip of his drink had him raising his eyebrows, smiling and taking a larger sip – the drink, whatever the ingredients, was delicious, positively nectar-like.

A tall, imposing man with a strangling stiff collar held out a well-manicured hand. 'Howard St George. You're most welcome. May I inquire after the health of your dear mother?'

William looked up at him and went into the gracious spiel that was second nature to him. From babyhood, Nanny insisted that he made up in charm for lack of stature. Ruffling his hair she'd predict, 'In your time, I warrant you'll charm many a bird from the trees.' Then she'd give a lugubrious sigh and return to whatever chores had been occupying her.

'And this is my wife, Evelyn.' Howard dipped his head and drew her forward.

A shiver rippled over William's scalp and ran down his spine. Every inch of his body tingled. Evelyn St George was magnificent: at least a whole foot taller than him, wearing buttery coloured silk with seven or eight strands of creamy pearls falling to her waist. Her golden hair was luxurious, dressed in a casual style, and she was smiling, her eyes dancing in delight. Unsure of how to react or what to say, he was certain that he'd encountered his soulmate.

She took the initiative, nodding in the direction of his almost empty glass. 'Did you like it?' Her voice was pure American. Silvery, he thought. He had not met many Americans, and those he had he labelled as brash and rather vulgar. But not this woman.

'It's good.' And to emphasise its goodness he raised the glass towards her.

'It's a cocktail – cocktails are all the rage in the States.'

He sipped the last of the drink. 'Does it have a name?'

She twisted her glass. 'It's called a Manhattan.'

'What're the ingredients?' William was pleased to see Howard moving to the other end of the room. He wanted to keep this woman for himself.

'Rye whiskey, vermouth and a dash of angostura bitters.' She threw back her head and laughed. 'Though it's hard to beat your national drink.'

'Our national drink?'

'Porter.' She smacked her lips. 'It's such a satisfying taste.'

'You've drunk porter?'

'Yes. In Connemara.'

He took her in from the top of her glossy hair to the tips of her satin shoes. 'I can't imagine you in Connemara.'

'We've a place at Maam Cross. I love it. I spend a lot of time there. Do you know it?'

As William was forming his answer a gong boomed in a discreet way from the hall announcing it was time to move to the dining room, an elegant room of moss green décor with cabinets at either end, holding sets of silver and a selection of Waterford glass.

As hosts, Howard sat at the head of the table and Evelyn at the end. William was seated two places away from her on her right-hand side. He was aware of her every nuance throughout the meal that, by the elegance of the surroundings and the standards of the time, was simple: vegetable soup, a joint of lamb with overcooked cabbage, floury potatoes and, to finish, apple pie with a whip of cream.

Howard and Evelyn, consummate host and hostess, drew out their guests. The conversation meandered from subject to subject. A portly man with a generous moustache grieved for Henrik Ibsen's death, to which Evelyn briskly re-joined, 'As he wasn't able to write for the past six years, life must have been torturous for him.'

William remembered hearing the playwright had a stroke. 'I saw *Ghosts* in the West End.'

Evelyn clasped her hands together. 'Well,' she drawled, 'what did you think of it? If I remember rightly, it ended up annihilated by the critics? We missed it in London, didn't we, dearest?'

Howard nodded.

'Any more news from San Francisco, Evelyn?' It was the fat, florid-faced man.

'No. Regretfully, no word about my cousin.'

'What a disaster,' said the woman in green.

'A firestorm and the water mains damaged – millions of dollars-worth of destruction,' rattled off Howard.

'It's the cost of the human lives that's the most appalling.' Evelyn sounded distressed.

'I hear there's been another demonstration by the Justice for Women group in London,' said the woman in green.

'Hell will freeze over before women have the vote,' vowed Howard.

'I wouldn't be too sure of that, dearest.'

The men dawdled over coffee, brandy and cigars while the women repaired to the drawing room. William, who had planned on leaving as soon as was politely possible, found himself lingering, engaging in a conversation on the likelihood of war, while hoping to have another opportunity of talking to Evelyn. The florid-faced man, a banker from London, standing with his back to the fireplace opined, 'If we have a war, it's one that won't be entered into lightly.' William thought he'd give it another half an hour before leaving,

but within a few minutes, Howard led the way to join the women. William was pleased to find a seat beside Evelyn.

'Did I hear that you paint?' she asked, handing him a silver dish filled with dark chocolates.

'Well, yes.' He felt at a disadvantage having to explain himself – had getting him here been a ploy of his mother's? She had a habit of throwing him in at the deep end, expecting commissions to flow in his direction, and frequently they did. If Howard was planning to commission a portrait of his wife, obviously he had not mentioned it to her. 'What do you recommend?' he pointed to the chocolates.

'The hazelnut is divine.' And to prove it she popped one into her mouth and chewed with obvious pleasure. 'And if you like caramel ...?' She repeated the process with a square-shaped chocolate.

William was not used to women eating with such gusto, but he considered an appetite for food reflected an appetite for sex, and as yet, he had not been proven wrong.

'What do you paint?'

'Mostly people.'

'Do you do portraits?'

'Yes.'

'Do you accept commissions?'

He was amused and intrigued at her naïve enthusiasm. Since his *Play Scene from Hamlet* won the 1899 Slade Prize, he was used to both men and women fawning over him for who he was and what he had accomplished. Evelyn St George was a refreshing change. As he was wondering how to engineer a further meeting with her, Howard crossed the room and perched on the arm of the sofa.

He leaned across Evelyn to address William. 'I'd like you to paint my wife. We're in Howth for the next few weeks. And I understand you're teaching at the Metropolitan? Shouldn't be a problem fitting in sittings?'

'Howard.'

'Leave this to me, dearest.'

Evelyn got up, murmuring something about seeing to her guests. Howard took her place on the sofa.

'My wife will sit at your convenience, my dear fellow.'

William did not possess hackles, but he felt imaginary ones rise at Howard's attitude, both towards his wife and towards him. 'I don't have time over the next number of weeks.' He tipped his head. 'And now, if you'll excuse me?'

Howard did not comment as he escorted William to the hall and had his cloak fetched. 'Do give my best wishes to your charming mother. I'll be in touch.'

Despite his earlier opposition to the idea of painting a portrait of Evelyn St George, William had time to think and to revise his attitude. Flossie had lost her appeal, so when Howard St George approached him a few weeks later about setting up a series of sittings for the portrait, William found himself uncharacteristically amenable.

It was to be a large portrait painted in the intimacy of her bedroom at Clonsilla. The rich, moody décor of the green and maroon setting with its crystal chandelier, potted palms, gold-framed paintings perfectly suited the sensuality of her pose. She reclined, head resting on a satin cushion on a chaise longue at the foot of her Sheraton four-poster bed, her expression knowing, possessive and confident.

During the painting they joked a little and laughed a lot, but William held back much of himself.

'I detect in you a sense of life's comedy.' When he least expected, she was in the habit of throwing out such remarks.

'Perhaps it's because I'm innately absurd in appearance and stature?' As he felt his way with her, he recognised her strength, unconventional ways and the self-assurance that came from second-generation wealth and beauty, as well as American candour.

'You're talented and ambitious. You've a gutsy sense of humour and an appealing way with words.' She broke her pose to stretch her

arms above her head and drew her knees up to her chest, so that she was sitting at the head of the chaise longue.

'Do you think?' He put down his brush and sat into a buttoned rose-velvet armchair alongside the chaise longue.

She relaxed her pose and leaned towards him. 'What were you like as a young student? Where did you go to school?'

William ran his fingers through his hair. He disliked having to admit that formal schooling had not been a feature of his childhood – his early learning was non-existent. He had little recollection of where he picked up the rudiments of reading, writing and basic arithmetic. He had rather ad hoc forays into other areas of education with his mother and occasional lessons from Mr Samuels, who called to Oriel to grind his older brothers in Greek, Latin and mathematics during their school holidays from St Columba's College. He shrugged, disadvantaged by Mrs St George's questioning, and threw his hands wide in the dismissive gesture he employed whenever he felt cornered. 'I was a mere child when I enrolled in art school. Luckily, I found my calling early on in life and was able to pursue it. Those were good years.'

'Tell me about them,' her voice cajoled.

'I left home before nine o'clock each morning, walked to the station at Booterstown, caught the train into city, ran all the way to Kildare Street and frequently did not get home until late. When I was too tired to walk the mile or so from the station, I bargained for a ride in a hansom cab, and ravenously devoured whatever food Mrs Byrne put in front of me.'

She laughed. 'I wanted to know if your student days were creative?'

'No. Far from it. Over the previous decades the school moved from art for art's sake towards art that could be applied to industry and commerce.'

'Bet you won prizes?' Mrs St George seemed genuinely interested and was looking at him in a disarming way that had his heart flipping.

Interior at Clonsilla with Mrs St George

'Well, I did. Gold and bronze medals for life drawing, and a scholarship for tuition. And I got a write up in the *Irish Independent*.' His moue was self-depreciating.

'What did it say?'

William shrugged. 'I can't remember.'

'Bet you can.'

'Perhaps something about mine being the cleverest work in a collection of heads shaded from nature. And I got invited to attend a summer course at the South Kensington School of Art. And now ...'

'Yes, I know. Back to posing.'

As William worked on *Interior at Clonsilla with Mrs St George* he felt they were becoming increasingly companionable. When the

portrait was completed, there was a familiarity about it that took him by surprise. When he stood back in perusal, he grimaced – it was quite ridiculous, but Mrs St George echoed how he had interpreted Grace in *The Red Scarf* painted in 1903. And yet the two women could not be more different.

After much thought a week after finishing the painting, his new-found soulmate still on his mind, he wrote to Mrs St George: *You are certainly the most wonderful thing that ever happened.* And when there was no reply from her, a few days later he sent another note: *I'm bursting for work – who was that bloke that held the lightning? – well, I feel like him.* William was an impulsive writer of notes, certain words appealing to him, but overall, he was rather illiterate, and had a cavalier attitude with regard to spelling and punctuation, frequently favouring ornamental uncials. There was no reply to his second missive either. While he did not dismiss thoughts of Mrs St George, neither would he allow her to intrude into his life.

Chapter 7

Summer 1917, Amiens & northeastern France

William was remembering the swirls and tails of the extravagant uncials finishing off those first notes to Evelyn as an elderly waiter with thick glasses and straggly grey hair dragged his clubfoot across the restaurant. He brought a basket of hot bread and red wine to the table, steadying himself before setting the bread down and removing the cork from the bottle with unexpected expertise. He poured a little wine into William's glass and waited with an expectant look. William tasted the wine, held it in his mouth for a moment before smiling and raising his eyebrows at the waiter. '*Parfait.*' Perfect. The old man nodded.

William ran his hand over his stubbly chin and leaned back into the velvet-upholstered gilt chair that had seen better days. He was hungry – he'd only eaten a slice of bread with a scrape of jam since breakfast, but he was both exhilarated and energized by that day's painting. Another sip of wine had him signalling that he was ready to discuss the limited menu on offer.

The old man bent low. William interpreted his communication as, 'You may wish to know, sir, we've a fine pike in the kitchen. It's expensive, for we've only the one. But it's delicious.'

A fresh pike was not to be passed on. William knew he was one of the lucky ones, able to enjoy the fine fish on offer – there were no such delicacies for the fighting men. Sipping his wine and waiting in anticipation for the pike, the porter responsible for relaying Major Lee's many telephone messages entered the dining room. He looked around and seeing William he lumbered towards him – he was a heavy man with a disgruntled expression.

'Telephone for you, Major.'

Did William imagine it or did the porter look gleeful? 'Who is it?'

'Don't know. Didn't say.'

'Could you find out?'

'Suppose so.' As he ambled out of the dining room, the fish arrived on an oval platter. It had William's mouth watering: the fine skin was glazed with butter and sprinkled with a scattering of parsley. He tackled it with gusto. After he'd enjoyed a few mouthfuls, the porter arrived back looking smug. 'It's the Field Marshal, Major.'

The only Field Marshal William knew was Sir Douglas Haig. Despairingly, he looked at his fish. 'Is he on the telephone?'

'No, sir. It's someone from his office.'

As William looked down at his fish and looked up at the porter, he rummaged in his pocket and pulled out a handful of francs. 'Tell whoever it is that you can't find me.'

'Like when Major Lee was looking for you?'

'Precisely.'

Next morning the porter handed William two envelopes. Recognising Evelyn's scrawl with a rush of delight he opened that first – it was several weeks since she'd written. It was one of her brief notes, a few sentences merely lauding the wonderful time she had at a lavish dinner hosted by Sir William Haig the previous week. In a sombre mood, William opened the second envelope: an invitation from Sir William to lunch with him on the following Monday. William sighed gustily and shoved the invitation into his pocket. That he did not need.

He was on a roll, at grips with capturing the war action, painting relevant scenes, pleased with what he was producing and ignoring Haig's admonishment to avoid the gore. He suspected Major Lee's involvement in Haig's invitation, and presuming he might be called on to account for his activities, he carried out a tally of his recent work. He was impressed at the quality of his paintings but not the

number – from what he knew of Major Lee, he thought it likely that quantity would supersede quality. Still, his first batch of paintings had been passed without comment by Lee and sent on to London.

Sir Douglas was billeted in a stylish manor house that had Howlett letting out an appreciative whistle as they drove up the meandering driveway – the gracious stone building and rolling lawns could be anywhere in England, or indeed, Ireland.

The luncheon consisted of oxtail soup and superb lamb steaks washed down with a fine Bordeaux. Haig ate and drank with the same enthusiastic concentration as he had done over afternoon tea in Claridge's. He was an affable host at pains to assure William that 'every facility is being given to you to study the life and surroundings of our officers and our troops in the field, so you can paint pictures of lasting value.'

William said that was precisely what he was doing.

'I haven't yet seen any of your paintings.'

'They went to Major Lee and then to London. He's dealing –' William began.

'From what he tells me you're quite the laggard.' As William was about to comment, Sir Douglas raised his hand. 'I know of Philip Sassoon's intervention on your behalf.'

Nothing to be said to that. William dabbed at his lips with the linen napkin. What Haig said next was unexpected, and the first William had heard of it. 'I'm informed that you're to paint a portrait of me while I'm here. We'll do it in the drawing room.'

The drawing room was the perfect venue as a backdrop for a man like Haig, impressive with high ceilings and bay windows looking out across the rolling lawns. Its elegant proportions put William in mind of the Vere Foster room in Clyde Court but without the chaos.

When it became known that William was painting the Field Marshal, a Tommy with a makeshift crutch told him, ''Aig is a decent skin.' The mere mention of Haig's name raised differing views at

the front as they did in London – he was either loved or hated, and people were not shy about mouthing their opinions. Some said he was a humanitarian who cared for his men. Others maintained he had treated his soldiers as cannon fodder during his command of the battles of the Somme, Aras and Passchendaele.

William worked fast and he finished the portrait over a few afternoons. After sitting for more than an hour during their last session, Sir Douglas broke his pose, stretched and surprised William by saying, 'Why waste your time on me? Go paint the men. They're the fellows who're saving the world, and they're the ones getting killed every day. They cannot and should not die for nothing. Their suffering has to bring a final victory.' He settled his features and resumed his pose as abruptly as he had broken from it.

As Haig was leaving the drawing room he paused in the doorway and announced, 'War is a fickle mistress.' William wondered was it his imagination or was there a twinkle in the eye without the monocle? As he was mulling over that, Sir Douglas continued, 'I enjoyed the company of Mrs St George last week. What an indefatigable fund raiser she is.' As his footsteps receded along the tiled hallway William was left speculating about Haig's relationship with Evelyn – the tone of her letter had him uneasy, and Haig's praise of her left him dubious.

One thing to be sure he decided, as he tidied up his painting equipment, Sir Douglas was right about Evelyn's fundraising skills. William had seen her in action and observed at first hand her infectiously enthusiastic fundraising on his behalf. When first he had mooted the idea of going to the front to paint, she was pleased that he would be in France, joining Avenal, the most loved of her children who was fighting with the First Life Guards. She came up with a unique plan to raise funds for the war effort, and at the same time to raise William's profile.

Her idea had been to auction blank canvasses donated and signed by William who would paint the buyers' portraits or a portrait of

someone designated by them. The innovative idea appealed. Since the start of war there was little occasion for stylish socialising and what William called the Mayfair set rowed in with their full support. Evelyn made a glamorous, social event of each occasion, organised maximum publicity and chose locations like Claridge's, the Ritz and Dorchester hotels for the auctions that took place after the guests had dined and wined well.

Then came the devastating news that Avenal had been killed in Zillebeke. As soon as William heard he visited Evelyn. When Dora opened the door, he ignored her greeting about 'the mistress not receiving' and walked past her into the drawing room. He found Evelyn inconsolable, wringing her hands, pacing backwards and forwards. He had never seen her so dishevelled. Her face was blotchy, her hair unkempt and clothes awry. He went to put his arms around her, but she pushed him away, yelling, 'Get out, leave me alone.' She threw herself onto the sofa, thumping its arms, wailing, 'Avenal was only nineteen. Too young to die.' Dora, in her quiet efficient way, eased him out onto the street, assuring him, 'The mistress will come around, sir. Given time she will.'

As William walked back across the square, he wondered would Evelyn ever come around – her love for Avenal

Avenal St George, painted posthumously from a photograph

was all-consuming. For several months he had no way of knowing how she was. She withdrew from society, disappearing to grieve in silence. He heard she was dividing her time between the family home at Coombe House in Surrey and their place in Connemara. One part of him wanted to condole with her, his other part suspected that he lacked the skills to be a grieving partner – Grace had been most scathing about his handling of his mother's death. Eventually, Evelyn emerged from mourning and took to frenetic socialising with an air of sadness that further enhanced her natural beauty.

Chapter 8

Summer 1917, Amiens & Ovillers-la-Boisselle

Whether wandering the streets of Amiens or close to the action, increasingly William was recognised – the little Irish artist, he was called. He received congratulations for what he was doing from various officers, keen to be part of the aura of fame that surrounded him, and more heartfelt comments from the ordinary soldiers. He acknowledged their compliments with a dip of his head and a smile, although privately he was amused by his raised profile. Major Lee was silent, and with the portrait of Douglas Haig finished, it was with an easier mind that William returned to painting the ordinary soldiers going about the business of war.

From the shelter of a tent at dusk he watched as a group of Tommies exited a truck – grumbling figures encased in clothes that rain followed by sun had made as stiff as cardboard. There were sighs, groans of relief and curses as they took off their packs. Some dropped to the ground and lay tight against the mud; others sat with crossed legs, forming loose circles as they set out their possessions; more clambered back into the truck. Notwithstanding candles for the troops being in short supply, several flickers of faint candlelight pierced the murk.

William watched, imprinting the sight, sounds and atmosphere of the men's actions on his memory, understanding how their need for light was stronger than the necessity to conserve, how the smallest stumps of wax were preciously guarded and lit. Reddened hands shielded guttering points of flame that cast shadows on the faces of the men bent over a card game. Water was swigged from cans, mouths wiped, noses blown, hard biscuits bitten into. Somebody

started to sing – predictably 'Tipperary' – it was such a long way to there. The sound bounced around the walls of the trucks, vibrating like a communal ribcage.

From the comforts of London, never in his wildest imaginings had William envisaged anything like the sights and sounds he was experiencing.

That morning Howlett had driven though more miles of devastation, passing the walking wounded, the crawling wounded and the dead. Past broken-down tanks, crosses and crater-like holes bisected by the road transporting an endless stream of men, guns, food lorries, mules and cars.

Sketch pad to hand, William watched as ranks of men ploughed doggedly and determinedly onwards, towards almost certain death at the front. He wondered did they know. He was not near enough to see the expression on their faces, but snatches of song wafted on the breeze, '*I want to go home, I want to go home. I don't want to go to the trenches no more, where the whizz-bangs and Johnsons do rattle and roar.*'

He varied his locations and themes. Sometimes he worked on the edge of battle, other times as far away as he could get. One day it might be misery being depicted – a charcoal drawing titled *Frozen Feet*, a watercolour, *Poilu and Tommy*, a pencil and watercolour study *Howitzer in Action*. Next day it could be the countryside caught on paper with watercolours – grass green, sky blue, sunshine yellows and touches of white. Frequently, he ended up with a mixture of man's dejection and nature's beauty. Sitting on the grass sketching, a little away from action: broken walls, the fields beyond, dotted with farmhouses with a backdrop of woods. The many acres of meadows were fenced with barricades, becoming the front line of defence.

Near to battle action and the boom of artillery he was surrounded by curses and groans from the wounded. The acrid smell of dying and death was everywhere; the desolation of once green fields, homely cottages and handsome trees brought tears to his eyes.

He understood what that young captain had been talking about when he had spoken of the smell of the Somme – it was an all-pervading, rotting mustardy whiff of death and despair.

For several days William sketched, skirting the edge of battlefields. There was security in knowing that Howlett was parked just a little way off, but Aikman, a constant, watching presence, sitting on a portable canvas chair, was an irritation.

He grizzled in a letter to Grace: *I get working at some inspiring place like the mine crater at La Boisselle and I look around and there is little TT reading the* Financial Times *– it's not in the picture you see – the* Financial Times *does not fit in with this crater and the endless little crosses and remains of Heroes.* But despite this minor annoyance, he was pleased with his paintings – they were an accurate portrayal of what he was seeing, as well as capturing the emotions of war.

'How do ya do that?'

William looked up from his easel. A pink-faced boy with a mop of curly blonde hair stood by his side. 'Do what?'

'Get us. The way we are.'

William turned fully around and smiled. This boy, for he was little more than a boy, was aware of what he was accomplishing. For that alone he deserved an explanation. William stood up from his stool, eased out his shoulders and offered him

Frozen Feet – Fleurs

a Gold Flake. Cigarettes companionably lit, he said, 'I know that somewhere beyond the edge of each canvas is the real war with bullets flying and bombs exploding. I haven't yet got into the trenches with you, but I try to capture your dazed, confused, shell-shocked attitudes as you come out of the trenches. I hope I manage to do that?'

'You do, Major. You do.'

On a sunny June evening before returning to bathe and dine William stood a little way off from a group of about half a dozen officers who smoked and chatted easily among themselves as they watched the men come out from the trenches. They came in weary groups of twos, threes and an occasional lone figure, silently with grim set expressions – some limping, many glancing towards the sky. The majority were worn out, sad and dirty; some looking so ill that they barely managed to drag themselves along; a few were on stretchers, carried by their comrades, haphazardly patched up with bloodied bandages. As he was thinking himself into their situation, imagining what they had gone through and what they would have to go through again and again until the war was over, a short, plump fellow with the stripes of a captain came to stand alongside him.

Poilu and Tommy

'Bloody awful day we've had in the trenches.' He offered William a cigarette. When it was declined, he lit his and took a satisfying drag.

A Howitzer in Action

'The men are in a God-awful state – no rain for the past days, but they're still waterlogged and muddy. Stinking.' He wrinkled his nose in a fastidious way.

William took in his immaculate uniform and highly polished boots. 'You been there today?'

'Good God. No. I give the trenches a wide berth.'

William moved away. After what he had seen and heard, he knew he had to get into the trenches, get down and dirty, experience being waterlogged and the smells, so that his paintings could celebrate the heroism of the ordinary soldiers. He was beginning to despise the decisions of the authorities – sitting behind desks, filling in forms and rapping out orders that sent men to their doom.

Some of the officers offered words of support and encouragement but the soldiers' faces remained impassive, expressionless – their eyes wide open, too often their pupils reduced to pinpoints and their mouths sagging as they trudged towards their few hours of respite. As William watched, he likened them to dead men unaware where they were, where they were going or what they were doing. They showed no relief at leaving the hell of the trenches – it was as though they had suffered so much, gone through such horrors that they were reduced to automatons: as emotionless as the wind-up toys of his childhood.

William had always kept meticulous records of what and when he painted, payment due, and when he received it. Because he was at war and painting war scenes, he saw no reason to change his methods. He

Soldier after a fight

drew up a list of locations to be visited –Thiepval, Le Boisselle, Le Péronne – and themes to be painted – more of the ordinary soldier, German prisoners, officers, battlefields, tanks, carcases, corpses and the open vistas of Picardy.

He remained mostly based in Amiens where he could dine relatively well but expensively at the Godbert and Cathédrale restaurants, and less well and considerably less expensively at the Hotel de la Paix. Invariably, his evenings finished with him visiting a selection of bars and drinking too much.

With a sigh of relief, he sent off another dozen paintings to Lee. He would have appreciated acknowledgement, but he was not too surprised when none was forthcoming. That done, and for the present a burden lifted, as he was intrigued by the town's sixteenth-century prison, he decided a visit was in order.

It was a building of imposing proportions, one he frequently stood outside, looking in admiration at the height and handsomeness of the dome, at the towering stone walls, wondering at the stories those walls could tell. He'd done a few sketches of its exterior but wanted to experience what it was like on the inside. His requests to visit were met with outright refusal. When he asked why, he was treated to a treatise on lack of hygiene, squalid conditions, rats and lice.

One morning after an early breakfast he went along to the prison. A door leading to the entrance hall was ajar. Inside it was soot black and awe-inspiring. An enormously fat, old woman with endless folds of facial flesh sat on a three-legged stool, lit by an oil lamp hanging from a stone fireplace. He had heard that such a woman was keeper of the keys. When he bestowed on her his best, most ingratiating smile she scowled. Refusing to be daunted, he rummaged in his pockets and pulled out a fistful of francs. She grabbed the coins, and dropped them into the pocket of her apron, still scowling.

He had his sketch book with him, and as he moved towards her, opening the page with his drawing of the outside of the prison, he

caught the whiff that he had come to associate as the unwashed smell of poverty. He tried not to breathe as the old woman looked at his sketches from all angles, cackled, showing uppers of blackened teeth and pointed to herself. She wanted him to sketch her.

He moved a little distance from her, took a shallow breath and nodded. When she did not seem to understand, he pointed at her and back to him, opened a blank page of his sketchbook, drew a few wriggly lines and said, '*Vous et moi.*' Perhaps it was not grammatically correct, but she caught drift of his meaning and bestowed on him a smile of wide delight.

He would paint her, but first he wanted to visit the belfry that served as a holding place for deserters and about which there were many conflicting stories.

He gave her another of his smiles and pointing upwards, '*En haut, s'il vous plaît.*' She treated him to another of her smiles, but then she frowned, crimped her lips and shook her head.

'*S'il vous plaît.*' He handed her some more francs, threw his arms wide, executed a few steps of a jig and bowed before her. His antics threw her into paroxysms of laughter, and she waddled over to the narrow stairs and pointed upwards. William took the steps two at a time, afraid she would change her mind, although it was unlikely she'd be able to negotiate the weeping, uneven steps.

William walked along a dark corridor of cells lining the corridor of the belfry tower. There was no sign of guards. He looked in through the small metal grill of the first cell. It was black dirty, packed to capacity with men who were rag and bone starving, many of them wild-eyed, with matted hair, squatting on stone beds covered with filthy straw. Even looking in from the outside had his flesh crawling. As a group of them came towards the grille, pushing and shoving, their skeletal fingers grasping and pulling at the bars as they tried to reach him, their moans were pitiful and their jabbering was in many tongues. Blood rushed to his head, his palms became clammy, and he thought he might faint at man's inhumanity to man. But he didn't.

All he could think of was to whisper his nanny's mantra of 'Shush, shush, it will be all right.' But it wouldn't be all right; it would never be all right. There was nothing he could do for them and likely they knew it too. He didn't know where they had come from, who they were or why they were incarcerated. And he knew he never would.

As he walked away, on unsteady legs, the prisoners set up a wailing that could not be worse if it were coming from the depths of hell. He had seen enough, heard enough and felt enough for the incarcerated men to be able to capture their images on paper.

He waved at the old woman and stepped out into the sunlight, relieved to be away from the naked misery of the place. He would keep his promise – return to paint her. But he never got the chance. A few days later he heard she had died of a heart attack. She was found sitting in her customary place. He was surprised at the wash of grief he felt at her passing.

He asked Madame Brodeur to buy a bouquet of flowers. 'Ah, ah,' she said with an approving giggle. '*L'amourex?*' he thought was the word. He knew enough French to know that *amour* referred to love.

'No, no,' he was at pains to assure her. 'The old lady who guarded the jail here has died and I wish to honour her memory.'

Madame Brodeur crossed her hands across her chest and bowed her head. 'It is my pleasure, Major. Shall I get roses or daisies?'

William didn't hesitate. 'Roses. Yellow if possible. A big bouquet.' It was the least he could do for the old woman with the unlikely desire to have her portrait painted.

Chapter 9

Summer 1917, Péronne & Saint Pol

As the weather grew warmer, locked into painting the scenes around him for days at a time, nothing existed for William but the present. Using mainly pencil and charcoal, to be painted later in the quiet of his room, he worked on studies of soldiers. He drew them in La Boisselle, outside Albert, as well as Pozières and as far away as Saint-Pol.

He grasped at the opportunity to spend time with the division fighting around the town of Péronne, wandering freely behind the lines, becoming familiar with the mass of supply lines, training establishments, stores, workshops and all the other elements of the modern warfare.

On an afternoon of June sunshine with a light fluttering breeze, he arrived at base camp: a series of small, camouflaged huts in a wood of waving fir trees through which the filtering light cast splintering shadows.

When he stepped from the motorcar onto the ground covered with pine needles, he stood listening. Peace had been missing from his life since his arrival in France. As he heard rustling pines, chirping birds and the sounds of the wood as it breathed, he was transported back to Oriel. And then, ruining the sensation of isolated peace, came the rumbling boom of distant guns.

As Green was lifting his valise from the back of the motorcar the major in command of operations arrived to greet him. A plump man with red and blue veins crisscrossing his cheeks, he was full of smiling bonhomie, hand held out for a bone-crushing shake as though William's visit were a social rather than a battlefield occasion.

The set up was so well organised and efficient that it was difficult to believe war was raging only a few miles away. First impressions had William wondering had he stumbled onto a holiday camp, but whatever it was, it was an ideal location for drawing and painting many of the images he planned, and from the look of the place he would be working in relative comfort. But he and his batman, Green, were shown to a small hut holding only the basics of living – an uncomfortable-looking bed, topped with the usual grey blankets, washstand with a jug and a bowl, a functional but ugly table and a few upright chairs. Not an iota of comfort.

As he was unpacking his sketchpads, easels and paints, the major's batman stuck his head around the door. 'The major says to come to dinner. Seven o'clock for seven-thirty.'

Washed and freshened as well as he could manage with the tepid water, William made his way to the major's tent. After several schooners of dry sherry and an excellent meal of baked trout, he sipped a whiskey and soda as he relaxed back in one of the major's comfortable armchairs.

He touched its arm, 'Any chance of getting a loan of one of these?'

The major beamed – nothing was too much trouble for him to have his batman organise. 'If it is within the realms of possibility, dear boy, it shall be done.'

As William was leaving the first shell of the evening shrieked overhead. His host looked to the sky. 'They're at it again, and it's likely to go on all night.'

When William reached his hut, he poured a large whiskey to which he added a small squirt of soda. As he prepared for bed, the roar of artillery was continuous and the smell of cheap oil from the lantern made him nauseous. A shiver ran up his back. 'I won't sleep a wink,' he told Green, but he was asleep within minutes of getting into the narrow bed. He woke at dawn feeling considerably better.

After a surprisingly good breakfast of fried corned beef and potatoes, a young lieutenant with bright blue eyes and a cleft chin arrived

to escort William to the painting site, about a half a kilometre distance from base camp. The place was a meander of scraggy pathways winding through lumpy grass and across a drainage culvert. A stone entranceway lay half-hidden among vines and blackberry brambles and heavy iron gates hung askew on rusted hinges. William was dismayed.

'Everything all right, Major?' The lieutenant looked worried.

'No, it's not.' William threw his arms wide at the unappealing scene. 'Everything about here is all wrong for the painting I want to do.'

'I think I understand. My sister's an artist and everything has to be right for her – the exact way she wants it. Why don't you go over to the other side? I think it might suit better.'

Accompanied by Sam and Ben, the privates to be painted, William headed across the embankment. He was used to being looked at with open curiosity – amid all the military uniforms he was an unusual sight – his pristine khakis covered by a loose smock and a soft cap set at a jaunty angle. He counteracted the curious looks with smiles and waves, and accepted a tin mug of strong tea with a quip about the weather.

He laid out his pencils, sticks of charcoal, brushes and a box of watercolours. The lieutenant was right. This was a good spot with sunlight filtering through the treetops and the red earth carpeted with pine needles.

Sam opted to sit first while Ben sprawled against a tree whittling away at a piece of wood. Sam was the older of the two, a peaceful type with vague dreamy eyes embedded in random wrinkles. A perfect subject. William's inquiries about his family and life before the war were met with disinterest and monosyllabic answers.

When a German shell appeared to explode directly overhead William jerked. Sam soothed, 'Only 'appens around this time of the day, Major, and it's all right, it's nothin' much. You'll get used to it.'

Whatever about the continuous thumping sounds from distant batteries, William could not get used to the belly-churning jumps

of fear he experienced from bursts of nearby shelling. With dread darting though him and his heart beating faster, he found it difficult to concentrate on his sketch as he kept anticipating the next explosion. In an effort to conceal his nervousness he put down his stick of charcoal and dug his nails into the palm of his hands.

'How long since you were home?' he asked Sam.

'Twenty-two months.'

William began to breathe easier – Sam seemed unaware of his fear. 'That's a long time.'

'Yea, but I can't complain. Some of the other blokes ain't been 'ome for more than two years.'

William eased out his fingernails, surreptitiously wiped the ooze of blood from his palms onto his smock, picked up the stick of charcoal and with a few lines he finished Sam.

'Thanks, Sam, that's fine.'

'I'll hang around – if it's alright with you, Major?'

William positioned Ben against the blasted landscape. He was long and lean with an untidy face, a crooked mouth and an uneasy stare. With a quick sketch William captured his upright perch, fierce gaze and impatient expression, thinking there was nothing fragile about him; nothing innocent either – the outline on the sketchpad could hardly hold him in. All the while, in a Birmingham monotone, Ben went on and on. 'Them trenches are cesspools. Dissolve our bodies in slime, so they do. Slime.' He repeated himself again and again in an increasingly raised voice.

For a while William paid his litany scant attention – he was too occupied with capturing the man on paper. But it began to grate. 'Shush, take it easy,' he admonished.

'It's all right, Ben. Just give it a few more minutes. The Major is nearly finished,' Sam urged.

'Cesspools. Slime.' Ben yelled over and over. And then it was back to repeating his sentences rote-like.

William walked over to where Ben was seated, placed a hand on his shoulder and gave him a comforting squeeze. 'Just a little longer,' he soothed, 'then you and Sam are off the hook.'

Ben's reaction was unexpected. He jerked upwards, looked around wildly and bolted back in the direction of the stone entrance.

'Should we go after him?' William worried.

K.O.S.B. – 'just away from the Chemical Works', Roeux

'He'll be all right when this damn war is over. I look out for him. His best friend was killed. Standing right beside him, he was. When the shell exploded Ben picked up some of the pieces of Jim, none of 'em bigger than a leg o' mutton. He put them in a sandbag and buried them.'

After absorbing the horror of those few sentences William did not know how to respond. He offered Sam a cigarette. They lit up and smoked in companionable silence.

That evening in the quiet of his tent William painted Ben, the colours he used staining the air like muddy glass.

Next morning, he was up at dawn wandering around the camp. Despite its shortcomings, its location was panoramic.

'Nice view, isn't it, Major? But sure you can't eat a view, sure you can't?' The boy had a cut lip and a jaunty Dublin accent. It was as though he was reading William's mind. He was little more than a child – not yet having experienced the pull of a razor, William thought.

'That's true. I often think of the food we had as boys.' Compared to the men, officers were well fed; still, William craved the type of

midday meal served in Oriel throughout his childhood – a bowl of sturdy beef stew redolent with carrots, onions and potatoes, followed by a rice pudding with a crispy brown top. In his time, he'd seen good and bad food but nothing as consistently awful as the meals being served to the fighting men – both the quality and quantity having deteriorated over the past months.

'I dream of me ma's bit of bacon and cabbage …'

'That's a fine dish.'

He was a rangy boy but too thin, with red hands and nails bitten to their quick. 'We hadn't much. But we never wanted. And me ma'd lend out our pig's head along the street, to give the neighbours' cabbage a bit of flavour.'

William was struck by how little he knew about those less fortunate than him living in the city of his birth. 'How are your rations? I hear they've been cut?'

'The fightin's terrible, but the hunger's somethin' else. Worse. Me belly's stickin' to me backbone. We're on Maconochie and biscuits now. 'Ave been for a long while.'

'What's Maconochie?'

'A stew of sorts, Major. But between you and me, it's a stew in name only – scrappy bits of meat and skims of veg.'

'I never heard of it.'

'The likes of youse wouldn't. The lads say it's a contract left over from a previous war. I'm not complainin' …'

'You're entitled to complain. How can you fight if you're hungry?'

'Terror, sir. Sheer bloody terror when there's guns firin' at you with bullets that might have your name on 'em. Anyways, a lot of them officer fellas think of us lot as little more than food for Fritz's cannons.'

Since coming to France, William had seen and sampled the comfortable living quarters, fine dining and batman service enjoyed by the majority of officers, many of whom criss-crossed the Channel, travelling backwards and forwards on social whims. Such goings-on

had him outraged, especially when he saw the conditions and hardships endured by the private soldiers.

William handed the lad half a bar of milk chocolate and made his way to the big tent serving as the hub of catering where pots constantly bubbled on the industrial-sized ranges.

'What's the story about the men's rations?' William asked a skinny man with a bulbous nose.

He bristled. 'What d'ya mean?'

'The men's rations? I was wondering about them?'

'Aren't you that painter fellow?'

'Yes.'

'Don't ya eat in the officer's mess?' He tightened the strings of his outsize apron. His attitude and voice were sullen. William wouldn't be surprised to be told to mind his own business.

'Yes. I do. But I'm constantly looking for background to give my paintings an authenticity.'

The man looked at him suspiciously, then his face broke into a sliver of a smile. 'Artists.' He put an index finger against his right temple and rolled it around.

'Yes, indeed, we're quite daft.' William repeated his gesture.

'Fresh meat is hard to come by. Since the beginning of the year the men's ration is reduced to six ounces of bully beef, and the poor souls fightin' on the front get even less. No wonder there's so much belly cramps.'

William absorbed that information with a heavy heart, acknowledging it with what he hoped was a knowledgeable nod. 'And what's this thing called Maconochie's stew?'

'That's another story. Maconochies of Aberdeen got the contract for the food for the Boer War, and again at the start of this war, mostly to feed the poor buggers in the trenches – the stew is skimpy, but I haven't told you; it's nothing more than bits of meat and vegetables in a thin broth.

'Are the men getting any fruit and vegetables?' As far as he could see there were none in evidence.

'Pah. If you asked the officers they'd say yes. Regular supplies.' He put on an exaggerated accent and touched his finger to the side of his nose.

'That's why I'm asking you.' William handed him a packet of Gold Flake cigarettes.

William moved to Saint-Pol some weeks later. It was a grubby little town, full of French confidence and character. He was billeted in a hotel where hygiene was not a priority and the menu mainly consisted of tinned tongue or bully beef.

The town's saving grace was a large, open-air swimming bath, democratically open to all, with warm water pumped in from a nearby chemical works. After working for the day, William looked forward to a swim in the evening. Competitiveness was inbuilt in him – from the time his sons were toddlers, Arthur Orpen had instilled in them the importance of winning. William hated being beaten at anything – he excelled at tennis, boxing, swimming and even ping-pong.

After a solid half an hour of a fast crawl up and down the pool, during which William passed out the majority of swimmers, he was in the habit of treading water while looking around. Nakedness was a great leveller – the heads bobbing alongside him could belong to either tramp or lord. But it was the difference between nudity and uniform that was most intriguing, and it had him playing a guessing game as swimmers entered and left the pool. That tall, finely built lad had an aristocratic air – there was no doubt in William's mind that he was an officer. But look at that fellow shambling along – what a beer belly; obviously no breeding there. Frequently his theories were turned upside down when the bathers emerged dressed from the bathing huts – the aristocrat turning out to be an untidy Tommy, with beer belly ending up as a smartly dressed officer.

Chapter 10

Summer 1908, London; 1917, Amiens

When William painted, he was completely absorbed in the creation of his current picture. From boyhood that was the way it was with him. The older he grew the more grateful he was that he could rely on painting to wash all else from his mind. His concentration on the content, brushstrokes and application of colour left little room for outside thought.

During the dead hours of the night when sleep eluded him memories of Evelyn were comforting, keeping him company, protecting him from the flashes of nervousness, a nervousness that increasingly lingered long after a shell had exploded nearby or gunfire stopped. He likened his trail of memories of her to reels of film from Lumière Brothers, projecting happy, moving pictures onto his mind.

When Mrs St George had not replied to the two notes he'd sent after completing the painting of her set in her boudoir at Clonsilla Lodge, he got on with his life, believing he must have misread her interest in him but not for a moment doubting his interest in her. Occasionally, her name came up in the society pages and several times their paths almost crossed, but it was two years before he saw her again.

London's Royal Academy was exhibiting several of his paintings. It was another summer's evening and there she was, wearing white; several ropes of pearls adorned the neck of her blouse and lacy ruffles fell over her wrists; her hat was white too, large with a floppy brim. He watched her as she went from painting to painting, perusing each one thoughtfully, referring to her catalogue – making little notes in the side margins with a small silver pencil. She appeared to be

unaccompanied. When he approached her, she greeted him warmly, and he got the impression that she was not surprised by his appearance.

She was more radiant than he remembered, and he was invigorated by the pull of her attraction. 'You look well,' he told her.

'I've been well occupied.'

'Oh?' He raised his eyebrows.

'Yes. Furthering the St George dynasty. I've produced another son to Howard's delight. And you? Has Grace added, perhaps a son, to your daughters?'

He was pleased that she remembered his daughters. 'No. Still just the two.'

'Ah, well. The world is over-populated.'

'Have you plans for dining?' he asked after they exchanged a few minutes of further pleasantries about the paintings on show and the state of the world.

She looked down. 'No, I haven't. But I'm hoping.' She gave him a wink and threw back her head in laughter.

They went to the Café Royal in Piccadilly. He knew it was a banal choice, but he was known there, and he wanted to impress her.

'We've a pumpkin yellow sunset – how propitious,' she said.

He wondered about that propitiation.

'Good evening, Mrs St George. Good to see you again,' greeted the manager, then adding, 'Good evening, Mr Orpen.'

The maitre d' showed them to a secluded corner table in front of a handsome palm where they sat side by side. William wondered if they would run into anyone either of them knew. He hoped not. He did not want to share her.

As though reading his mind, she twisted around. 'Just checking to see if we're likely to be spotted.' She raised her eyebrows and smiled at him. 'I believe we're safe for now. You know ... I've often wondered about you.' She drank a hearty mouthful of champagne.

William glanced up and down the expanse of stiffly starched white linen tablecloth and fiddled with his glass. 'Yes, and I've wondered about you too; how you were; what you were doing; and the family, you know?'

'No, I don't know. And we've already covered those topics.' She laughed at him across the rim of her glass.

There was another pause. He hoped it would not be an evening of pauses. She finished her drink and swivelled the glass between her thumb and index finger as she looked down the menu while the waiter hovered. 'What do you think? What are you having? I'm not remotely hungry. It's much too warm to eat.' She didn't wait for his reply before ordering. 'Chicken sandwiches and a pot of Earl Grey,' she announced. 'That'll do nicely.'

The waiter remained impassive.

She let out a little laugh. 'I bet this dining room isn't used to serving tea and sandwiches at this time of the evening?'

When the waiter disappeared, she sat forward, put her elbows on the table and looked into William's eyes. 'Tell me about you and your paintings. When Howard invited you to the Lodge, I had no idea of how famous you were. And now I have the honour of being captured in paint by you for posterity.'

'Hmm. Captured? Is that how you see it?' She had the bluest of eyes and the creamiest of skin.

'Only on canvas. I shall never allow myself to be captured by anyone.' She spoke slowly and firmly. There was no doubting what she meant.

William fancied Mrs St George like he had never fancied a woman before. He had come a long way since that summer in Vattetot, when he had skirted around Grace and been too shy to ask her to pose for him. As the years passed, he had become adroit at creating and nurturing relationships with both married and single women – always on his terms.

Café Royal, London

When the tea and sandwiches arrived, they ate and drank with enjoyment. 'May I tell you something?' Evelyn was between mouthfuls. She gestured to the glass holding the remains of the champagne. 'They always so kindly hand me champagne here, but I dislike it, it has such a watery taste, don't you think? But I wouldn't want to offend the establishment, and so I drink most of it.'

'Porter, if I remember rightly, is your favourite tipple?' William smiled at her.

'You do remember. And rightly too. A famous painter with a prodigious memory. And I have to admit to a fondness for your Irish whiskey.'

He got up from the table. 'Come on.'

'Where?'

'You'll see.' Adding the bill to his tab, he approached the concierge's desk, and after a few whispered words, he was handed a light black cloak that he draped about Evelyn's shoulders.

'We'll leave the hat here.' He gave it to the concierge. 'It'll be picked up sometime tomorrow.'

'What are you up to?' She stepped nimbly through the revolving door.

'We're going for your tankard of porter.'

They walked along Piccadilly, towards Leicester Square where they turned into a narrow alley. A few steps along William entered a dark tavern and led her towards a seat in the far corner lit by twilight from a small rectangular window. As she settled herself, covering her white outfit and gleaming pearls with the cloak he went to the bar and returned with two tankards of foaming porter.

She raised her eyebrows along with the tankard, 'Your good fortune, Mr Orpen.'

He clicked his tankard to hers. '*Sláinte*, Mrs St George.'

She took a deep drink. 'I've heard that before. What does it mean?'

'Merely health. We Irish ask for little.' He took a long draught.

She leaned a little closer, 'Ah, but don't you know the old saying – ask and you shall receive?'

He looked at her with raised eyebrows and a smile. 'Is that an invitation?'

She considered him. 'Yes. The first time we met I sensed a connection between us?'

It was a question. A question waiting for the answer that they both knew. He was nonplussed, unused to such forwardness. He had enjoyed several relationships with different women, always being the one to do the leading, setting the scenes for seduction. American women must be different, he thought. The debutantes and society women with whom he was familiar played elaborate games of harmless flirtation that led nowhere unless he made the moves. But this Evelyn St George? She was different. He played for time: 'A connection? What sort of connection?'

She rose to her feet, shrugging out of the black cloak. 'I consider such playful nonsense to be immature and unworthy. I expected more from you.' She took a few steps backwards.

He stood too and ran his fingers through his hair. 'Evelyn, please wait.' It was the first time he had called her by her first name. 'I'm not used to such forthrightness.' He reached for her hand.

'And how do you find my forthrightness?'

His heart thumped. He closed his eyes momentarily, a gesture he used to employ delaying tactics. 'Deliciously terrifying. I'm unsure of what to do next. You're an enigma. Let's sit back and sort this out.'

They did, watching each other, their tankards abandoned on the coarse wooden table. She crossed her arms over her chest, and he read her expression as one of wariness.

'I want to make love to you.' He felt he needed to be as forthright as this.

Her expression softened. 'I'd like that, William.'

As one they rose and left the tavern.

'Shall we walk? Or would you prefer a taxicab?'

'Walk. It's such a beautiful evening. Where are we going?'

'I thought the Ritz.'

Evelyn St George was the perfect lover. Next morning, he watched as she lay sleeping in the tumble of crumpled sheets. It was past eight o'clock when she opened her eyes. She sat up, stretched luxuriously

and cast a look around the room. He liked to believe she was looking for him, and having located him, she smiled. It was a smile of happy promise, of future assignations. He crossed to her side, sat on the edge of the bed and reached towards her. She sat up, nestling into his arms.

'Shall I order room service? Breakfast?' he asked.

'No. We must be careful, cautious.'

He was relieved on two counts – firstly, her insinuation that they had a future, and secondly, her awareness of how London society gossiped. He held her face between his hands and kissed her, starting with her forehead, then her nose, mouth, cheeks, and in some inexplicable way he found himself back in bed, his bath robe tossed to the ground. She lay on top of him, her body covering his. 'Hope I don't squash you.' She laughed heartily, and he watched the laughter bubbling along her fine white neck.

William knew that Evelyn would call the shots, control their relationship, and he was all right with that. While she dressed, he lounged on the bed, admiring the delicacy with which she washed and patted dry her skin, the fastidious way she put on her undergarments and her competent movements as she stepped into her skirt, smoothing the material over her hips and buttoning up her blouse. Her hair styled to her satisfaction, she turned from the mirror. 'Book for luncheon in the dining room, Woppy darlingest. One o'clock. That small centre table will do nicely.' She kissed him briefly and left the room with the black cloak folded neatly across her arm.

By one o'clock when she walked into the lobby of the Ritz, she was wearing a costume in sage green with a cream silk tailored blouse and a black and green hat tilted to the left side of her head. All eyes were on her – at just over six foot she was a striking figure. As William rose from his seat, she held out her hand, and after a quick look at her, he raised it to his lips. Companionably, he ushered her into the dining room before him. Their progress between the

tables and across the carpet was watched with interest and raised wondering whispers.

Seated, having studied the menus and given their orders, William took in the crowded dining room, recognising several faces. 'This is very public.'

'Yes,' she laughed. 'Lunch at the Ritz is public enough to be harmless, and we'll let it be known that I've commissioned you to paint my portrait as a gift for Howard's fortieth birthday.'

He had never met such a woman. Over luncheon, she outlined her plan.

Afterwards they strolled back to her house in Berkeley Square. A rosy-cheeked maid opened the door to them. 'William, this is Dora, and Dora, this is my guest Mr Orpen. We'll have tea in the conservatory.'

She sat down with a pleased smile. 'I'll choose what to wear and we'll paint it here.'

The opulence of Evelyn's accommodation astounded William and confirmed what his mother frequently said about Americans: how they were collectors of houses, paintings and furniture, usually adding darkly, 'as well as people and reputations'. He was comfortable in Evelyn's rooms – the Louis Phillipe furniture, gilt pier mirrors and powder blue carpeting appealed to him, and he was at ease with her in a way he had not been since he was a child walking the grounds of Oriel with his small hand held in his mother's gently reassuring one.

He visited Evelyn several times a week. She bolstered his confidence, insisted he think about the direction his painting should progress, speaking to him along the lines of needing to mould and refine his talent. In the beginning when she brought up the subject, he parried her suggestions with amusement, pointing out that he had more commissions to paint society women than he could manage. She was not impressed by quantity.

'Be selective. Choose your subjects with care.'

William had never been selective. If a husband was willing to pay for a painting of his wife or mistress, he was willing to paint her, although he found it difficult when the subject was unattractive.

William was grateful for Evelyn's handling of their relationship. It was beginning to be a matter of public conjecture, with many a whisper running along the grapevine of Mayfair gossip. When William mentioned it, more worried about her reputation than his, she was unfazed. 'Don't worry, Woppy darlingest. You are commissioned to paint me. What could be more appropriate?'

Indeed, while initially tongues may have wagged, the fact that it was public knowledge that Mrs St George was having her portrait painted by William Orpen as a birthday gift for her husband put a socially acceptable complexion on their outings. As one Mayfair matron put it, 'It's hardly likely that little Irish artist is having an affair with the lovely Mrs St George – as well as him being socially and financially out of her league, she must be a whole foot taller than he is.'

William joined his family at his home in South Bolton Gardens most evenings, unless it was socially expedient for him to attend a dinner, be at an opening or when he needed to travel. Grace did not make demands of him – as always, she was accepting of his life as an artist and built her life around domesticity and rearing her daughters.

He settled into a relationship with Evelyn that was both beneficial to his painting, personally stimulating and sexually satisfying. He had never known a woman, other than his mother, to take such an interest in his work. 'You must fulfil your greatness as an artist,' Evelyn urged frequently on taking a break from her portrait.

'Greatness?' He would laugh, pleased to put down the brush and join her on the sofa. He never tired of showing his affection, kissing her gently, stroking her neck, reaching down her bodice to her breasts, finding the nipples and bringing them to attention and

all the time she smiled with abject enjoyment. 'You are a sensual creature,' he murmured into her hair.

'I never properly knew the meaning of sensual until I met you. And now I can't imagine life without it and you.'

Evelyn haunted him – her presence accompanying him; her scent lingering on his clothes; a strand of her hair snaking across his canvas or jousting with his bundles of brushes.

The portrait came together in an effortless way with Evelyn, a woman in perfect balance between youth and maturity, coming alive on canvas, thanks to William's skill and the way he used sunlight to bathe her skin in a peachy glow. She celebrated her height in a brocade gown of bronze, cream-coloured furs and one of the picture hats she wore with such aplomb.

'From this nobody would ever guess that we're lovers.' She gave a satisfied smile. 'Wait until it's formally exhibited.'

'I thought it was a gift for Howard?'

'Well, it is. But there's nothing wrong with generating a little publicity for you along the way.'

She decided on a stylish gallery off Piccadilly for the unveiling. For days beforehand she went backwards and forwards checking on food – well, hardly food, more the nibbles she so favoured to go with the selection of cocktails. She refused to allow input from William.

'You're the artist and I want you to attend with Grace and your daughters.'

William looked at her aghast. 'I'm not sure that's a good idea.'

'Well, I am quite sure. And I have a further plan – an even better plan as you shall see.' She bent down to kiss the tip of his nose.

Chapter 11

Summer 1917, near Thiepval

A change of clothes and extra socks were crammed into the battered portmanteau William had owned since his days in the Met and tucked into the seat beside it was a Fortnum & Mason hamper, along with a few bottles of his favourite Dewar's whiskey – in Amiens he had achieved a somewhat enviable notoriety, being pointed out as the anomaly of being an Irishman as well as an official British war artist.

As Howlett drove with Green sitting alongside him, William tried to snooze, but the distant pounding of big guns constantly jerked him to wakefulness.

In the clusters of towns and villages nearer to the front, he saw the toll the war was taking on the people – skinny, ragged children crying with hunger; women scavenging for food; young boys turned criminal for survival. When he looked back at his naïve self, he cringed at the person he was: the person who strutted about Kensington Barracks lauding the nobility of war. From what he had seen and was experiencing so far, he concluded, it was only the educated, wealthy classes who could afford the academic and intellectual excitement of war. And they were the ones least likely to be in danger.

His camp for the next number of days was a sprawl of wooden huts, lines of triangular white tents and a few observation posts. In the distance was a small red house, believed to be a German post, and to its side, tucked into a copse of straggly trees, barely visible, was a white cottage surrounded by what looked like tumbled down out-buildings.

Seated a little way off from the centre of activity with sketchpad at the ready William observed the soldiers as they went about their day. So many and so young. He paid attention to how they moved; their facial expressions; the way some of them threw back their heads in laughter and more had an inbuilt air of solemnity; he wondered about the loners, about the twosomes and the groups. He wished he could join in, experience a little of what they were going through – feeling his empathetic understanding of their world was crucial for the emotional realism he wished to reflect in his work.

He stood up, the better to watch their off-duty activities – some of the lads were bent over basins of soapy water, washing out shirts, socks and drawers; more grouped together playing intense games of cards; someone sang, throwing the words to the others out of the corner of his mouth; many were hunched into writing letters. They brewed and drank mugs of strong tea incessantly. Smoked. Chatted. Here in his place of war, William envied their ability to be at rest, even for a short while.

'Mother will soon do her in.' The boy snuck up quietly alongside William.

William knew Mother was the name of a gun, but he wasn't sure what the boy was talking about.

'Goin' to take on that German post, Major, so we are.'

'Give her five, three, six, four,' William heard a gunner cry through the phone.

Mother uttered a horrible bellow, and a few seconds later, an enormous spout of smoke rose from near the house.

'A little short,' shouted the gunner. 'Two and a half minutes left. Raise her seven five.'

Once again Mother bellowed. William stood up and watched. There was a flash of fire on the house, followed by a pillar of dust and smoke. William felt sick, his belly in spasm as though he was about to throw up. As simply as that flash, the German post was gone. By exercising willpower that he did not know he possessed, he

remained standing, his hands by his side, his mouth clamped closed, tasting the bile in this throat, bitter and surging. He did not join in the cheers of the men, and he was somewhat appeased to see that the little white cottage remained standing.

The news was out that an artist was in the camp to paint them, and he had become a magnet of interest. Later that evening two young officers came alongside him. They were boyish-looking, of Mutt and Jeff proportions. The Mutt-like one bent towards William and announced, 'Fritz strafed our new trenches with heavies and searched round the support with HE shrapnel. Know what HE is, sir?'

William shook his head.

'High explosives.'

The Jeff of the partnership chipped in, 'One shell claimed three NCOs – know what they are, sir?'

'I do.'

The shorter officer lit a cigarette off the butt of his previous one. 'That shell wounded three men. I saw the killing go down the line. It was a pitiful sight. Shellfire is a horrid thing.' The young lad blew heartily on his handkerchief. 'A fellow who'd made sergeant was hit the worst – his body was full of gaping holes.'

'I wonder if the people at home realise what's happening. They're never going to be able to repay the debt they own to the ordinary soldiers.' It was the taller of the two.

William agreed. 'No recompense could make up for what I've seen. And I haven't seen the worst of it.'

'No, sir, you haven't. And pray God you never have to.'

'Not that I've heard any of the men asking to be rewarded.' The tall officer plunged his hands into the pockets of his trousers.

'Our reward and theirs is to get close up to Fritz with our bayonets.' There was vehemence in the way the short youngster jabbed out his cigarette, leaving William saddened and depressed at the barbarity of the likeable lad.

As he was considering seeking consolation in a strong whiskey, he noticed a young soldier, cigarette dangling from his lips, standing a little to the side. When William looked at him, he removed his cap and moved forward. 'Remember us, Major, sir? The village?'

It was the boy from the village that William had met on one of his first forays. The arm of his uniform was intact. He had recovered from his wounds. But he was older in looks and manner. Mature. No longer with that appealing aura of boyishness.

'When I saw the Rolls drive in, I told the others you'd come back to paint us lot.'

'Your friends, how are they?' As William spoke, he wondered and hoped – these days it was not safe to ask about the wellbeing of a fighting man.

'The fellas I was with that day. Paddy and Joe. They're good. We look out for each other. It makes us happy to see you drawing, Major, sir. We feel like you're doing it for us – like as if you're expressing in paint what we're thinking of in our heads.' He laughed, looked around. 'This is our squirrel hole. It's all right now; fairly peaceful, ain't it? Not always so.'

'Yes. It's peaceful.'

'I'm still writing things down. In my diary. So I won't forget.' He groped in his breast pocket and pulled out a notebook and pencil. His nails were stained dark brown and hooked slightly over the tops of his fingers. Clutching his notebook, he waved an embracive arm around the camp. 'I know you're going to say it's not allowed. But if us lot don't write down what's happening, it'll be lost. And, sure, aren't you keeping a painting diary?'

William nodded; he had nothing to say.

'Animals are better off …' the boy began. William was about to point out the horrors endured by the cavalry horses, but the boy was in full spate. 'At least the animals in the woods are. If you could see the squirrels, Major, sir. The other day, I saw three of them – running along the ground, climbing up a tree, their tails waving as

though they hadn't a care in the world. And another time some of us watched a flock of birds as they rose crying in the dusk. It was as though they didn't want to leave us.'

As the last rays of twilight danced on the horizon the fragile beauty of dusk was a perfect backdrop for communication. The painter in William wanted to say an appropriate something, spoken from his heart to this boy soldier who had the sensitivity and language of a poet and who had experienced too many horrors too soon. He settled for, 'I know what you're talking about.'

The sensation of peace did not last for long – it broke during the night, bubbling into trouble. William woke to the sounds of gunfire roaring in his ears. His body shook. Beads of sweat crept out from under his hair and trickled down his forehead. He sat up in bed and lit a candle. It was a black night with flares burning red against the sky. At daybreak, William saw that the little cottage and outbuilding were reduced to whispers of smoke. His senses felt charred as he looked at the suffering landscape with the blackened stumps of trees gouging deep shadows on the ground.

If he lived to be a hundred, never would he become inured to such sights – and yet in front of him was the silvery nimbus of another morning.

Sometime later his attention was caught by a young soldier in full kit sitting on a rock against the backdrop of a dark blue sky. With his hand held pensively to his chin, his pose evoked Rodin's *Thinker*. William pulled out his sketch pad, and in a few minutes, he had captured the unknown soldier on paper.

'I hope we're not in a trap.' It was the boy from the previous evening, back again. He spoke jauntily, as though being in a trap was inconceivable. William envied him his air of insouciance. Their talk from the previous evening seemed a long while ago.

A short time later there were barked commands, and the Allied artillery began its bombardment of the enemy trenches. The boy thrust a notebook into William's hand. 'Mind this for me. I've to go.'

William waited, knowing that after the barrage had ceased the first wave of officers in the trenches would blow their whistles. Sure enough, the sound travelled on the breeze. He could hear the officers urging their men up ladders and over the top to struggle across no-man's-land, through sheets of rifle and machine gun fire. He touched the notebook as though it were a talisman and offered a prayer to a god he did not believe in for the safety of the boy.

Unable to resist, he opened the notebook. The writing was in pencil, capitals letters, chunky and blocky. He read: *mud, shells, barbed wire, rain, rats, lice, trench foot*. He turned over a few pages: The same bold hand wrote: *the mud is a sucking mud ... a monster that sucks at you*. The impact of the words was greater as there were so few on each page.

The bold strokes summed up what William had seen. A page further on: *Rain and artillery fire turn the trenches into cesspools – the men flounder and even drown – if killed by shellfire, their bodies dissolve into the slime.*

William itched to capture the boy's word pictures in paint. He turned a few more pages. *It is not all horror.* The five words stood bold on the page. The following page amplified: *Our days are of boredom interrupted by bursts of terror – most of our time is in small, damp dugouts, making*

The Thinker on the Butte de Warlencourt

tea, eating bully beef, delousing and gossiping – at night, the trenches come alive, troops are replaced – carrying parties replenish supplies and small groups of us get sent out to conduct trench raids or repair wires. It was as William had heard again and again from the ordinary soldier.

As the sky was bruising dusk, a private approached William. 'I'm to get Liam's notebook off you, Major.'

William hadn't known the boy was called Liam. 'Where is he?'

'He didn't make it. Halfway across no-man's-land he was mowed down.'

William covered his grief with, 'What about Paddy and Joe?' He was glad he remembered their names.

'They went back for him. Copped it too.'

William returned to his tent, looked at his pencil sketch of the young soldier he had done that morning. Perfect. Scarcely pausing for breath he pulled out his box of watercolours and painted the lad against a background of dark blue sky, his features illuminated by a light shining down from the top left corner of the composition. For no reason, he titled it *The Thinker on the Butte de Warlencourt*.

Over the following days he experienced so many differing emotions that he was spun out. On occasions, for no reason that he was able to fathom, his pulse thumped, a headache hammered and he had a frightening sense of time falling into itself. He was sleeping heavily and waking befuddled and sweating. He had more than enough of this God-awful camp. He packed up and returned to Amiens.

Chapter 12

Summer 1917, Mont-Saint-Éloi; Summer 1911, London; Spring 1912, London

After a few days of nursing what TT unsympathetically labelled 'a bit of a head cold', William relocated to the abbey at Mont-Saint-Éloi. It had a prime position on a ridge, a mile or so north of the city of Arras and was a valuable vantage point for the British Army. From the time of its establishment in the seventh century, the abbey had served as a lookout and observation post during the many battles fought in the area. In recent months the guns belching out flames on the plain had scarred and slashed the once fertile plain – land that had grown crops and housed generations of families was reduced to a shell-pocked mess of craters and broken-down tanks.

William wandering around with his sketchbook found the place depressing, but he could not fault its organisation – the British forces had dug in, establishing billets, medical facilities, gun sites and a Royal Flying Corps aerodrome that was situated beneath the abbey's twin towers.

He was to paint a portrait of the commander-in-chief. The man was long-faced, with sharp, searching eyes, and he was chatty, boasting of how he had instigated the plans to blow up underground mines with the aim of destroying the sector's German defences. William's non-committal grunt of acknowledgement had him admitting that they had ended up with little more than mud-filled craters and continuous fire from the Germans.

In an effort to change the subject from death and destruction, William said, 'I'd like to see around the aerodrome.'

'That's unlikely. Extremely unlikely.' The man beamed. 'One of our pilots managed to fly his aeroplane between the towers.'

Later, as William leant against the parapet, taking a breather and wondering at the commander's refusal to let him see over the aerodrome, he was joined by one of the pilots, lean, blonde and good-looking. The pilots were a breed apart. They held demigod status – aloof from the masses, they strutted around in their leather jackets and flapping flight caps. Many were from aristocratic backgrounds and had originally trained as cavalry officers, but now that the cavalry was more or less defunct, they had turned to the skies.

William glanced sideways at him as he lit a large cigar. 'Could you get me into the aerodrome?'

He shrugged. 'I wouldn't think so.'

William ground out his cigarette. 'Why not?'

'Security.'

'I'm hardly a security risk.' The more obstacles being thrown in William's way, the more determined he became to see this aerodrome.

Next morning as William was applying the finishing touches to the portrait, the commander received a message that had him jumping to his feet. At the doorway he looked back at William. 'The general has arrived. Why don't you join us?'

As they drank gin and tonics in what passed for the officer's mess, William was surprised to hear the commander announce, 'Can somebody organise that this fellow gets to see around the aerodrome?'

After all the impediments thrown in his way William expected something spectacular, but he was singularly unimpressed with his guided tour of the vast hanger. It housed flimsy aeroplanes that looked as fragile as moths, with fleets of mechanics and pilots bustling backwards and forwards in nurturing attendance. He could not imagine taking to the skies in one of the delicate-looking aircraft.

Evelyn frequently talked of the thrill of flying and how she planned to take lessons. 'Be one of those petticoat aviators,' she had

laughed, planting a firm kiss on his lips. No matter how many portraits he painted, what horrors of war he observed, what delights future technology promised, William missed her with every fibre of his being. He missed her outrageous sense of fun, the risks she took, her joy of life.

The correspondence between them was light-hearted. His letters were mostly humorous with little sketches on the side margins, occasionally a touch of affection crept in, but he observed propriety, never adding too obvious intimacies. She was a laggard about writing – she had warned him of that before he left London – so her few dashed lines were doubly precious, although they left him in no doubt that the war had not reduced her appetite for socialising and enjoyment. She was in his mind as he dropped off to sleep at night and again when he woke in the morning.

He was bemused at the strength of their feelings for each other. Instead of waning, over the years their lovemaking grew more passionate – it was both tender and sophisticated. Sophisticated was the word Evelyn used and William was intrigued – he had never thought of applying the word *sophisticated* to their love affair – or indeed to any love affair.

But then there weren't many women like Evelyn.

In the early days of their togetherness, as he sketched her while she stretched out on the chaise longue, they talked about this and that, a flowering conversation where one thought opened on another. The subject of children, babies specifically, came up.

'I take precautions,' he said. It was a spontaneous admission – they had never discussed the likelihood of Evelyn becoming pregnant.

'I know you do. And I take precautions too. We need to be sure. We wouldn't want the scandal of a pregnancy, now, would we?'

She laughed heartily at the idea, but he didn't. He had no trouble imagining the disastrous implications if the unwelcome happened, but he wanted reassurance from her. 'But suppose it ever came to that?'

'You needn't worry, Woppy darlingest. That's something I'd deal with.' Her voice was firm, emotionless. 'Could you imagine?'

Only too well could he imagine the scandal reinforced by the wagging tongues of gossip. But she was so certain, so definite that there was no likelihood of her ever becoming pregnant with him that he put the idea of them having a child together out of his mind.

For a few weeks during the spring of 1911 Evelyn was difficult to contact, ignoring his notes, his bouquets of flowers and boxes of the dark chocolates she favoured. William fretted that she may have tired of him, taken another lover or he wondered if this one of her 'sophisticated' ploys – he could not be sure. When he bumped into the St Georges dining at the Ritz, at Howard's suggestion, he joined them for coffee. They appeared to be the perfect, happily married couple. He worried that Howard had found out about them. He worried and worried. Then he received a cryptic note from Evelyn that had him even more worried. Would he join her in Berkeley Square on Tuesday at five o'clock?

At five minutes to the hour, groomed to perfection wearing a new worsted Savile Row suit, wing-collared white shirt and a polka dot bow tie, he presented himself at her house holding a bouquet of summer flowers – pink and yellow lupins and deep blue delphiniums.

Dora ushered him into the drawing room where Evelyn lay on the chaise longue. William had a moment of panic. She was not in the habit of lying down or resting. Was she ill? He looked down at her, a frown of worry creasing his forehead – she was smiling and appeared to be blooming with health.

'Your expression, Woppy darlingest. You look as though you're attending a funeral.'

'I was worried about you.'

'Come, sit beside me. I've a surprise for you.'

William was so worn out with fretting that he was in no mood for surprises.

'I'm pregnant, having a child,' she said.

He took a gulp of breath. 'Are you sure?'

'I am. It was as much of a shock for me as no doubt as it is for you.'

'Are you all right?'

'As well as can be expected, I suppose.'

'How?' he questioned weakly, and when she laughed, he joined in but more out of politeness than jest. His thoughts were full of the likely scandal and the dreaded gossip. Worries tumbled through his thoughts

'How do you think?' she asked. 'I didn't know I was pregnant until it was too late to do anything about it. I hid my state for as long as possible, and during those weeks of concealment Howard and I had a reconciliation.'

William absorbed the news without comment, merely a tightening of his lips. Evelyn lifted the silky material of her blouse, showing the creamy swelling of pregnancy. 'Now that we can no longer hide the news Howard is publicly delighted.' Evelyn reached out a hand to William. 'Come, tell me your news, and how you've been.'

William was confused by Evelyn's attitude.

'Do you and Howard ...?'

Evelyn interrupted whatever he was going to say with a burst of laughter. 'Darlingest, on occasions, needs must. This is one of those occasions. And that's all you need to know.'

'It could be mine?'

'Yes. It could be. But Howard is the child's father. We're both delighted with the surprise addition to our family. And it's best if you and I are not seen together for the next few months.'

Throughout the pregnancy, Evelyn continued her usual frenetic lifestyle. Dora was their go-between. From her, William learned that the child was born 'efficiently' – Evelyn's description of the birth – an hour or less after she left a stylish New Year's Eve Party in 1911. William had no difficulty imagining Evelyn sitting up in bed surrounded by frilled pillows, revelling in motherhood, delighted with

her New Year baby. From what he heard, she was a doting mother and Howard a besotted father.

Gradually, William came to see the sense of Evelyn's attitude. They needed to be of accord about the advent of Vivien. When he finally received an invitation to Berkeley Square, a young, fresh-faced nanny from Connemara brought the child to the drawing room. Taking the swaddled bundle from her, Evelyn dismissed the girl and when the door closed behind her, she unwrapped the baby and thrust her into William's arms, declaring, 'There's no doubt; she has your nose, your flaring nostrils of intelligence.'

William was bemused by the situation – he couldn't remember much about Bunnie or Kit at that age. The child reminded him of the baby owl his brother Richard had caught in the grounds of Oriel. As he was making sense of the situation, he was taken aback when Evelyn asked, 'Are there likely to be more Orpen children added to your two daughters?'

'I don't know.'

'And I refuse to think about you copulating with Grace.'

William closed his eyes, reached for her and planted a firm kiss on her forehead, 'I can't bear the thought of you copulating with Howard.'

They frequently joked at the ugliness of the word *copulation*.

'Some things are better not envisaged,' said Evelyn briskly. 'And now for tea.'

That was Evelyn – efficient and practical when she was not enjoying their copulations. He smiled with pleasure at the thought of resuming their relationship.

On his return that evening to South Bolton Gardens he did a quick sketch of him holding aloft a plump baby. At the bottom of the page, he wrote: *This drawing is supposed to represent what the ordinary baby from 4 to 5 months looks like. So you can judge how much your Vivien is superior – NB this gives you no chance for criticism, so that is the reason I have done it!!*

Chapter 13

Summer 1891, Dublin; 1911, London; 1917, Cassel

There was never a question of William's work being criticised. He had two particular talents. One was his artistic ability – from his earliest days at the Dublin Metropolitan School of Art he won awards and kudos, allowing him to roll through life on the carpet of success.

The other talent – if talent it could be called – was the magnetism he held for all ages of the opposite sex.

He was little more than a toddler when he knew that his all-powerful mother doted on him, giving him a feeling of confidence, and indeed, a swagger of arrogance that he carried with him throughout his life. Mrs Byrne, their housekeeper, her face round and as predictable as the face of a clock held the reins of the household in her capable hands, constantly slipped him pieces of apple pie or porter cake, ruffling his hair and predicting his ability to charm. Nanny, a thin slip of a woman, raised the Orpen children from birth and she took it as a compliment that he could twist her around his little finger. Then there was Mary, their junior housemaid, with her freckled complexion and easy smile frequently directed towards him. He was more than a little in love with her and devastated when his mother sent her away.

'Consumption,' was Annie's terse explanation. 'Given half a chance, it'll run through the household.' Within an hour an ambulance drew up at the back entrance of Oriel where William was hanging around. First Mrs Byrne opened the kitchen door, looked to right and left, stepped back and ushered out a sobbing Mary. The sight of the girl, her few possessions in a cloth bag, being hustled into the ambulance haunted his dreams until Clarissa came for afternoon tea on a sunny Tuesday.

His mother's guests for her weekly 'at home' included a selection of lady-like cousins and friends dating back to her childhood, as well as committee members who wore big hats and talked in loud voices. Those who had daughters of a suitable age were encouraged to bring them along. Annie was great for introducing people to each other, and she did her best to inveigle her children to join the party around the tea trolley. Boring. Boring. Being older, William's brothers usually managed to be excused, but frequently he ended up spending the best of two hours in the drawing room, sitting still on the brocade sofa.

Clarissa, his third cousin once removed, was different. Even watching her alight from the carriage, he suspected she disliked afternoon tea as much he did, but she was pretty and grew prettier with each visit. She made no attempt to be pleasant. She sat, scowling, crumbling cake and sipping tea.

Annie handled her with uncharacteristic brightness, asking about her piano lessons, the books she was reading and how her watercolouring was coming along. The girl answered with ill-concealed boredom, an occasional yawn and a general air of disinterest, while her mother, who doted on her only child, nodded and smiled at her every sentence.

The week before William was due to start at the Dublin Met, Clarissa and her mother were the only guests for tea. William sitting opposite Clarissa noticed the tumble of her hair spilling out from a red ribbon and the neatness of her feet in their buttoned boots.

'Please, Aunt Annie, may I have your permission to ask William to show me around the stables?' Her voice was sweetly melodious.

The two mothers looked incredulous before glancing at each other in a conspiratorial way. It was not only an unexpected and unusual request, but coming from Clarissa, it was out of character. Annie Orpen, ever the gracious hostess cleared her throat. 'But of course, dear. That's a splendid idea. William, please.'

He and Clarissa rose in unison. He held open the door for her, and in the hallway, she turned to him and laughed. 'Come on, race you.'

She ran out the front door, while he went the back way, through the kitchens and into the yard. He was first and waited, hidden behind a water barrel. When she came around the corner of the house, looking to the right and left, he jumped out at her and executed a war dance of victory.

'That's not fair,' she pouted.

'All's fair in love and war.' It was out, said before he quite knew what he was saying.

But Clarissa did. 'And which is it?' She cocked her head in knowing way.

'What do you think?' Remembering Nanny's advice about smiling when in doubt, he bestowed on Clarissa his widest smile.

'I know, but do you?'

William felt an unfamiliar stirring. 'These are the stables,' he stated unnecessarily, waving an equally unnecessary arm in their direction.

'I know. And what are you going to do?'

'Well ... show you around.'

'Show me what?' She had moved inside the door and was standing in the gloom, looking around.

'The horses ...'

'When you've seen one horse, you've seen them all, don't you think?'

William was saved having to answer by Clarissa darting to the end of the building, climbing to the top of a pile of hay and patting an invitation to him to join her up on her perch. He licked his lips, ran his fingers through his mop of hair and looked beyond the stables to the brightness of the outside afternoon before easing up beside her. She swung her legs backwards and forwards.

'Do you go to school?' he asked.

'I've a boring tutor. Stuck with him in the boring nursery learning boring lessons all boring morning.'

'I'm going to the Met next week.'

'I know. I heard. Mama says you've enormous promise. Perhaps someday you'll paint my portrait?'

As William sat alongside her, he sneaked a look at her profile – the plump curve of her cheek, tendrils of hair and the lace of her collar seeming to stroke the softness of her neck. 'Perhaps, I shall.' His voice was thick again, and he jumped down, planted his two feet squarely on the ground, placed his hands on his hips and regarded her in what he hoped was a sophisticated manner.

She was not a girl easily taken in. 'Cowardy, cowardy custard, stick your head in mustard.' She jumped down too and landed in front of him. Her lips were parted and her eyes sparkling. He held out his hand and she took it: hers was warm and soft, curling into his palm. He looked into her eyes, and they moved closer.

'Master William. Are you out there?' Mrs Byrne called from the kitchen door.

Clarissa put her index finger to his lip. 'Shush.'

William drew back from her and moved towards the entrance. 'Yes. What do you want?'

'Is Miss Clarissa with you?'

'She is.'

'Her mama's looking for her. Their carriage is out front.'

Clarissa placed her index finger against William's lips, brought her mouth close to his ear and whispered, 'Later ...' Her voice trailed off as she ran laughing across the cobblestones of the yard.

Mrs Byrne crossed over to him. She had a knowing look that had him blushing, the heat spilling up his neck and across his cheeks. She glanced in the direction Clarissa had taken, 'Well, I never, Master William. Pranking again. It looks like you've an admirer.'

Clarissa may have been his first admirer; she was far from the last.

But none of the many women he loved endured as Evelyn did. Invariably, no matter what he was doing, his thoughts rewound to her – their relationship presenting like an intricate mosaic. What a

woman. He smiled as he remembered the aplomb with which she handled her birthday gift to Howard.

On the evening of the unveiling of William's portrait of her, sunshine dappled the tree-lined streets and glimmered off the buildings along the square. The guest list was made up of the usual mixture of the society people who attended such events – glittering socialites, the titled, right-honourables and wide-eyed debutantes, as well as a scattering of art dealers and several dignitaries from the Royal Academy.

William, with Grace and their daughters, were among the first to arrive. He was on edge with a fluttery feeling in his stomach, unused to the deviousness of the double role he was playing. Husband and lover. The two women present. He did not have Evelyn's over-riding social confidence, and he wondered at his ability to handle their relationship in such a public setting and with so many people looking at them; he felt they were exposed – he the artist and she the subject. He shuddered at the thought of the comments that would be free to flow backwards and forwards, ripple through the guests and beyond.

'Your dress suits you – the blue colour's nice,' he whispered to Grace as they walked up the steps. 'I don't believe I've seen it before.'

'It's new. I thought ... The occasion ... It's an important one for you, isn't it?'

He was touched. Grace paid little heed to who he painted or how he did it. Over the past four years his reputation had taken an upward turn making him increasingly sought after as a painter of society portraits, but she appeared to be oblivious to his success.

And then Evelyn, wearing white shimmering silk, was coming towards them in all her magnificence. She swooped down to take both of Grace's hands in hers, stood back from her and said, 'How wonderful to meet you at last.' She looked at the children. 'And your daughters!' She turned to William. 'They're so pretty, just like their mother. You're a lucky man.' He felt an unfamiliar pang of guilt at seeing Grace standing by his side, oblivious, he hoped, to his relationship with Evelyn.

William and his family were swept along as a tide of other guests arrived. He remained by Grace's side, introducing her to the various people who came to talk to him.

For her part, Evelyn played both dutiful wife and hostess with her usual aplomb, keeping by her side Howard and her daughter, a pretty child with dimpled cheeks and a mass of reddish golden hair.

William lifted one of the most exotic-looking cocktails from a passing tray and handed it to Grace who giggled as she took a sip.

'Can I have one, Papa?'

'No, you certainly can't.' He got two glasses of lemonade from another tray for Bunnie and Kit.

The nibbles, as Evelyn called them, were Connemara smoked salmon and Dublin Bay prawns, transported to London and artistically curled on the small crackers she imported from America. Personally, she had overseen the placing of every prawn, each piece of salmon and the laying out of the cracker display on silver platters, with strategically placed wedges of lemon. That was the way she was – attentive to the smallest of detail.

And then it was time. The gong rang with such forceful enthusiasm that Grace jerked. William leaned towards her, whispering, 'I wish this was over.'

'You've no reason to worry.' She spoke loyally, and he was grateful.

Howard, with Evelyn by his side, stood in front of a rich velvet red curtain with bobbly fringing, hanging from a row of brass rings.

William's mouth was dry and he licked his lips with nerves, wishing he had something stronger to drink. Evelyn was such a non-conformist that he was never sure how she might act, what she might do.

Howard cut a fine figure, a controlling figure, in a well-cut suit of tails, with a white wing-collared shirt, gleaming diamond studs and an elegant silk necktie. He used his hands to quell the sounds of conversation and the room fell silent.

He moved closer to Evelyn and put his arm about her shoulders – they were an evenly matched couple in height. 'You're all most welcome here this evening. It's a great occasion. And it's my pleasure to unveil a portrait of my wife by the most famous portrait artist of the era. It's her birthday gift to me, and it's such a secret that I haven't yet seen it.' He moved aside from Evelyn and pulled on a tasselled cord.

Slowly the curtain moved to one side, revealing in a leisurely way the portrait, the full glorious eighty-four by thirty-six inches of it. Evelyn St George stood proud, a symphony in creams and browns, her natural beauty heightened and enhanced by William's skill. There was a gasp and a scattering of clapping from the assembled audience. Howard turned around to look at the painting, stepped back for a better view, threw his arms wide and faced back to his guests, his hands held in a high clap. 'What can I say? But please, let the artist come forward.'

As William walked up the centre of the gallery, a path cleared for him, and his progress was marked with more clapping. He stood by his painting, dwarfed by the St George husband and wife team, feeling foolish, unsure of what to do except to keep smiling.

Evelyn kissed his cheek – it was so chaste a peck, a scarcely-there touch, that he hardly recognised it as coming from her.

Howard stepped forward bringing his daughter by the hand, the child was bent over with blushing giggles. 'I'm pleased to say that we plan a further commission for William Orpen' – he paused dramatically – 'it's to paint Gardenia's portrait.' More claps and an occasional cheer. But Howard was not finished. 'My innovative wife has come up with the idea of having Gardenia painted each summer at our place in Connemara. So we can monitor her progress in oils.'

Over the following weeks Evelyn kept William informed about her plans for him to visit their house at Maam Cross. He wrote to her: *I am worse than ever now – quite hopeless, did you hear I was getting a Rolls-Royce – I see I am turning into a bit of a blood myself – some car if I am ever able to pay for it.*

While stationed at Cassel, William was pleased to be re-acquainted with Madame Brodeur, whom he had first met on the outskirts of Amiens when she had translated his words from English to French for the distraught women looking for news of their menfolk, many caught in a bout of shelling, and she was the person he had turned to when he wanted to mark the death of the keeper of the prison.

She was working in the local hotel where he had taken rooms for a few weeks and gave the word competent a new meaning as she went about her daily tasks. She reminded him of one of the young women painted by Metsu and Van Meer, posing at a piano, dressed in silks and satins.

He found himself looking at her a lot – perhaps too much. She'd smile at him, and he'd smile back. Smiles. That was as far as their relationship went – if you could even call it a relationship. She was someone who knew the horrors of war but was not in despair – her husband had died from poisoning contracted in the trenches.

That he was cautious about becoming involved with local women had little to do with being faithful to Grace or Evelyn: it was to keep intact his reputation as 'the little Irish artist', a description he rather liked. There had been women during his time at the front; his couplings with them were hurried, secretive and paid for, used purely to satisfy his sexual urges. He was not ashamed as such, but he was circumspect, wanting to avoid any finger of suspicion being pointed at him, never to earn the reputation of a 'womaniser' as he had heard Howlett describe another officer with contempt.

There was just one bathroom in the hotel, and although it had a bath, it irritated him that there was never any hot water.

'Is it asking too much to have an occasional bath?' he asked Green.

'The hot water would have to be carried up two floors, Major.'

'I'm aware of that.'

Green never refused a request outright, but he had a habit of skirting his replies. He gave his usual cheery smile and scratched his head. 'Leave it with me. I'll check it out.'

'Do that. Make a few enquiries – shouldn't be a problem.' William was uncharacteristically grouchy. He had developed a skin infection that itched, and his current head cold with its accompanying sweats was lingering on. He craved the luxury of soaking in a hot bath.

One rainy Saturday after lunch he returned to his rooms, planning to paint up his recent batch of sketches and hoping by doing so to take his mind off the persistent itch. There was a knock on the door, and before he had a chance to reply, in walked Madame Brodeur, paler than usual but with an air of unexpected authority. She closed the door, stood with her back against it and looked at him, frowning. He moved from one foot to the other, uncertain of why she was in his room. In an instance his disquiet was dispelled when she told him she had solved the problem of his bath.

She opened the door and gestured. A giant of a young man, with chipmunk cheeks and arms like tree trunks stepped into the room. Madame Brodeur spoke to him in rapid French. He looked at William and nodded before reaching across and shaking William's hand in a bone-crushing grip.

From then on, several times a week, hot water in a bronze tub, the size of a bath, arrived upstairs. Basic and crude as the bath was, memories of Evelyn came crowding in. She loved bathing, making it a sybaritic occasion. Her settings were luxurious – swathes of white marble, golden taps, thick, soft terry towels and sublime scents. The first time they bathed together he thought she'd forgotten to remove the ropes of pearls that nestled most titillating between her breasts. As she eased an exploratory toe into the jasmine-scented water, he reminded her. 'Your pearls?'

'No, I haven't forgotten,' she teased. 'Surely you know the natural lustre of pearls are enhanced by skin? They're meant to be worn.'

He missed her with every fibre of his being, particularly when he was unwell. Not that she was likely to provide nursing care – that was Grace's strength, while Evelyn's was making love and nurturing his career. His needs were well met by wife and mistress, the two most important women in his life.

A few days before he had sailed to France, he and Evelyn had spent the best part of twelve hours in her bedroom, their lovemaking fuelled with injections of whiskey and smoked salmon arranged on crackers by the indispensable Dora, who also supplied pots of coffee alongside dishes of scrambled eggs.

'I won't forget you while I'm away,' William had assured Evelyn, looking around, imprinting on his mind the lavishly appointed bedroom with its mahogany furnishings, gilt mirrors, swags of velvet and fringing.

'I wouldn't expect you to,' Evelyn laughed.

'I'll be back in London occasionally.'

He had never told her about the birth of his last daughter. She was in Boston visiting her father for much of Grace's pregnancy. On her return to London, when finally they met up, they were so devoured by passion for each other that there was no right opportunity to look her in the eye and say, 'By the way, Grace has had another baby.' It was easier to let the matter drift, but now that he was going to war, he felt an obligation to tell her.

'Grace and I have had another daughter.' There it was said.

'Another one? That makes four.'

'No three. Bunnie, Kit and Diana Evelyn Olivier – Dickie for short.' Hoping for a positive reaction, he stressed the middle name, *Evelyn*, when rattling off the child's first names.

'Well,' she drawled, 'she must be three or four by now?'

He was flummoxed. All along she had known about his youngest. And never said a word.

'How much easier it is for a man rather than a woman to have another offspring. And to be able to keep quiet about it.'

After a moment or two of feeling rather foolish William agreed. She did not comment on the inclusion of her name – at the time of the baby's baptism he had been adamant, and relieved, when Grace had not demurred, believing her reaction confirmed that she did not know about him and Evelyn.

Before leaving London, he sent Evelyn a note with a drawing of him in uniform: *England called her last resources little Orpen's joined the Forces*. It was written in his usual cavalier style with scant regard for punctuation. She had not replied.

Despite the warm water and longed-for soakings in the bath, William's itching got worse and he developed a reddish rash. The medical officer, tracked down at TT's insistence, was young and harassed with a baffled frown that inspired little confidence.

He wore his stethoscope uneasily, pressed it to William's chest, listened with a grim look and diagnosed an infestation of lice, assuring it would pass in time.

Green who fancied himself as a bit of an authority on medical matters was hanging around in the background, watching intently. 'I've examined the major and his clothes on several occasions, Doctor, and I haven't found a trace of lice.'

The medical officer looked at him with raised eyebrows. 'I beg to differ.'

Green spoke firmly. 'I know about lice.'

'I'm sure you do. And now perhaps you'll leave me to my patient.'

The doctor's diagnosis was not for changing, and he left the room with an assured swagger. Green was concerned enough to take TT into his confidence. William's itching became constant, and his scratching drew blood. Much to his embarrassment, Green insisted on a minute examination but without finding a trace of lice. A week later William's aide insisted on a second medical opinion, but the same doctor presented, looking even more harassed. He changed his diagnosis

from lice to scabies, unapologetically advising William, 'It's best you go to the local field hospital. Let the medics there take a look at you.'

Green warned, 'It's filthy, a charnel house, Major. You'll come out of it worse than you go in and you won't be the first. I'll get you into the military hospital.'

William hoped the treatment for scabies, unpleasant as he'd heard it was, would work. But a few days later an orderly with an efficient air and a cowlick negotiating his eyebrows, examined him. 'You haven't got scabies, Major. This sulphur treatment will kill you.'

'What's wrong with me?'

'Blood poisoning.'

'It that serious?'

'Very.'

After a week as an in-patient, and what William considered to be ineffectual treatment resulting in no improvement on his condition, he discharged himself, announcing he'd settle for out-patient treatment. He wrote to Grace in graphic detail: *I have blood poisoning and still have it – a white hole with a black band around it, and all the flesh for about six inches beyond the hole is deep scarlet.*

On a lighter vein in a note to Evelyn he included a drawing of himself in oversized hospital pyjamas: *I'm quite merry and bright – and I try to make the whole hospital laugh, and sometimes I succeed.*

Chapter 14

Summer 1917, Picardy

On a morning of dazzling brightness William looked out from the barn that had been set up as an outpost. Stretching as far as the eye could see was a Corot landscape alive with nature: the road pocked with sheeny puddles, crazy tree-stump sculptures, a meadow framed with a line of willows beside a running stream, and in the distance, a small village, circled by a few houses, veiled in a light haze.

It was a relaxed and casual outpost, some miles behind military lines, almost cheerful compared to some of his previous painting locations. Still not fully recovered from his bout of blood poisoning, he had another head cold. Or perhaps it was a continuation of the previous one? He couldn't make up his mind and he didn't much care.

In the distance, a Tommy, swinging his helmet, called out, 'Come. Come quickly. We've captured thousands of German prisoners.'

William left the barn and followed the crowd.

The prisoners – all three thousand, five hundred, as he later learned – were hunched, crowded together in huge cages. From what he could see they were crawling with lice; some were naked, more half-naked, scratching, clawing at their bodies, drawing blood with filthy hands and dirty nails.

'Where are they from?' he asked an officer who had come up alongside him.

He spun his swagger stick and shrugged. 'Don't know, don't care. It hardly matters.'

'Do you know how they were captured?'

German prisoners POW camp, France

'No. I don't.' Another spin of the stick and off he swaggered.

William was appalled at his attitude. He moved away from the officer and the stench, and rested his back against a wall, feeling his own flesh crawl as he opened his sketch book, chose a pencil and looked at the scene before him. He was sickened, his belly somersaulting bile up his throat. Man's inhumanity to man. It had come to the point where he was waging his own private war within himself, and he wondered would this goddamn war ever end?

Suddenly with no warning the air was still, followed by a loud whirr as the heavens opened with a bombardment of heavy, black 15 cm shells dropped by the Germans. William's heart boomed in the hollow of his clavicle, and he as sure he could feel his blood running cold as he heard the crash of shattering glass. Yelling, shouting people ran all around him and into him. He tasted smoke and knew he should run for cover. Frozen, he was numb as he looked around. A shell burst short of the corner where he was stood. He threw himself flat on the ground, protecting his head with his hands as he was

surrounded by the flash and bump of the burst, the acrid smell and the rattle of fragments of falling brick.

The prisoners forgot their imprisonment. They clasped their hands above their heads and like a victorious tidal wave they rose shouting and cheering at the sky while shell after shell shrieked overhead.

That night William woke in a lather of sweat dreaming, not of the German shelling of that day, but of what Sam had told him about Ben and Jim. In his dream he was with Ben and Jim at the site where he had done the painting. Without warning the scene had erupted with exploding shells, flying debris and that acrid smell. He watched in horror as Jim toppled over, disintegrating before him – an arm here, a leg there, his head knocked sideways and an out-pouring of blood. Trying to avoid the worst of Jim's bleeding, he picked up his remnants and passed them one by one to Ben who positioned each piece carefully in the sandbag.

He sat up in bed, lit a cigarette and gave himself a mental shake – too much introspection, too many thoughts floundering around in his head. He was held fast by this war, as though an invisible net of steel was thrown over him.

Damn. He was missing home. The more he remembered how pleasant his life was, the more he had flashback memories of holidays in Howth during the early days of marriage – painting Grace and Bunnie lying on the shingle beach, his daughter asleep, his wife smiling, her eyes closed against the brightness of the sunshine. He could see her as though she was standing before him, clapping her hands in delight at the completed *On the Beach, Howth* and *By the Seashore, Howth*. That was Grace in those days.

He stubbed out his cigarette and burrowed back down under the blankets. He closed his eyes, breathed deeply and evenly, but sleep would not come and thinking would not go away.

From early on the war was referred to by generals, newspaper columnists and the general public as 'the war to end all wars' – a war

that would be over within a few months; but still it blasted on, with the weapons becoming better killing machines and the number of injured and dead escalating.

Viewed from the safety of London, without personal experience of soldering, weapons or day-to-day survival at the front, William had thought of the war as exciting and epically heroic. But since coming to France, his attitude had changed, was continuously changing. He was increasingly sickened by the reality of war.

Doggedly he had ploughed on, determinedly fulfilling his commission, depicting the war as he saw it. It never crossed his mind to give up, to return to London. He and his brothers were raised to be fearless, to persevere to the end.

Whenever he remembered Field Marshal Haig's admonishment about presenting 'the facts of soldiering without the gore' he smiled in disbelief – as though war could be sanitised. With nothing more than brushes, paint and a slab of canvas, the onus was on him to show courage, fear, nobility and self-sacrifice, to create portraits that caught the men's expressions of bravery and terror, shell shock and exhaustion, as they were shot at and shelled, ravaged by lice, shamed by defeat, starved and distorted by death. It was incumbent on him to portray truth – if that involved 'gore', so be it.

He had never much gone in for circumspection. It was his habit to draw and paint rapidly. When he had looked over his latest batch of paintings, it was with analytic eyes. Spread out on the bed and along the walls of his room, a glass of whiskey in one hand, a cigarette in the other, he walked around, viewing his canvasses objectively, pausing before each. He was pleased. He was achieving what he had set out to do. For the landscapes of the Somme he used light blues, yellows and whites of the *plein air* canvasses to good and gentle effect in *A Clear Day: View from the British Trenches opposite Le Boisselle* while still keeping the composition formal. He was pleased with the power of the paintings depicting the inhumanity of war such as *Adam and Eve at Péronne* – the dichotomy

Adam and Eve at Péronne

of a laden-down soldier being offered a rosy apple by an attractive woman; *The Howitzer in Action* – pen and watercolour as soldiers get ready to fire and *The Mad Woman of Douai* – harsh greys depicting the woman seated centre in a ruined church backdropped by the devastation of the town.

The Mad Woman of Douai

What he had not captured, and what no one could capture, was the smell of war. He frequently thought back to the captain he had met during his early days in France and his undramatic assurance that the smell of the war was the memory he would carry with him for the rest of his life.

Chapter 15

Summer 1917, Paris

A few days away from the misery of the front to visit Paris was a welcome respite. William feared he might find the city damaged, its beauty tarnished, and he wondered about food shortages. Around the camps there were stories of menus in the best restaurants of the capital that included elephant consommé and roast camel. It seemed even the zoo animals were playing their part in the war effort, someone joked. Another person told of *civet de chat aux champignons* being served. Cat with mushrooms? That couldn't be right. If the rumours being bandied about were to be believed the main dining option was fast becoming sewer rats.

On his arrival, he was pleasantly surprised. He stood on pavement of the Champs Élysee breathing in the nectar air of boulevards. The places he knew and loved appeared to be untouched by the war – the luxurious hotels were functioning as always, and he saw no sign of domestic animals on any menu.

He had been invited to join a party of British officers for dinner in Ciro's. It was the thought of dining in Ciro's that had him accepting the invitation. He'd first discovered the restaurant when he began to make his name in London. The Parisian outlet with its signature white and gold front opened in 1911 on the ground floor of the Hotel Daunou. From the beginning it surpassed its London cousin and was an instant success with Rue Daunou becoming the ultimate in stylishness.

On the Thursday evening, with a sense of anticipation, William crossed the carpeted lobby and entered the smaller of the restaurant's dining rooms, known as the bar room because it had a bar at one end

and held only about thirty-five tables. The evening's host was Major General H.M. Trenchard, who he'd painted shortly after arriving in France and who was credited with the success of the Royal Airforce. He drew William into the group of military men, resplendent in dress uniforms decked with medals and ribbons.

A red-faced general holding a brandy glass in one hand and a cigar in the other was saying something about being 'a firm believer that war contributed to enhancement of self'. He appeared to be inordinately pleased with himself as he looked from one to the other of the party.

'Have you been to the front, General?' William asked.

The man turned towards him, taking in with a dismissive glance his civilian tails. 'No, I haven't, but I don't have to experience war to endorse the sentiments of the cognoscenti and intelligentsia of Europe. Not that I've any time for the Germans, but Friedrich Meinecke declared at the outbreak that war was one of the most wonderful moments of his life.'

'And may I ask who is this Friedrich Meinecke?'

'Only one of the most respected German historians of the era.'

'And I presume he hasn't been to the front either?'

Trenchard shepherded his party in a determined way towards a corner table at the back of the room. Seated with drinks ordered and social pleasantries exchanged, he leaned in towards William. 'There are a lot of high-ranking officers stationed around Paris who think the same as the general, and it's best not to ruffle feathers.' He was as gruff and as forceful as William remembered.

'Nobody should be voicing such sentiments without experiencing the front.' William would not back off.

The remainder of their party busied themselves studying the tiny menu. William looked around, seething, wishing he had passed up on the evening's invitation. He could have dined alone and enjoyed his own company. As it was, he looked around at the other diners, noting an attractive, slender woman of indeterminate middle age

with refined features. She was sitting with two men a few tables away from their group.

The woman seemed familiar to William, and while their waiter settled an order of gins and tonics on their table, he remembered having seen her in Claridge's hotel. She was English, he was sure, although he was unable to remember who she was. She was dressed with conservative elegance and several strings of exquisite pearls.

She reminded him of how Evelyn might look some years into the future – perhaps it was the pearls? When the jazz quartet struck up with the popular 'I Ain't Got Nobody', one of the men in her party stood up and bowed to her. She rose gracefully, smoothing down her skirt, touching tendrils of hair escaping from beneath her hat and catching his hand she led him to the miniscule dance floor. She moved easily in graceful time to the music, keeping up a stream of animated conversation.

Another general with slicked back hair and a supercilious look clicked his fingers. He too had been watching the dancing couple. 'Strange, isn't she? I believe she's some sort of an English duchess, although I can't recall what she "duches" over.'

They dined and wined well that evening on prawns, fillet steaks and several bottles of excellent Burgundy. As they were getting up from their table the woman with the pearls came and stood in front of William; she smiled and nodded at him as though they had been formally introduced. As he bowed his head in acknowledgement, two waiters seized her by her elbows, ran her up the centre of the room and out.

'I wonder what that was about?' queried the supercilious one. 'It's a strange sight, surely! To see an English duchess being thrown out of Ciro's.'

William was flushed with the anger he had kept in check all evening. He went up to the maitre d', a plump man, with a thinning head of hair.

'Yes, sir. And how can I help you?'

'You can help me by explaining why you had a lady, a member of the English aristocracy, treated in such a manner.'

The man shrugged. 'She was on her own. The men she was with had left.'

'But' – William wanted to come across as reasonable – 'she wasn't behaving inappropriately. Why didn't you just ask her to leave?'

'I did, but she refused. I did what I deemed necessary for Ciro's reputation.'

William went out into the lobby to try to find her.

Another of their party, a thick cigar clamped between his lips, followed him. 'I wouldn't let it bother me, old boy. There's lots of odd people wandering around Paris these days.'

William turned on him angrily. 'I'm bothered at the thought of her being set upon. I'd like to ensure she gets back safely to wherever she's going.'

But she was gone – vanished into thin air, it seemed. On further enquiries William heard that she was staying at the Ritz. But when he called there the following morning, he was informed that they did not have an English duchess as a guest. It was as he had half expected, and it aggravated his worries about her.

A few days later as he was passing the Hotel Chatham he saw her coming towards him, well dressed, in a white coat.

She walked straight up to him. 'Young man, I want you to do something for me. Don't be nervous – it's nothing immoral. I'm not that sort. I just want you to come along with me to a café around the corner.'

'What's the name of this café? And why do you want to go there?'

She ran her fingers along her pearls. 'I don't know. I just do. I want you to find it, to come with me.'

Her eyes darted uneasily, and she had a strange look about her.

'I'm sorry, Madam. I can't do it. I've a previous engagement.'

She wiggled her finger in front of his nose. 'Ah, naughty, naughty boy.'

She continued along the crowded street with William following at a discreet distance. Every man she met, no matter what class, age or nationality, she stopped, all the way down the boulevard, and from their body language William had no doubt that she was asking them about the café. The last William saw of her was her disappearing down the steps of Olympia leaving him with a feeling of uneasiness, anxious about Grace and his daughters and fretting about Evelyn. This damn war was taking a lot out of him; it had him obsessed, shaken to his core and yet he had no alternative but to return to capturing its images on canvas.

Chapter 16

Summer 1917, Roeux & Albert

Despite the civilized elegance and fine dining, he'd experienced during his stay in Paris William was pleased to leave behind the military bullshitting, as he thought of it, and to return to the front, to his meagre lodgings, the unappetising food and the relentless continuation of war.

When fighting, followed by fire, broke out around the chemical works at Rœux, he was on the spot to sketch the men as they emerged from the inferno. Many were in a bad state, dragging themselves along, being dragged and dragging others. They were moaning, yelping, crying with injuries ranging from gunshot wounds to burns – a young man had half of his face out in a blister; another dragged a blackened leg with flittered trousers stuck to the flesh.

William railed at his helplessness – there was nothing he could do to alleviate the men's suffering, except to record what he was seeing and this he did with delicate pencil strokes, at variance with the inferno.

He caught up with a lanky soldier ambling along, his left hand thrust deep into his pocket, his right hand black and raw. He was whistling 'Keep the Home Fires Burning'. There was an appeal about him. 'Mind if I do a quick sketch of you?'

The whistling stopped, the soldier shrugged, 'Well, you may. But can I have it?'

'Sorry, son. I'm a war artist and my drawings and paintings are the property of the War Office.'

'I'm goin' on leave. Goin' to get married next week.'

'Congratulations.' Up close the man was impressive. His looks, attitude and the way he carried himself fulfilled William's ideal of a soldier. 'Where's the wedding?'

'A small village near Manchester.' He rooted in the top pocket of his jacket and drew out an envelope with a picture of a pretty girl. 'My girl. She'd like the picture.'

'Sit over there. I'll see what I can do.'

While the soldier sat on a low wall, William did a quick drawing of him, pleased at how within a few minutes he caught the lad's attitude of bravery and integrity, as well as his slight air of awkwardness that made him all the more endearing. He handed him the sketch. 'That's for your girl.'

The lad nodded. 'Thanks, guv. Sure, who else but her'd want to be lookin' at me?' He rolled the sheet of paper carefully, put in his pocket with the photograph, patted the two together and stood up.

'Back you sit,' William ordered with a smile. 'Do you actually think there's such a thing as a free portrait in the British Army?'

The soldier sat back, awkwardly manoeuvring a pack of cigarettes from the top pocket of his tunic. They lit up, smoked companionably for a few puffs, and then William got down to the business of capturing his likeness again. The sketch finished, the soldier thanked William gravely and continued on his way, whistling. A shiver ran up William's spine at the uncertainty of life at the front. He didn't know the man's name and he'd never know if he made it to the church to be married.

Day after day that August the sun towered high in the sky drying the chalky mud into a dazzling whiteness, clothing it with scarlet poppies, yellow-eyed daisies and blue cornflowers. William set up his gear on a hillside among crippled tanks, deserted trenches and dried out shell craters. He turned his back on a severed **hand lying in the grass and a Boche and a Highlander locked in a deadly embrace** while he painted a series of memorials. He did his best to ignore

The Gas Mask. Stretcher-bearer, Ramc, near Arras

the continuing evidence of death alongside life and instead wrote to Grace complaining of sunburn: *the skin off my nose is falling down like ribbons.*

In the evenings he adjourned to the recently opened restaurant in Albert. A few months ago, he had more or less written off the town, but now that the war had passed through, it was coming back to life. He was intrigued to watch it emerge phoenix-like from the ashes.

A father and his three daughters ran the restaurant. They patched up a little house by the station, painted the walls a bright yellow, acquired bales of red gingham check that they cut into squares and rectangles to disguise the unsightly tables and they put plump cushions on each chair. They scavenged a mismatch of pots and pans, cutlery and delph, and opened for business with streamers of celebratory bunting strung across the windows.

William was one of their first customers, entering through the narrow door and choosing a seat by the window. The pretty eldest girl called Adèle presented him with a glass of wine. She was slender and moved with a dancer's grace that reminded him of Anna Pavlova. It seemed another lifetime since he and the world-famous Russian ballerina had dined on lobster and drunk vodka in Dublin's famous Jammet restaurant. Briefly, he closed his eyes and saw the ballerina, laughing impishly, peering out from her netted swathe of headgear as she had announced, 'If I can't dance, then I'd rather be dead.' He felt much the same way about painting.

He held the glass of wine against the window, turning it this way and that, intrigued at the way its crystal cuttings caught the light. '*Merci*. This is impressive,' he complimented Adèle.

She dropped a tiny curtsy. 'It's our best glass, sir.'

He raised it in a toast to her, her sisters and father, wishing them every success with their restaurant. 'And what's on the menu?'

'We don't have a menu. Not yet. But tonight, there's rabbit stew.'

'So rabbit stew it is, and I look forward to it.'

By the time William was served with a bowl of aromatic stew and a small basket of crusty bread, several British and American officers were seated. The atmosphere grew cordial with laughter and jokes were bandied across the room. Despite difficulties in obtaining supplies, the restaurant was a success, and from that first day it did a roaring trade.

William watched the revival of the town with interest – houses with battered doors and broken window panes were patched up; gardens, borders and plots of land not too damaged by gunfire and

A tank in Pozieres

the tramp of boots were revived; the baker was back rising at dawn, and people woke to the aroma of fresh bread; children skipped and tossed ball; young and old men played chess and boules; once more a smart skirt could be seen, and even occasionally the flash of a shapely ankle. He enjoyed wandering the streets, hands shoved deep into his pockets, sketchbook and pencils tucked into his uniform jacket. There was something special about watching a town emerge from the ashes of war. It gave him hope.

The Madonna and Child was one of the first sketches he'd done – pencil on paper, only eighteen by fourteen inches, and he was fond of it. Whenever he passed the cathedral, he looked to the tower with its miraculously balanced statue leaning out. The story was that it had been knocked sideways by a bomb during the early days of the war. Despite the town's engineers' diligent bracing, it looked to be permanently on the point of collapse. Myths and miracles surrounded the statue: it was credited with occasionally dripping blood; reputed to be watching over the safety of the town; even prophesising the end of war. He took with a particularly large grain of salt the belief that whichever side shot down the statue would lose the war.

As the town renewed itself, its courage reminded him of the small, sparsely occupied villages in Connemara where every stranger was greeted with, '*Dia dhuit*' and the nod of a head.

Chapter 17

Summer 1912, Connemara; Summer 1917, Péronne

Officially, William was visiting Connemara in the west of Ireland to paint Gardenia. Unofficially, Evelyn had engineered the commission so they could spend time together. Life couldn't be better for William – he was being spoken of as one of the best portrait artists in England; he had a comfortable home with wife and children, a mistress he adored and the war was still three years away. As he rode along the laneways on the horse hired from the local stables, the air was like nectar, the sky a bright cold blue, and he was enchanted by the low stone walls surrounding the patchwork of tiny, scrubby fields.

In the distance, what had to be Screebe Lodge dominated the landscape. He rose on his stirrups to better view the solid-looking three-storey Victorian building set incongruously amid the wilds of Rosmuc. Riding up the avenue, he saw Evelyn standing on the front steps of the house, and as he reined in his horse, she moved to meet him, holding Gardenia by the hand. She was wearing a cloak of grey flecked tweed – during his time in France he often recalled how effortlessly she blended into the landscape.

As he dismounted, she held out her arms. 'My dear William, how lovely to see you.' The kiss she deposited on his cheek was as chaste as the one she had bestowed on him at the unveiling of the painting. For his part, he wanted to enfold her in his arms and carry her to bed. It may have been what he wanted, but the idea of it brought on a smile – and her a whole foot taller than him. It was six long weeks since they had been together.

A stooped man wearing a baize apron came around from the side of the house. 'John Joe will take your animal to the stables,' Evelyn said. 'And John Joe, please ask Molly to bring tea to the front room.'

Gardenia held out a tiny hand and smiled up at him. She was a slim, pretty child with tumbling golden curls. Turning to her, Evelyn said, 'Now, my darling, go with Nanny while Mr Orpen and I discuss your portrait.' From Evelyn's attitude, William could easily persuade even himself that he was in Connemara solely to paint the child.

Alone they moved into the house. In the hallway an enormous fire of smouldering turf gave off a peaty scent. The room Evelyn entered was dark and soothing with another fire. She curled herself into one of the chairs, featuring giant tweed cushions and knitted blankets in the stitch he knew to be Aran. It was a quiet solemn room. He looked around appreciatively.

'Well? What do you think?' Her American accent was more obvious than he remembered.

'It's wonderful. All the sky and space. And the sharpness of the colours.'

'I should have known … You're talking about the landscape! And I'm asking about the Lodge.'

He shrugged. 'What's to say. I'd like to see around it, but from what I've seen, it's impressive. Is it yours?'

She laughed. 'No, Howard rents it from Richard Berridge – he's reputed to be the largest landowner in Ireland.'

'I believe I've come across the name somewhere, but not in the context of land.'

'He's a brewer from London, associated with the Law Life Assurance Society – likely that's how you've heard of him?'

A large woman with stocky forearms and capable-looking hands eased open the door with her foot. She was carrying a tray of tea things. 'You're welcome to Rosmuc, sir. Miss Gardenia's right

pleased at bein' painted.' Her voice had a gentle burr that made deciphering what she was saying difficult. William supposed he'd get used to it.

'Thank you, Molly.' When she left, Evelyn stretched in her cat-like way, raised her eyebrows expectantly and gave him a wide smile. 'Molly Flaherty and her husband, John Joe, look after us. And, of course, there's Gardenia's nanny. And during the summer holidays from Eton, it's a full house with Avenal, Ferris and the two Howards.'

'You seem very settled here.' One of Evelyn's many attractions was the way she blended seamlessly into wherever she was. He'd seen her acting as the gracious hostess at Clonsilla Lodge, dining in the Ritz and Claridges, drinking porter in a back street pub, holding forth at political receptions, chairing fundraisers, at home at openings and launches, and now here she was in the outposts of Connemara.

'I'm truly happy. I love the wildness and bleakness of the place and the honest sturdiness of the people.'

William looked around. 'Don't you miss your home comforts?' On more than one occasion he'd seen her lap up comfort, like a cat.

'It's relaxed and cosy here – you'll see better tomorrow. But we've ensured it's without losing the personality of the West of Ireland. Out back, we've a few bedrooms and a water closet of sorts. Nanny and the children occupy one of the small lodges, and Ruadari, the tutor, stays when the boys are here.'

'Ma'am.' It was Molly, her head coming around the door. 'There's bread 'n' butter 'n' cheese 'n' ham laid out in the kitchen. And I'll be seein' ye all in the mornin'.'

William sat with Evelyn at the long wooden table scrubbed to whiteness. Gardenia and her nanny, a plump, rosy-cheeked girl with a touch of a smile, sat opposite. A dresser held blue Willow Pattern dishes, and along the sides of the walls were chairs and benches. A round brown pot of strong black tea stayed warm on the top of the range and jug of buttermilk sat centre table. He cut thick slices from

a loaf of brown soda bread and handed them around. He slathered his with butter before topping it with chunks of ham. He was starving.

'This is good.' He spoke enthusiastically, his mouth full. 'I've never tasted the like of this butter.'

'We make it here. Connemara isn't known for its cattle, but Howard insists on keeping a small herd.'

After eating, Gardenia and her nanny disappeared through the door that led from the kitchen across the yard. Evelyn looked at William with raised eyebrows. He raised his in return, smiled and nodded. She led him up the stairs. Her bedroom was spacious with reed mats on the floor and thick blankets on the bed. A coin-like moon cast its golden light into the room and fanned across the floor. After making tender love they slept like babies.

For breakfast they ate boiled eggs, mashed into cups with hefty amounts of butter, a dash of white pepper and more brown bread, washed down with tea.

William's painting equipment had come on ahead of him. Evelyn had it stored in the one of the guest bedrooms. He was the first to stand up from the table, 'I'm going to check out my gear, make sure it's in order.'

'It is,' Gardenia assured. 'Mama wouldn't let us into the room. May I watch you paint?'

'That shouldn't be a problem as it's you I'll be painting.' She was a charming child.

William found his equipment in efficient order. His easels were ready to set up, a small table held boxes of paints and paintbrushes. His sketchpads were stacked to one side, along with a box of fresh charcoal and another of sharpened pencils. Gardenia, with her air of alert stillness, was a perfect subject and he was pleased with his *Portrait of Gardenia St George with Riding Crop*. The child's enthusiasm was as infectious as her mother's.

In between sketching and painting, accompanied by Gardenia, they rambled the narrow boreens, rich with cow parsley and swathes

of white hawthorn, Evelyn keeping up a running commentary on life in Connemara, Gardenia demanding answers to her innumerable questions and William at peace

There was a dreamy look about him as he ran the palm of his hand along the softly weathered grey stones of the walls that divided the small fields into squares and rectangles of patchwork grass. 'I can feel their story.'

'Stone walls. Famine walls; terrible times here, when the Great Famine – though what's great about it, I've never been able to fathom – and the lesser famines raged for several years in the mid-1840s. The kinder and more compassionate of the landlords got their tenants to build these walls, paid them a few pence a day and provided food for their families.' Evelyn strode out, shoulders back, breathing deeply, her hands dug deep into the pockets of her cloak. She went hatless and wore sturdy boots, more suitable for a man than a woman, much less a society woman.

Three weeks later William left Screebe Lodge, buoyed up with Evelyn's promise that he'd be painting another portrait of Gardenia the following year.

Like Connemara, Péronne was a place of stones. William likened the town to a polished skeleton, clean, neat and brittle, with an air of insubstantial bravery as its occupants returned and did their best to pick up the threads of their lost lives. He could not rid himself of the sensation that with the merest of breezes the stones would disintegrate and the houses tumble down. There was a vulnerability about the place, a fragility – it had none of the sturdiness of Albert.

He was intrigued by the College for Young Ladies and did a sketch, looking through the windows. Next day when he returned to complete the picture, he discovered that several of the walls had collapsed.

As had happened in Albert, the local residents set about patching up the houses. One of the bigger buildings opened up as a club. It was

Portrait of Gardenia St George with Riding Crop

airy, not intentionally so, but many of the windows were without glass and doors swung drunkenly on damaged hinges. On a hot day it was an ideal venue, with its unsurpassed view over the Somme. Its menu was monotonous, merely bully beef pie, cheese and beer, although nobody complained as groups of men, worn out by the rigours of the war, were pleased to sit around wobbling tables, raise their glasses to the future and sing when the humour took them.

The main complaint became the quality and flavour of the English chicory-type coffee.

'If only we could have French coffee instead of this terrible stuff,' William grumbled, 'things would be much better ... well, perhaps a little better.' When he raised his cup, he was edified to have nearly everyone in the club jump to their feet and endorse his wish.

'Where does the coffee come from anyway? It's like tar,' a slight-figured officer wondered.

'It's imported especially from England, likely for you lot.' One of the serving girls had excellent English and both cheeks dimpled when she smiled, which was often.

But life wasn't all dimpling pleasantries. The business of war continued apace.

Down in the valley of the Ancre River, a group of Indians appeared. William first came across them during one of his early morning strolls. He was stopped in his tracks at the sight of groups of brown men washing in the river, their bronze vessels sparkling amongst the reeds. Later he heard they were a cleaning-up party, brought in to remove debris from along the river, working in a dedicated way and accomplishing the clearance in a short space of time. They were of the Catholic faith, accompanied by an elderly priest who, it was said, had worked as a missionary in India for forty-five years.

For six days of the week the men worked from dawn to dusk, on the seventh day they prayed in the open air on the side of the hill. Their makeshift altar had a backdrop of colourful draperies hanging from about thirty feet. William was impressed with the warmth of their devotions and their melodious hymns during the Sunday afternoon services.

Sometime in early July, a formal burial party appeared, in the charge of a sturdy Scottish lieutenant with a doleful expression. The burial party's brief was to dig up, identify and re-bury the thousands of bodies that lay scattered over the area. William watched from a

slight incline and knew he was not imagining the drifting smell of death. Below him, the men went about their work silently and automatically, their faces grim, their progress brisk, determination in their every movement to get the job finished as quickly as possible. The talk in the club was that many of the bodies were too far gone and others without identification could not be named.

William was not the only one to be disturbed at the sight of groups of men sitting side by side in the evening sunshine counting out and divvying up the spoils of the day, mostly money, knives and cigarette lighters. When one evening he mentioned it to the lieutenant, he concurred. 'It's a sordid sight, all right.'

'But why permit it to be done in public?'

'HQ considers that being seen to be making an effort to identify the bodies is better done than not. It's tactically agreed that what's found on bodies that can't be identified is fair spoil for the burial party.'

'But it's like grave-robbing,' joined in an elderly local man with a luxuriant moustache.

The lieutenant lit a cigar. 'In the circumstances, it's not in the least. But perhaps it's difficult for a non-combatant to understand.'

'Not a job I'd like,' commented another local man. 'I'd prefer to be at the front.'

The lieutenant spoke again in his doleful way. 'It's a difficult job; even more difficult when you know that when the burial party is disbanded, most of them will be back in the trenches.'

'I can't say I approve – it seems disrespectful to the dead.' It was the man who had first spoken.

'I, for one, don't grudge them whatever few francs they make.' The girl dimpled and then wiped at the counter. 'God knows their lives are hard enough.'

Chapter 18

Autumn 1917, behind enemy lines in northeastern France

William folded himself into the passenger seat of the Rolls-Royce, tossed his sketchbooks onto the back seat and stifled a bout of sneezing in his handkerchief.

'You alright, Major?' asked Howlett.

'I'm exhausted. This blasted war is getting to me. First it was the cold and snow, then rain and damp, now it's the heat. And there's not a damn word from Colonel Lee about my last lot of paintings.' As soon as he had spoken, he realised he should not have unloaded on Howlett and that his comment about Colonel Lee was inappropriate.

His driver, a man of impeccable discretion, behaved as though he had not heard. 'Fancy a swim later, Major?'

'I'm not in the humour for jokes.'

'It's no joke. And you've often said how well you feel after a swim. Might cure that cold of yours. There's a long stretch of water in Aveluy, and some of the men have put up a springboard.'

That evening it was a joy for William to take off his clothes in the car and jump into the water. He felt free in the water, at his best. Sated, after a half an hour's solid swimming, he trod water and watched the men stripping, diving, swimming, drying and dressing in the waning sun. Joking and laughing they were full of life, not thinking of what the morrow might bring.

Word got around and the evening swim became quite a social occasion.

Frequently, a man who introduced himself simply as Joffroy joined the swimmers. Later William discovered he was France's official war artist, previously an athlete who lost a leg, right up to his

trunk, during the early days of the war – undeterred he clambered over trenches, not in the least impeded by his wooden stump. He was muscular with a strong arm-stroke, in his element in the water. One evening, after bathing, as they were driving back to Amiens, he stretched out his arms and said, 'Orpen, I feel like a young Greek god!' After a pause and a sigh, he added, 'Perhaps only a fragment of a god.'

William envied Joffroy's attitude. Despite the pleasure of the swimming, he felt unwell – not properly ill, but not properly healthy either. He debated seeing a doctor until he overheard Howlett and Green discussing 'whining officers', their tone scathing. He did not want to give them or anyone else cause to label him as 'whiny'.

His painting was going well; he was pleased with the canvasses he'd completed. But the relentlessness of the war was getting to him, and he was doing too much thinking – fretting about Evelyn, wondering how Grace and his daughters were managing, and speculating at how his family in Dublin were getting along, choosing to forget the scorn they poured on his position of British officer. Throughout his life he had gone with the flow, living in the present, responding instinctively to circumstances as they occurred rather than mulling over the past or planning the future. But now ...

These days he felt he was living with a permanent feeling of anxiousness that had him looking over his shoulder for he knew not what. Nightly, he alleviated his sense of uneasiness with wine and whiskey. He was sleeping badly too. Frequently, he woke up in a lather of sweat aching for Evelyn.

When he'd first seen her at Clonsilla Lodge, a frisson ran up his spine and with it the certainty that he'd encountered his soulmate. When they met years later at the viewing in the Royal Academy, he took the meeting and the ease with which she relaxed into their liaison as fate.

A short time into their relationship, after dining together they were relaxing by the fire in her drawing room nursing balloon glasses of brandy. 'Don't move,' he said, reaching for his sketch pad where, with a few strokes, he captured her air of easy sensuality as she lounged on the opposite sofa. 'Shall I stay the night?'

'No, go home. It's better not to over-egg the pudding. Your Grace is an angel. Are you sure she doesn't suspect?'

'I think not. And you insist on circumspection.'

'We're lucky to have each other.'

'Since I've found you, it's as though part of my soul has loved you since the beginning of time. Perhaps we're created from the same star.'

She smiled, her secret smile. 'A soulmate is not found. A soulmate is *recognised*, and I recognised you in the instant you stepped into the drawing room.'

Up to that evening they were so taken up with each other that they had not spoken much about their families. During their times together he was not in the habit of discussing Grace or the girls and she said little about Howard or her children. Sometimes he wondered where they all lived. Certainly not in London; perhaps Dublin or Connemara? It was not only unusual – it was unheard of in their circles – for a wife and mother to live apart from her family. But then Evelyn was unlike the other wives or mothers of the socially correct Edwardian era.

As though reading his mind she said, 'Howard has bought a place in Surrey – Coombe House, I believe.'

'What's it like?'

'I haven't seen it.'

'Will you be living there?'

'In theory, yes, I will. But in practice, I'll continue to divide my time.'

She lifted the sketchbook from his lap and removed the stick of charcoal from his hand. She nestled her head against his shoulder.

'Howard bores me, and I'm not much interested in motherhood. Too many children too quickly.' She shuddered and smiled. 'Although, I admit to a soft spot for Avenal – he's fearless.'

'It's easy to imagine you as mother to a fearless son.'

William had grown up in a household with five siblings and now he had three daughters, little people who controlled the timbre of the home with their demands. In the early days of their marriage, he had Grace most nights until the pregnancy made intercourse too awkward, and he had waited impatiently until after the birth to resume his conjugal rights, but his early passion for her had worn off – drowned in domesticity, he supposed. He could not imagine his passion for Evelyn waning.

On occasion, with a disapproving look, TT would remark along the lines of, 'You're too popular and too good company with too adroit a turn of wit. And, typically Irish, you're too able to hold too much drink.'

William would laugh at him and respond, 'And don't forget talented and modest too.'

In the evenings he could choose from a variety of invitations from officers to dine with them or to join in their drinking sessions. In the beginning he accepted all enthusiastically. But some months in he began to avoid socialising – opting to be on his own, painting or in desultory conversation with whoever he happened to meet.

He became friendly with a plump, middle-aged captain called Norton. He was an intriguing man, apparently as popular with French officials as he was with the British. He held an administrative job that he was cagey about, although he spoke with enthusiasm about his 'boys', as he called the miscreant young officers who he 'sorted out', seemingly on a regular basis. His reputation for kindnesses and compassion was well-known, and frequently while dining he would be interrupted by an orderly with a message running along the lines of, 'Excuse me, sir, but a young officer has had too much to drink, and is behaving badly.'

Norton would rise from the table muttering, 'Damnation. Can't I have a bit of peace at dinner?'

'What happened? What called you out tonight?' William asked curiously on one occasion when he had been gone for more than two hours.

Norton accepted his offer of a brandy and mopped his forehead. 'Young firebrand. Grand fellow. Developed an anti-war attitude and a social conscience that dictated he go absent. Without leave.' Norton was more forthcoming than usual.

'Where is he now?'

'On the train, on his way back to his unit, I hope.' He sighed. 'It would be easier all round to have had him arrested, but it'd finish the young lad. And his family. The shame. It's bad enough having their son at the front without him being charged as a deserter.'

'I hope the lads you've rescued from spending time in the cells or facing court martial appreciate what you do for them?'

'I think so. They're a good bunch. Perhaps a little high-spirited when they escape from the trenches. Understandable. This God-awful war. The unfairness of it. Do you know that officers with what are termed 'the proper connections' can escape trench duty? When will it all end?' He turned to William. 'Have you seen the conditions in the trenches?'

'Well, yes. I've had a look. But perhaps not seen the worst.'

'Pray God you don't. I've been there. The state of them is appalling. Unforgettable.' His eyes flashed with memory. 'Oozing slime, **shell-holes with the shapes of bodies showing through the putrid water,** constant shellfire and murderous gas. Some choice.'

He removed from his pocket several sheets of lined paper covered with a scrawl of writing. 'I took these off the lad – he shouldn't have written them in the first place, and if he was caught with them ...' Smoothing them out he handed the pages to William. 'Strictly speaking I shouldn't give you this. But ... here.' He thrust the pages

at William and stood from the table. 'I've to go. Keep them safe. And return them to me. They're for your eyes only.'

William poured another brandy and began to read:

> Suddenly, we were engulfed by the yellowish cloud we'd come to fear. Gas. The alarm was sounded, and we scrabbled for our masks knowing we had less than twenty seconds to put them on before our lungs would be filled with a stinging fluid. I pulled the cloth over my head resisting the urge to gag as I put the rubber tube into my mouth. The trench was chaotic with men running about, adjusting their masks and fixing bayonets. Gun crews, masked up, readied their machine guns along the parapet. As the gas descended, the Boche followed with an infantry attack. The trench was filled with a foul-smelling vapour. A soldier staggered into me clutching the mask that he hadn't managed to get on in time. To my shame I sidestepped him as he gagged and gasped and spasmed, clutching at his throat before falling to the ground and lying still. When I looked around, I saw the others were going over the side, crawling under the thick fog, but one soldier had his hands over his mask, his shoulders were working and he was making gurgling sounds. I wanted to leave him, but I didn't want to go over the side, so I went to him. There was a rip in his mask, the gas was seeping into his eyes, his nose, his pores. He tried to tear it off, but his fingers were too weak. I put my arms around his shoulders and stayed with him until he dropped to the ground and then I followed the rest of the men over the top.

That night William was restless, tossing, turning and sweating, waking up on several occasions thinking he was choking and unable to breathe.

He spent the next few days wandering around the edges of the trenches. After reading that diary entry he wanted to capture in paint what that young officer had brought alive with words. While he sketched, he listened to rumblings of discontent among the ordinary soldiers, mutterings about the infantry being treated like rabbits in the shooting season. A young lad, eyes small and shiny with fear, confided,

'We're constantly on the lookout for a safe hole, Major. And as soon as we find it, we're ordered to move.'

While William was on one of his meanders behind the lines he stumbled on the remains of a Tommy and a Boche – two skulls and some bones. They were identifiable only by the scraps of material adhering to them. Saddened, biting on his lip and with tears prickling behind his eyes, he looked at the debris of the dead men who during their lives would have laughed, cried and, perhaps, loved and, he hoped, been loved. He straightened up. Blinked rapidly. What the hell was wrong with him? Before him was the making of a powerful painting – the way the bones lay made an appealing composition. And the British skull was unusual in that it had a division in the frontal bone. He set up his easel with a canvas, checked he had pencils, palette, brushes and paints to hand.

He liked working on his own, but there was security in knowing that Howlett was parked up a short distance away.

After a few hours, as the painting was coming together, he had a strange sensation of not being alone, of being watched. He stopped, brush in hand, and looked around. Nobody in sight. Nothing moving. He was on his own under a cloudless sky without a puff of air and with the sun beating down. He shivered. From fear. It was the place. Nervously, he turned full circle to scan the horizons. It felt as though a bad happening was imprinted on the atmosphere. As a child he heard such stories from his Kerry relatives – hungry grass, haunted fields and ghostly hedgerows. He gave his thigh a slap of his hand to stop such ridiculous thinking.

It was high noon and growing hotter by the minute, a silver haze writhed in the distance, a sweep of mauve willow herbs wilted and the birds were mute. As his imagination ran riot, he wondered if, perhaps, he might have a touch of sunstroke?

He sat down on the trunk of an uprooted tree in the scant shade provided by a skinny sapling, a miraculous survivor from past shelling. Again, he looked around, from side to side, sweeping the area

thoroughly. There was nothing to be seen. Absolutely nothing. But there was something. An unseen something. Perhaps, only a sensation. But by God, whatever it was, it was with him. He felt its presence. A shiver ran up his spine and his heart boomed. Suddenly, he was thrown upwards, landing on the flat of his back on crumbles of soil. From his prone position he saw that his easel was toppled and his canvas had become impaled on a branch of the uprooted tree.

He rose slowly, balancing carefully on his knees, before feeling his way to his feet. His trousers were torn, a stream of blood seeping through the material. He dabbed at his shin with his handkerchief. He would not, he could not, allow his imagination to take over. He had to hold himself together. Unsure of whether he was being brave or foolhardy, he rescued his easel, set a fresh canvas on it and began painting again, working without incident until it was time to leave.

That evening he told Joffroy about coming across the skulls, and the peculiarity of the British one. But nothing else.

'I'd like to see that,' said Joffroy.

Next morning William brought him to the place. 'Howlett has organised a hamper. I'll be back around lunchtime. We can eat together.'

He set up his painting equipment a little further up the hill in Thiepval Wood. Even with Joffroy's company there was no way he would spend time in yesterday's location.

The morning passed pleasantly and productively as he painted a landscape, with predominantly white, lavender and blue tones. He was pleased with the painting, its gentleness strangely appropriate to the summer wilderness left by the war. He titled it *Thiepval*. When he rested back in admiration, he was reminded of *Midday on the Beach*, his 1910 study of Grace and Kit underneath a parasol – it was the sense of peace and the beauty of nature that he'd managed to capture, he supposed.

Around noon, well pleased with his morning's work, he went back down the hill carrying the hamper of bread, cheese, fruit and wine.

Midday on the Beach

Joffroy, head in hands, was sitting on the trunk of the uprooted tree. He looked distraught and gestured with his arm. 'I feel very unwell.'

William shivered.

Joffroy looked ill, sweaty, his eyes cavernous in a grey face. 'It's the smell from those remains.'

'There's no smell.'

'There is. Didn't you see that one of your skulls still has an eye?'

William knew all four eyes had withered away months before. He said nothing, but he was shaken by Joffroy's experience. The Frenchman did not strike him as being easily spooked.

'It's the heat. Have some wine.'

Joffroy looked around and hoisted himself upwards. 'Not here. There's something strange about this place.'

Between Joffroy and William there was an unspoken pact that they would not discuss the incident, but it loomed lumpy, silent between them.

Later that week news circulated among the men that the English poet John Masefield was in Amiens. He had become a household name with the publication of *Gallipoli*.

When William came upon him dining alone in a small café up one of the side streets, he joined him.

John jumped up in greeting. He was a tidy shape of a man, dark-haired and with a well-groomed moustache. 'My dear fellow. How good to meet you at last.'

He gestured to the girl who was waiting table to bring another setting, another bottle of wine and a glass. It was rabbit again that evening – William had grown partial to its gamey taste.

After general chit-chat, John asked, 'Are you getting the assistance you need from the War Office?'

'Yes and no. There are certain portraits I'm more or less ordered to paint, but other than that, I've been able to negotiate a more or less a free hand. How about you?'

John twirled the stem of his wine glass, 'I'm encountering endless obstacles.'

'After the success of *Gallipoli*, I'd have thought your way would be paved with help.'

'Well, it isn't. I'm refused access to official records.'

'How can that be? I heard you were working on a book about the Battle of the Somme?'

'I am. That's the title. And it's official.'

'That's ridiculous. What is Whitehall thinking? *Gallipoli* raised our spirits and lifted the British public from their disappointment at the Allied losses in the Dardanelles. Surely it's only about a year ago since it was published?'

'I know that. I also know that eaten bread is soon forgotten.'

Hearing of John Masefield's treatment by officialdom William was somewhat mollified by Lee's attitude to him. It was comforting to know he was not the only artist suffering at the hands of bureaucracy.

'I'll see if I can have a word,' he promised.

Chapter 19

Autumn 1917, Amiens & Boulogne

In the quiet of his room before settling down for the night William was in habit of processing his day. Since the skull incident, as he labelled it, his intake of alcohol had increased – wine, whiskey and brandy – anything that would give him a few hours of sleep and take the edge off his pall of anxiety. He had taken to standing in front of the looking glass in an effort to reassure himself that he bore no resemblance to the shell-shocked soldiers who wandered the streets.

He thought he was succeeding until the afternoon TT appeared unexpectedly at his shoulder. As an exercise in escapism, William had returned to the village where he had first met Liam, Paddy and Joe. There was no sign of any soldiers, injured or otherwise, and he was relieved to see the village remained untouched by war. He was sketching the sturdy stone houses, cobbled streets and fountain with the cherub still spouting water when he heard a clearing of a throat. It was TT, the inevitable *Financial Times* tucked under his arm. 'There you are. I want to talk to you.'

'I'm working,' William's reply was sour. What was his aide doing here? He knew he didn't like being disturbed. He could get him in the hotel that evening. A moment of panic. Had something happened to Grace? His daughters?

'You're sober and alert while you paint. That's why I'm here.'

William debated using his boxer's punch but decided against it. How dare Aikman.

'I'm anxious about you,' TT began without preamble, 'I suspect you're burned out from the sights you're surrounded by and the work you're doing.'

William shrugged. Burned out? The phrase was bandied about. 'Surely such symptoms only apply to fighting men in uniform? Not to a smock-wearing artist?'

In an uncharacteristic gesture TT rested a hand on William's shoulder. 'Howlett and Green are worried too. You're unwell. Would you consider going home for a few weeks rest?'

William was touched to the point of feeling tears prickle behind his eyes. How ridiculous was that? He blew his nose forcefully. 'Thank you, but I'm all right. And now you'll have to excuse me, I want to get on with this.' He gestured to his open sketchbook. On a lighter note, adding, 'See you for a few drinks this evening?'

William could leave France whenever he chose. He could go back to London, to Grace and his daughters. And to Evelyn. But he was caught up in the web of the war, lacking inclination to do anything other than paint.

The majority of artists coming to the front came for two or three weeks but he had inveigled an unlimited length of time. He would not give in to what TT had said, but deep within he suspected he was right.

Sitting over yet another glass of wine that evening – there was no sign of TT joining him – he was in a reflective mood, unnerved by his aide's concern, and worse, knowing it was shared by Green and Howlett. He knew he was just about keeping a handle on himself, as his father would have said. The shelling and gunfire were consuming him. Perhaps his seeds of fear were sown as early as meeting up with Liam, Paddy and Joe – all dead now? The bodies in the ditch? Painting Ben? The skulls? Horror lurked around every corner. Of course, it did. That was war.

He tried to analyse the extent of his dread in proportion to danger. The *joie de vivre* of what he now regarded as his earlier mindless sense of adventure was gone, supplanted with fear. Fear was with him on awakening; it lurked alongside him as he painted; it was his drinking companion, his constant. In vino veritas. A fleeting thought. Instead

of him controlling his fear, it was controlling him. That was as terrifying for him as the war. He and his art should be immune from fear, safe from flawed reasoning. But that was no longer the case.

He grew angry at his batman's concern about his health and his diplomatic suggestions that wine was no cure; he was annoyed when TT spoke about the 'psychological effects of warfare', and distressed when a few mornings later, Howlett said, 'Best you take it easy today, Major.'

Time came when William could no longer recall what it was like to live without fear.

Since coming to France he had worked on his own, in solitary pursuit of his art, but increasingly he was being thrown into the company of artists at the front due to the enthusiastic commissioning of war paintings for Canada by Lord Beaverbrook. He was a powerful Canadian-British newspaper publisher and backstage politician who was determined to influence British politics and news coverage in both newspapers and radio. And he was succeeding.

William was shocked at the behaviour of some of the artists, particularly Augustus John – like him, he was in the uniform of a major, but John had added riding boots, spurs, gloved hands and a cane. He was, apart from King George V, the only bearded officer in the British Army, and he was immensely pleased when he was taken for the king by soldiers and officers alike. From their time in Vattelot, all those years ago, William knew he was arrogant but now he found him disruptive, lacking in compassion and with a flamboyancy that mocked the seriousness of the war.

A summons to meet Lord Beaverbrook resulted in days of changed dates, times and places. Eventually the Hotel du Louvre in Boulogne was settled on. Friday at three o'clock. The lord was a small, slim man with a large head and protruding eyes. He ordered champagne, settled himself fussily with his back to the wall, raised his glass to

William and without preamble said, 'I presume you're willing to work for the Canadians?'

Being caught on the hop, as it were, and considering he had little option but to answer in the affirmative, William's agreement was lukewarm, after which they engaged in a meagre amount of desultory conversation until Beaverbrook again raised his glass to the success of the venture. Aware of the Lord's power, William was uneasy at the timbre of the meeting and he felt he had no option but to speak out. 'It's a shame so many art works are going to Canada rather than remaining in England.'

Without answering Beaverbrook stood up and gathered his cane, gloves and hat. With a nod and a smile, he walked away, the cane twitching in his hand as though it had a life of its own.

William's foreboding proved correct. He was distressed at being in the grip of the Canadians and at the way the new restrictions disrupted his individualistic style – Beaverbrook wanted portraits of officers, whereas William wanted to paint the fighting men. Writing to William Rothenstein, he complained: *It's sickening to have to sit down and do a face, just as if one were in London. I'm running away to some old battlefield to get some peace.*

Instead of a battlefield, William found a quiet, out-of-the-way place with a gentle landscape. As he was setting up his easel, a small white dog with touches of black walked up to him, sat down at his feet and looked up at him with the most appealing eyes. 'Hello, dog,' he greeted. The animal responded by putting its head to one side, raising its ears, thumping its tail on the grass and, having made its point, running off. Later that evening it emerged from behind a clump of grass. When he called to the dog, it came, tail flying from side to side before throwing itself on the ground, legs waving in the air. William took the hint and tickled its belly. 'It's a strange thing, dog, you living here without humans or other dogs.'

Over the following days the dog appeared and disappeared. With a gentle nod to his mother's love of the Irish language, William named it Madra – no matter where he was sketching or making notes it would find him and approach, sure of an enthusiastic welcome. Madra's modus operandi was to have a good look around as though ensuring they were alone before, with ears on alert, it nuzzled at William's knees for attention. That was the signal for him to stop sketching and tickle behind its ears, a gesture that threw it into a paroxysm of tail-wagging delight. It liked to sit on his knees making sketching awkward, but more often than not, he was inclined to accommodate it, explaining what he was doing, why he was doing it and every now and again the little dog obliged with a wiggle to show it understood.

In the evenings it began to trail him back to his hotel, and when he scrounged a scrag of meat or a rare bone, it was nonchalant in either acceptance or rejection. One day Madra appeared with a tall woman of middle years dressed from head to toe in black. She was striking-looking with steel grey hair in a bun, high cheekbones and watery blue eyes. She regarded William incuriously. The dog ran backwards and forwards between them, as though urging them to friendship, but of necessity their conversation was stilted, although from gestures and miming William thought she was offering him a drink.

Perhaps it might be coffee? His throat was raw, sore, and he had a feeling of tightness about his chest. What he would give for a real coffee? But as far as he could see there was no place to conjure up a beverage. The thought was tantalising – he could almost smell the coffee's aroma, taste it on his tongue. He nodded. The woman smiled and walked off, calling to the dog, which ignored her and remained by his side. He watched as she negotiated a wall before disappearing from sight. With a sigh he lit a Gold Flake and turned back to his canvas, pleased at the way he was capturing the early autumn countryside.

About a half an hour later the woman appeared on the horizon. Madra raced to her in welcome. As she drew nearer William saw she was carrying a billycan. And yes, he was sure he could smell coffee. Graciously she accepted a cigarette from him and watched while he poured the steaming black coffee into his mug. He gestured towards her with the mug. She shook her head. 'Non, non.' He raised the mug to her; she acknowledged his gesture with a grave nod of her head and watched in an intent way while he drank.

When he was finished, she came close to him and pulled at the sleeve of his shirt, holding a fold between her thumb and index finger, frowning, tut-tutting. The cuff was both grubby and frayed. Laundry was increasingly difficult, and despite his best efforts, there were times when Green was unable to organise fresh linen, much less new replacements. From the woman's torrent of words William thought he could make out something that sounded like the word *lavage*. That was something to do with washing, wasn't it? He nodded enthusiastically. Perhaps, as well as someone with the ability to conjure up from the middle of nowhere the best coffee he had tasted in weeks, he might have stumbled on the local laundress.

He was right. He had. Or rather she had stumbled on him. Once again, she disappeared and returned a short time later with a shy-eyed young girl. She handed him a well-worn white shirt, gesturing for him to remove his garment. Hands on hips the two females watched as he stripped and put on the replacement, feeling as small boyish as when Nanny stood over him while he changed clothes that for one reason or another met with her disapproval.

The two women walked back in the direction from which they had come, this time the dog accompanying them. Some hours later the girl returned, holding his laundered shirt neatly folded. With gestures, smiles and pidgin English amplified with occasional words of French, William discovered that her three brothers were soldiers – there had been no word of them for several months. The girl and her

mother put him in mind of the sturdy women of Connemara who Evelyn had such respect for.

The woman came most days carrying a billycan of coffee, the dog loping alongside her. Alice, he discovered was her name, and she had a reserved way about her. He gave her some francs and a few packets of cigarettes that she accepted with quiet dignity, burrowing them deep into the pockets of her skirt. And then one day she did not come, neither did Madra or the girl. William was surprised at how much he missed them.

Abruptly the weather changed. Days became a landscape of grey autumn lashed by the gales; William had grown up with wind curling and swirling about the gables of Oriel. But the chill in that French wind stung his face and cut deep. He developed a particularly harsh and persistent cough, accompanied by alternating shivers and sweats. To crown it all as he was tidying up after a day's sketching and painting, he stumbled against a rock, tore his trousers and gashed his shin.

Next morning his leg throbbed, and he was riven with shivers. His efforts to rise had his head swirling. He plumped up the thin pillows, pulled the scratchy blanket to his chin and settled back, feeling more unwell than he had with any of the previous colds – they all took a lengthy and debilitating time to clear, and after each bout it was weeks before he got back his strength. With each cold he felt his overall sense of wellness was further eroded.

Sometime during that evening Green scavenged a hipbath, and as William sat basking in the warm steam, he brought him a hot whiskey, even managing to find a few cloves. Despite the unexpected luxury, William woke several times that night shivering and bathed in sweat. Next morning, he was flushed, sweating, trembling and with a violent headache. He was vaguely aware of Green's concerned face being replaced with Howlett's.

'Stay there, resting, Major, and we'll see what we can do. Have you been as ill as this before?'

'Only as a child. But I think the cut is more of a problem than the touch of fever.'

Howlett and Green confabbed over the swollen, red, oozing gash on his leg. Green took control. 'I'm going to find a doctor to give you something.'

William's eyes watered with the intensity of his headache. While he felt ill enough to die, he determined to be brave. 'I'll be all right,' he croaked. 'The doctors have their hands full.'

Next time he woke he was on his own and it was dark.

And then came the dream.

He was down in the trenches caught up in a nightmare of mud and water, floundering, watching men engulfed in sludge; seeing others shot, their bodies dissolving into slime. He was reduced to earth, his eyes to puddles of rain. He watched powerlessly as men navigated not by sight but through the immediacy of their bodies, creeping, crawling, burrowing and worming. The visual universe supplanted by a strange tactile geography.

A lantern shone in his face. Behind its light loomed Howlett and Green. Standing alongside them was a tall, thin young man, red-eyed, with spikes of dark hair and a stethoscope dangling from his neck. He stepped forward, bent over William and applied the stethoscope to his chest. Saying nothing he pulled back the covers and looked at the cut on William's leg. It was sore, throbbing. But not as bad as his headache. And then his world went mercifully black.

He slept and woke. Green changed the bandages on his leg. Howlett fed him soup. TT came and went like a wraith, muttering about hospitals.

Days, or perhaps it was weeks later, he could not be sure, the worst was over – the throb of his leg settled to a continuous dull ache; his headache was manageable and he had become used to his sore throat.

And so he limped, sweated, sniffled and coughed his way through another month. The intensity of his cold – for he insisted it was merely a cold, coming and going. With each return the symptoms were more debilitating, his misery more enveloping.

Within the family the fact that William was born delicate was freely debated. His mother enjoyed telling of the fragile baby who became a sickly toddler, grew into a boy and a man who was prone to illness 'as well as being a great artist,' and his brothers jeered him and his 'sniffles'. When he was ill, he was used to being luxuriously nursed to wellness. No such attention was available in the thick of war.

For days during the latter half of October he either sat out his misery in his hotel room in Amiens, willing recuperation, or insisted on Howlett bringing him to various sites to paint. His health didn't improve and he neither sketched nor painted anything of use. He snapped at Green's suggestions about having a doctor take another look at him.

Something must have happened. But he remembered little, except suddenly feeling dizzy in a floating room. Someone must have defied him and called in a doctor from the nearby hospital. William emerged, blinking from an unhealthy, sweaty sleep to find at the side of his bed another gaunt-faced man wielding a stethoscope.

Chapter 20

Winter 1917, Amiens

When William came to, he was in strange surroundings – a long room with tall windows and rows of beds. He edged upwards on his elbow, dragged his body along the sheets and tried to swing his legs over the side of the bed. A nurse in a crackling uniform materialised. She placed a cool hand on his forehead, nodded and pointed an accusatory finger at him.

'*Non, non.*' You must lie quiet. You are sick.'

As though he didn't know. Hating the feeling of helplessness that enveloped him he closed his eyes – he had an awful need to shut out the world. When next he looked the nurse was gone. The place he was in was quiet, bright and peaceful. Then the nurse was back – she had multiplied, there were several of her accompanying men, wearing white coats and more dangling stethoscopes. Although why they were staring down at him was quite beyond him. He did not know for how long they kept coming and going around his bed, peering at him, checking his pulse, fingering the glands on his neck as he drifted in and out of sleep.

Later he learned that he had been transported to base hospital by stretcher and was in a ward occupied by officers. Later still, he discovered that he had been diagnosed with a septic throat, pneumonia and a likely blood infection from the wound on his leg.

Eventually, promoted to sitting propped up on a bank of pillows, he took stock of the bandaged bodies and splintered bones occupying the other beds. Judging by the corpse-like immobility of the majority, he decided most of them must be badly wounded. The enduring

signals that they were still alive were groans, sobs and occasional blood-curdling yelps.

He passed several uneasy, dream-ridden nights when mud sucked him under, shellfire blinded him and vermin crawled across his body.

Slowly he began to feel better – his symptoms, although still present, were less distressing; his bloods were improving, he was informed; and his throat and chest no longer felt like barbed wire, although he was still under orders from matron to remain bed-bound. Gradually, he recovered enough to take an artistic interest in his surroundings. Through the long window he saw a sky of great clouds as swift and cold as those of the Dutch landscape painters and he was pleased with his pencil drawing of a young boy in the bed opposite who had the near side of his cheek swathed in bandages.

During the afternoons, when hospital routines were not disrupted by incoming wounded, patients were allowed to receive visitors.

One of William's first visitors was Major Parsons, himself only recently recovered from a fever. He was a tall, cheery man with an optimistic, questioning way about him, and he brightened the afternoon by asking innumerable questions about William and his art – he was knowledgeable and professed such an interest in seeing his war paintings that William sent a note to TT asking him to select some canvasses for the major to view.

Renewed barrages of heavy fighting at the front had the hospital staff caught up in an influx of wounded men – some would die, more might recover, but all required immediate medical attention. With several more beds added to their ward and additional ones set up in the corridors, the hospital was at bursting point.

The word *triage* cropped up with increasing frequency in the chit-chat of the ward.

'What's triage?' William asked the nurse he had come to know as Nurse Kelly while she was shaving him. She was not interested in chat, much less, he suspected, in questions. All he had succeeded in getting out of her was that yes, she was from Ireland.

The Receiving Room, the 42nd Stationary Hospital

'You must be getting better if you're asking questions. Triage is the miracle of battlefield medicine.'

'I haven't come across it. What exactly is it?'

'Pray God you don't ever have to. Previously thousands of soldiers died due to lack of medical coordination and organisation. Triage is the name given to the latest life-saving and time-saving method with wounded soldiers. It's a multi-step process to get the wounded as quickly as possible from battlefield to hospital.' She rattled off the description as though it was second nature to her.

'How does it work?'

'First the injured soldiers are stretchered to the regimental aid post, then they go by ambulance to a casualty clearing station and from there a hospital train brings them to base hospital. Here we use what's called a three-part system to categorize the extent of their wounds. Category One requires minimal care before the men are

able to return to the front. Category Two refers to the more seriously injured needing hospital attention, and the third category is for soldiers who even with medical intervention are expected to die.'

William was horrified. 'Good God. Defined by living or dying categories. The poor devils haven't much of a chance.'

'They have many more chances than they had previously,' Nurse Kelly disputed. 'Triage is the most efficient and compassionate way of treating wounded soldiers.'

For several days visitors were banned due to the numbers of wounded men needing treatment.

When next Green visited, he peered at William as though he were a rare specimen, before pronouncing, 'You're lookin' better, Major. But it'll likely take a while to have you back to your old self.' No matter what the situation, Green was determinedly optimistic, whereas Howlett was inclined towards pessimism. Despite the daily improvement in his health, William wondered would he ever be returned to that 'old self'.

Around five o'clock, after Green left promising that Howlett would visit next day, William, seeing some of the patients dictating letters to volunteer nurses, asked Nurse Kelly, 'Could I borrow someone to write a letter to my wife? She's in London.' Much as he would like to drop Evelyn a note, he suspected Nurse Kelly would disapprove if she knew of their relationship. As she appeared to be well informed about the private lives of the men in the ward, he did not want to take a chance.

'Really, Major Orpen.' She laughed at him, and he liked her sense of jollity. 'Getting frisky. I see you're on the mend. Won't be long now before you're back at your painting.' She plumped up his pillows and tweaked the bed sheet, her movements brisk and efficient. 'I'll see what I can do.'

William drifted back to sleep. When next he opened his eyes a VAD nurse was standing by his bed. He hadn't expected such loveliness from the Voluntary Aid Detachment. She had the bluest

eyes, the palest of skin and tendrils of golden hair escaping from the confines of her cap. He edged upwards on his elbow. She was young and pretty: quite the prettiest girl he had seen in a long time.

'You want to write a letter, Major?' Her English was excellent, accented in that husky French way he found enchanting.

He eased further upwards until he was sitting upright. 'Yes, thank you. There's notepaper and a pen in the drawer.'

She brought over a chair, and with the notepad on her lap, sat with an expectant look waiting for him to begin.

'And what should I call you?' There was a touch of flirtation in his voice.

'Nurse.'

As he dictated what he wanted to say to Grace, he worked at charming his letter writer. Speaking slowly so she would not have difficulty in keeping up with him, he apologised to his wife for his delay in writing, explaining why, assuring that he was on the mend, would soon be out of hospital and that she must not worry. He finished by sending his love to Bunnie, Kit and Dickie. 'My daughters,' he clarified. He thought the girl might be interested – perhaps ask their ages and something about his life in London. He was disappointed when she made no comment: he was used to women of all ages responding to him.

After addressing the envelope, he watched the VAD's tall elegance as she returned the chair to its place against the opposite wall and politely wished him a good night's rest. In her presence for the first time in months he had felt the stirrings of life, a touch of hope for the future.

Eventually, matron decreed that William could get out of bed. He was given a walking stick and advised to take gentle exercise. 'I'd like some sort of a dressing gown,' he mentioned to TT.

'A dressing gown? In the middle of a war?' TT queried with a laugh.

Next afternoon Green arrived with a loosely wrapped brown paper parcel out of which, with a flourish, he pulled a robe of red brocade with a black satin collar and deep cuffs.

'This stylish enough for you, Major?'

William didn't like to probe the source of the garment. From an early age he had used clothes to portray his personality and as a mood enhancer. He felt more confident when he was well turned out. The dressing gown gave him a psychological boost, resulting in him being in good form while wandering between the hospital buildings and the huts and tents that served as auxiliary functions.

As the soldiers he encountered during his painting forays had responded to his smock and cotton cap with waves, smiles and occasional jests, he and his brocade gown became a familiar sight around the hospital. Walking slowly – he had to favour his injured leg – he stopped frequently to exchange a few words with whoever he happened to meet, have a sit-down, enjoy a smoke. The more he saw, the more he was fascinated with the way the hospital operated. During his time in France, he had seen plenty of chaos, but within the hospital boundaries the worst imaginable pandemonium was subdued into organised efficiency. He began to recognise various doctors and nurses by sight and name and to pick up bits of information about their medical competence or otherwise.

On occasion he would draw back the flap of a tent and peer inside to see what was going on – sometimes he saw nothing more than groups of nurses and doctors chatting and drinking tea, eating wedges of bread slathered with that ubiquitous red jam; other times he watched dressings being changed, marvelling at the deft way the nurses discarded the old, treated the affected area and put on fresh bandages, all the while keeping up a soothing commentary.

He kept a look out for the young VAD who had written his letter to Grace, but he never caught sight of her. And he knew better than to ask Nurse Kelly.

Then he struck lucky.

Mid-morning on a Monday with the mustardy smell of rain on the damp earth and a nip of winter in the air, he watched as a group of people trundled a patient along the duckboard, the wheels of the stretcher squeaking and hissing on the wet walkway. William joined them, walking alongside the stretcher. The boy's eyes were closed against the misting rain and his teeth were chattering. His shattered right arm rested across his chest, splinters of bone sticking out through the mangled flesh and the flittered sleeve of his uniform. William couldn't believe his luck when he spotted his VAD – as he thought of her. She was running along the inside of the boardwalk. He stepped up and stopped in front of her. 'I've been looking for you.'

She looked through him as though he didn't exist.

'Excuse me.'

'What's your name?'

She looked at him in a puzzled way. 'Please, I'm on my way to the operating tent.' Again, that husky accent.

As he stood without moving, she jumped off the boardwalk and continued running along the muddy edges of what was once grass. William followed her, following the stretcher. As the stretcher party pushed through the canvas flaps into the operating tent there was a blast of unexpected heat wafting the unhealthy smell that William had come to know was a mixture of blood, creosote, disinfectant and perspiration with a touch of sewage. At the far end of the tent stood the operating table on to which the boy was eased. William found a good vantage point from which to view the proceedings and wished he had his sketchbook.

The boy was not unconscious, as William had presumed. He saw him move, raise his head, open his eyes and then scrunch them closed. The doctor on duty was a man from Yorkshire named Tuckey, a thin, alert man with sloping shoulders who was reputed to work miracles in the operating tent, and outside of it he was referred to in tones of awe. William's VAD stood alongside him.

'You.' Tuckey looked at her. 'Is this your first time in theatre?'

'Yes, sir.'

'Don't faint or vomit.'

She shook her head. 'I won't, sir.'

'If you think you might while I'm dealing with this, look away, into the corner. Not at what I'm doing.'

As Dr Tuckey spoke, he was struggling against his patient's choking and gagging as he fought to get an ether tube down his throat. 'You shot yourself, didn't you?' he asked when the tube was in place.

William jerked alert. This was bad. Little as he knew of military matters, he was aware that the penalty for self-injury was the firing squad. Dr Tuckey was known to be kind, with a breezy attitude, but as he dealt with his patient there was no trace of his legendary compassion.

'I know you did. No point in denying it. You shot yourself?'

William wondered how he could be so sure, and then he caught a snatch of a whisper circulating through the group, something about 'burn marks around the bullet hole'. Several nurses and medics stood around, silently watching.

'Well, unless you were keeping company with a German in the trenches, your wound was self-inflicted?'

The boy's whisper barely audible. 'Yes, sir. It was, sir. Sorry, sir.'

'You, poor devil,' said the doctor with a touch of his customary kindness. 'How old are you, son?'

The boy opened his eyes and spoke in a quivering whisper, 'Seventeen, sir.'

The doctor turned to his team grouped around the operating table. 'Take a look at this burn hole, all of you.'

As they gathered around, the VAD moved a little forward and asked, 'What'll you do?' Then she bit down on her lip and looked around as though she could not believe she had spoken out.

All eyes rested on her as the surgeon answered. 'Cut the burn out, of course. Can't have the poor beggar being shot. Now, can we?

Come on team. The fewer people who know about this the better. Give him some whiskey.'

By the light of the additional lanterns whiffing the usual cheap oil, the boy's coppery brown hair took on a luminous hue and tears, streaked with mud, ran down his face. Technically, the doctor was aiding and abetting a deserter. The orderly, a small Irishman with a steely look called Doyle, was a man of many and varied talents who was the hospital's go-to for information and goods. He held down the boy. When their patient yelled with pain, Doyle yelled at the VAD, 'For God's sake, stuff a roll of bandages or something into his mouth. Stop his God damn yelping.'

William thought if the patient didn't die of his wound or from pain, he'd choke to death from the enthusiastic way his mouth was being stuffed with bandages. As the doctor scraped and scooped the burnt flesh from around the wound, Doyle further steadied the patient by putting a knee on his chest. Tuckey straightened up, wiped his hands down the front of his stained scrubs before washing them in the basin of water held by one of his acolytes.

'Well done, team. Now some iodine and a dressing. And our job's finished. He'll live if he doesn't get any further bright ideas.'

That night, William lay in bed, exhausted, but too tense to sleep. In the distance was the noise of battle – the boom of shells, pitter-patter of gunfire and the rumble of the heavy transport – sounds that were magnified and all the more sinister in the dark. Over and over again he played the picture of the boy who had put a gun against his arm and fired a bullet into it at point-blank range. He didn't know how or why he had managed to do it – his fear of the trenches, fear of the unknown, he supposed – only God knew what terrors the child had gone through. But one thing for sure, William decided, he could not be lacking in courage.

Next day when he ran into Doyle on his wanders, he asked how the patient was doing. The orderly looked blank. 'What patient?'

'The young lad who shot himself in the arm?'

'I don't know what nonsense you're talking about, Major. A gunshot wound like that wouldn't be treated here. It's a court martial offence. Better you don't delay me from my work.'

In the same way as he had brooded over Ben and Sam; Liam, Paddy and Joe and the skulls, William could not erase the image of the boy from his mind. He thought of his vulnerability and how he had sobbed for his mother. A few days later, when he looked into one of the recovery tents, there the lad was propped up in a bed at the end of a large ward, playing cards with two boys, both with bandaged heads, his wounded arm resting easily against his body. Momentarily their glances met, but the boy's interest lay in his hand of cards.

Chapter 21

December 1917, Amiens

Eventually William replaced the dressing gown with his uniform and Christmas came and went in a muted way. The doctors and matron were of one mind that he should not be discharged yet and he was happy enough to remain on the premises – hospital life was a new experience for him with new sights to sketch and paint, as relevant to the war on canvas as life in the trenches. Over the next few weeks, he kept an eye out for his nurse, as he thought of her.

On an afternoon, as he was sitting in the watery sunshine, there she was, head down against a frisky breeze, walking briskly. He called out to her. 'I believe it's my letter writer.' William wondered would she continue waking, but no she turned around, stopped, looked at him and smiled. She was a graceful figure, despite the all-enveloping cloak, and he was feeling far from his best, muffled up in a greatcoat, woollen cap and a selection of scarves. He had a sketchpad on his knee and a stick of charcoal in his hand.

He chirped a friendly, '*Bonjour.*'

'You're better?' she asked in her lightly accented English.

'Yes. And thank you for writing my letter.'

She gave a gracious nod and asked, 'You draw?' She looked down at his sketchpad.

'Yes. A little.'

'So, do I. Well, I used to. May I see?' She moved nearer and looked over his shoulder. Working in charcoal he had been catching the mood of the breeze skittering around the trees and spindly shrubs. 'That's good.'

'I'm glad you approve. By the way I'm William. My friends call me Billy.' He held out his hand in a way that she had no option but to take it. 'And you are?'

'Yvonne Aupicq.' She began to move away.

'What do you draw?' He was keen to hold her attention.

'Still life, mostly. With the war, it's what we were reduced to. Apples and pears – when we could get them.'

'Have you had a chance to draw here? At the hospital?'

She laughed, throwing back her head in a gesture reminiscent of Evelyn. 'No. We're kept much too busy.'

'Did you bring any of your drawings or paintings with you? I'd like to see them.'

'No.' Yvonne laughed again. 'Are you from England too?'

'No. I grew up in Ireland. Dublin. Have you heard of it? It's the capital?'

'My friend Hannah Byrne is from Dublin.'

'We Dubliners are everywhere. Why don't you sit down? I'm getting a crick in my neck from looking up at you.'

Yvonne sat down, leaned against the back of the bench, and stretched out her legs. Then she slid further along the bench, increasing the distance between them.

'Tell me about yourself. And how you've ended up nursing here?'

Yvonne gave him an edited version of her life. Growing up in Lille. Her mother killed by a bomb during the early days of the war. Her father, an administrator; how hard he worked, how strict he was and how much she missed her dog, Kiki. 'Before the war we'd tennis parties and summer dances, but now ...' She shrugged.

William turned towards her. 'But what privileged lives we've been lucky enough to have? Tennis tournaments, afternoon teas, summer balls, and each year in Dublin, we've the Horse Show.' They smiled at each other.

In the distance he saw matron and Nurse Kelly walking together, moving in their direction.

As soon as Yvonne saw them, she stood up. 'I should be getting back.'

'Wait. Perhaps you'll take tea with me some afternoon?'

She was gone without a further word, walking briskly in the direction of the hospital building, leaving William looking after her, thinking how charmingly French she was – gracious but determined.

When William was finally discharged from hospital, it was with orders to recuperate for a few weeks before returning to the front. He had a relatively clean bill of health, a cough bottle and instructions to visit a doctor if any of his symptoms returned. By then he was eager to return to his painting.

On an afternoon when he was unable to settle before his easel, craving a decent coffee and perhaps a pastry or two, he had Howlett drive him to the nearest town. On arrival, he dismissed him outside a small café and asked him to return in forty-five minutes. As he pushed open the door, he tried but couldn't remember when he had last been in such an establishment.

The café was steamy warm with green check tablecloths and grubby paintwork; the walls were plastered with unframed posters of the Eiffel Tower, the Arc de Triomphe and an unknown boulevard lined with trees. The scent of coffee and pastries hung in the air, and there was a strange intimacy about the small, cluttered space that belied the fact that only a few miles to the west the war continued its relentless progress. The place was well patronised with women – the older ones with shopping bags by their feet and several young matrons with one or two well-behaved children. And there towards the back of the café was Yvonne Aupicq sitting with another young girl. William negotiated his way between the tables towards her. What a stroke of unexpected luck.

He pulled out a chair from beneath an unoccupied table and drew it up alongside their table. 'May I?' he asked.

Yvonne smiled shyly at him, her eyes the distinctive almond shape favoured by the artist Modigliani. William was intrigued by the way she had run off from him without answering when he had suggested afternoon tea. She introduced her companion as Hannah Byrne, who gave him a long look and patted the chair.

He ordered fresh tea and coffee and another plate of pastries. He was pleased to see the girls eat – Yvonne in a refined way, Hannah robustly. Because Hannah was so obviously outgoing, he turned his attention to her.

'What brings a Dublin girl to France in the middle of a war?'

'Well, it's certainly not my choice. It's a long story.' She had a mop of untidy brown hair, small eye spectacles and a snappy voice.

William noticed that Yvonne looked uneasy, frowning, watching Hannah.

'People are giving much of themselves.' William launched into the story of the woman, Alice, her daughter and the dog he'd called Madra. Yvonne listened intently and asked about the dog, but Hannah interrupted her bursting out with, 'I hate having to nurse those English men.'

William was amazed to hear Hannah speak in such an aggressive way and to a stranger.

Yvonne's voice was gentle. 'It's difficult, Hannah, and upsetting too, seeing those poor men, so injured and so brave. But I like to think we bring them a little comfort.'

William stepped in. 'You most certainly do. You're doing great work. War is a horrendous situation. All war is. I've been around the trenches, and I wouldn't wish the sights I've seen on my worst enemy.'

Hannah put her hands over her ears. 'I don't want to hear; I don't want to know.'

'How come you're in France anyway?' William asked, thanking his lucky stars he hadn't had to succumb to Hannah's ministrations. Little as he knew of her and the qualifications for nursing, he considered her

a most unsuitable person to be caring for anyone, much less the injured, but then, he supposed, in these times beggars couldn't be choosers. Short staff, short supplies, short everything was a constant refrain.

'My parents wanted me out of Dublin, out of harm's way, as they saw it. And here I am. After all sorts of legal strings being pulled.'

'Do you have legal connections?'

She rolled her eyes, 'Do I what? For generations our family has been involved in the law.'

With further questioning, William discovered that her parents and his family had friends in common. He tried to draw Yvonne into their conversation but noticed that she kept turning around to check the clock on wall. After a while she stood up from the table. 'We'd best go, Hannah. Otherwise, we'll be late.'

He called over their waitress and settled the three bills, adding a generous tip. Dismissing Yvonne's thanks, he said, 'I've a car outside. I'll have you back in the hospital in no length of time.'

Hannah enthused. 'Thanks, that's great.'

When they went outside, dusk was fringing in. Howlett drew up smoothly at the kerb, jumped out and opened the doors.

'Wow.' Hannah patted the motor and turned to William, 'Is this yours?'

'I can assure you it is.'

She nodded towards Howlett. 'And is he yours too?'

Howlett of the usually impassive expression was smiling as William answered, 'He kindly drives for me.'

'Wow,' repeated Hannah.

Yvonne stood by, silently.

'Would you like to sit up front with Howlett?' William asked Hannah.

Even in the gloaming William caught Yvonne's slight frown. And then all four were in the car and driving towards the hospital. He offered Yvonne a cigarette. She moved further into her corner. 'No, thank you. I don't smoke.'

'I do,' laughed Hannah leaning back from the front, lighting up with enjoyment.

When they reached the hospital Yvonne, with a brief thanks, hurried Hannah from the car scarcely waiting for Howlett to open the doors. William had stepped out to shake hands with the girls, but they were gone running and his thanks for their company fell on the winter air.

William was listless. He found it an effort to get up in the mornings, and when finally he was bathed, dressed and had downed the first of several strong coffees, he merely picked at his drawings and paintings in a desultory fashion. Green, who kept a watchful eye on his health, insisted he was in no fit state to be trying to work and William hadn't the energy to argue with him.

In the evenings he dined alone, by choice, in the half-empty dining room of the hotel, *The Shadow of a Crime* by his elbow, as a deterrent to chatty diners seeking companionship. His unwelcoming demeanour put off the majority of officers, but others sought him out to unburden themselves. He knew men were dying in droves, knew everyone was tired, exhausted and worn out by more than three years of constant warfare. Himself included. He had nothing left to give.

When an artillery officer who was too thin, red-eyed and inclining towards baldness asked if he might join him, William nodded reluctantly – he couldn't face explaining his preference to be left alone. The last thing he wanted that evening was a discourse on the progress of the war, nor was he interested in knowing the officer's name or anything about him. Too many of those whose company he had enjoyed ended up killed or injured.

His unwanted companion poured a glass of wine from William's bottle, took a long drink and confided, 'I'm the only officer out of the original division not killed, wounded, gassed or evacuated sick.'

William made a soothing sound. He did not want this conversation to go further. He looked around. He would leave. Eat elsewhere.

But the waiter, an elderly figure in baggy black trousers, was crossing the dining room carrying William's dish of rabbit stew. He was a sad soul, long beyond retirement, and William hadn't the heart to walk out on him.

His unwelcome dining companion looked at the stew, 'I'll have the same. And more wine.'

As William picked up his knife and fork the man leaned towards him in a confiding way. 'If this goddamn war isn't over soon, I'll end up like the others. If the Boche doesn't get me, the trenches will.'

His expression was bleak. William nodded.

The dish of rabbit arrived along with the bottle of wine. After eating a few forkfuls, the officer downed his cutlery, put his elbows on the table and leaned towards William.

'All day since first light, we've worked like the devil shoring up the trench. Whole sections had caved in. I was doing the overseeing as the men planked over the worst of the mud, filling sandbags and dragging them the length of the trench. There were two snipers at work and we'd to crouch double to avoid drawing their fire. Up the line the big guns started pounding as soon as it was light. And then one of the snipers caught Johnnie.' His face crumpled as though he was about to cry.

William did not know who Johnnie was, nor did he care. All he wanted was to stop the officer's flow of reminiscences. He stood up, pushed back his chair and left the dining room.

That night he dreamt he was being mown down by sniper fire. It was raining heavily when the bullet caught him in the shoulder and threw him backwards in the trench. He lay as he had fallen with yellowish mud sucking and oozing around him. In William's dream, the officers and men he had painted stepped on top of him, grinding down his body. Slowly he was sucked to oblivion by the mud.

He woke with a start relieved to remember he was due to travel to London for a series of meetings. He needed to get away from this hellhole.

Chapter 22

Winter 1918, London

William was summoned to Wellington House. As expected, his completed canvasses were the topic for discussion – the quantity, subject matter and quality of his paintings. From what William was able to piece together, the Director of Military Intelligence was involved in passing his latest batch of paintings, and he was enthusiastic about them. William came away from the meetings lighter in spirit, relieved and happy that his work was being well received on the English side of the Channel.

After two or three days in London he could not believe how well he felt. His health fully restored he was back to his pre-war self, delighting in the buzz of London, full of energy and enthusiasm, although he suspected his attitude had much to do with being away from the war zones. He was enjoying spending time with Grace and his daughters in the peaceful haven of his home, but it was Evelyn who had his heart racing. While in France, as well as missing their lovemaking, he missed her warmth, encouragement and optimism. He suspected she knew of his difficulties with Arthur Lee – invariably she was well informed with contacts and friends in high places, and she made it her business to be up to date. He wondered about her relationship with Sir Douglas Haig – and indeed Lord Beaverbrook, but he knew they were not questions to be asked.

For now, he wanted nothing more than to be in London.

Bond Street was a pleasure to wander along, Chelsea a hive of creative activity and Mayfair had never looked lovelier in the chilly sunshine. The sounds of the city were soothing: the hum of motorcars, the bustle of people and bursts of laughter; a panacea to

the sounds of war – ear-splitting shelling, cracks of gunfire and the rumbling bombs that had his nerves on constant edge.

He visited his tailor in Savile Row where he enjoyed special customer status. Sipping a glass of sherry, he fingered swatches of different materials – he was fussy about quality, texture and colours. He ordered a three-piece suit in Scottish tweed with a heathery hue, a double-breasted cream linen jacket and trousers, and another pin-striped navy lounge suit. He was smiling as he remembered Evelyn running the palm of her hand along one of his favourite jackets in a silver-grey worsted fabric and laughing. 'You dress like a stockbroker – a successful one, of course.' He equally enjoyed wearing formal and informal outfits, and delighted in dressing as the mood took him – from an early age he had been intrigued at the way clothes could change his persona.

Next, he went to Jermyn Street for a dozen fine cotton shirts, a selection of double-cuffed and a few short-sleeved ones.

Then it was into Bates for a trilby and a bowler – the order placed, he found himself dithering.

'Can I be of further assistance, sir?' The manager was obsequiously helpful.

'I was thinking of a flat cap in tweed.'

'A flat cap, sir?'

William ignored the manager's incredulity. 'Yes, a large flat cap, about the size of a dinner plate. May I see your samples?'

A book of samples of various tweeds was produced and William went through it. He settled for a windowpane design in browns, tans and bottle green with specific instructions not to skimp on size.

Tired by then, although exhilarated with the success of his shopping, he took an idling taxi to Barkers of Kensington for some fine leather boots and several pairs of shoes, including two-tone ones that caught his eye.

With a view to showing and selling his paintings after the war – the ones that weren't the property of the British government – he

contacted Charles Carstairs, the American art dealer leading the London branch of Knoedler's that was based in Old Bond Street; his brother-in-law, Jack Knewstub, owner of the Chenil Gallery in Chelsea; and Christie's art auction house on King Street. He requested that they put their proposals in writing and send them to South Bolton Gardens. Before meeting Evelyn at the Ritz for afternoon tea, he fitted in calls to several suppliers of artists' equipment.

Catching up with her in the drawing room, he was struck anew by her beauty. He was in high spirits as he joined her. 'A penny for your thoughts?'

She laughed. 'Surely, they're worth more than a penny to you?'

'Depends,' he joked, taking the chair opposite her.

She looked around, her glance sweeping the room. 'Our place. Where it all began. What times we've had, Woppy darlingest.'

After tea and scones, they walked through Berkeley Square in the silky twilight.

'I can stay the night,' he said when Dora left the room, after wheeling the drinks trolley to within easy reach of him.

'I hoped you could.' Evelyn, still standing, gave him what he called 'that look', a promise of intimacy to come. As she came to sit beside him on the couch, she moved the trolley out of his reach.

'Hey.'

'No, my darling, you drink too much, and while we're on the subject of excess, you smoke far too many cigarettes.'

William had known many women in the biblical sense, but he had never known a woman who was so fearless, such a straight talker and with such an appetite for sex. Evelyn was not only insatiable, she was out-spoken about her wants, and while he relished many of her demands, he did not enjoy her attempts to control his drinking and smoking. Strangely, she never asked him about his involvement with other women, nor did he want to know if she had other relationships.

One of the first sketches he had done of Gardenia during his time in Connemara was propped against the mantel. He remembered those weeks fondly. Despite Howard and Evelyn's plans to monitor their daughter's progress in paint annually he never returned to Screebe Lodge. Evelyn was particularly taken with the sketch, saying it caught Gardenia's spirit. William agreed, pleased at the way he had captured the child's sense of innocence. 'It's difficult to believe Gardenia's coming up to eighteen. She's very beautiful.'

'Yes, but she's such an innocent in the ways of the world – innocent in a way I never was.'

'You were born knowing,' William complimented.

'Still, when I look at her, I see echoes of my youth. Now, sadly, it's gone forever.'

'Your maturity is enhancing and enchanting.'

'Oh, darling, whatever would I do without you?'

'You won't have to. Ever. We'll always be together – we're joined. Sure, aren't we responsible for bringing Vivien into the world.'

Evelyn laughed, a deep rippling sound. 'Indeed we are. And what a surprise she turned out to be.'

'We're the same. You and I. As my nanny would say, "cut from the same bolt of cloth".'

'No doubt your nanny was a wise woman. But we're not the same. The war has changed you. Sobered you. Your experiences have created a finer, more caring, compassionate, thoughtful man, whereas I'm still a social flibbertigibbet.'

When Evelyn rested her head on William's shoulder in a tentative way that was unlike her, he tilted her face towards him and kissed her deeply and passionately. They rose from the sofa in accord and moved towards the bedroom where their lovemaking was as fresh and exciting as it had been that first occasion. Propped on an elbow looking down at her, William smiled. 'Better than ever. Don't you think? Further confirmation of our commitment to each other.'

She stretched languorously and reached for him. 'Actions speak louder than words.'

Next morning as Evelyn bathed, William, wearing a blue velvet dressing gown and embroidered slippers, sat watching, feasting his eyes on the mature lusciousness of her body. As she rose from the water, for him she was the embodiment of Botticelli's Venus, and he stepped towards her with a towel held wide.

At that moment there was a knock on the bedroom door. William returned the towel to its rail. 'Don't go away, I've unfinished business with you.' He moved into the bedroom. When the door burst open, Dora was standing to the side as Gardenia erupted into the room. In a glance she took in William's attire, the open bathroom door and her stark-naked mother standing in the bath, ropes of pearls falling across her breasts.

'Oh, oh,' she cried running from the room, down the corridor and slamming out the front door.

'Dora. Go after her and bring her back,' William ordered, pulling on his trousers as Evelyn emerged from the bathroom, modestly draped in towels. To William's astonishment she was laughing, and he found himself joining in at the slapstick ridiculousness of the situation.

William returned to the front a few days later, presuming without giving the matter much thought that Evelyn had succeeded in calming her daughter. It was weeks later that he learned Gardenia was refusing all contact with her mother. Writing to William, Evelyn mentioned the situation in passing, assuring that she was not overly put out. 'If I give her time, she'll come around. It's no harm to have her show a bit of mettle. At least she's keeping whatever she's thinking to herself.'

But she had spoken too soon.

While visiting her grandfather in New York, Gardenia told him the story of finding her mother in flagrante and actually named William. Evelyn wrote to William sparing no details of how her

father's outrage had blistered down the telephone line and across the Atlantic Ocean. 'An indiscriminate womaniser' was how he referred to William. As far as Evelyn could work out, leaving aside the morals of the situation, her father was furious that it was Gardenia who had discovered her 'indiscretion', as he called it, primarily because she was about to marry into the politically conservative Gunston family.

William sensed bubbles of laughter rippling through Evelyn's letter, but he did not find the situation amusing. Being described as 'an indiscriminate womaniser' was a hit below the belt, and a blow to his ego as he prided himself on gentlemanly discretion. From boyhood he had attracted girls, and on reaching manhood, he found he was drawn to being intimate with women as much as they were drawn to him. It was the way of it – he loved women and they loved him back. He enjoyed their company; their chatter and the way they dressed. But a womaniser? An indiscriminate womaniser? No way. He didn't learn the details of what subsequently passed between father and daughter – suffice to say George F. Baker demanded an end to their relationship.

Some weeks later, with yet another query emanating from Wellington House, William grasped at the opportunity of returning to London. To deal with the matter in person, he said, but his primary reason was to see Evelyn and to sort out their situation. He discovered her more upset than he had ever seen her. Twiddling her pearls, she worried, 'Papa says my reputation has suffered and so has Gardenia's.'

William wondered how Evelyn's husband, Howard, was taking the rumours but thought it wiser not to ask.

'Papa's threatening to cut me out of his will.'

'He never would.' William had painted the man they called the Sphinx of New York a few years previously, and he was touched at how vocally fond and admiring he was of his daughter.

'Yes, he would.'

William had never seen Evelyn as the obedient daughter, and he wondered at the hold George F. held over her. None of which he said.

He left her sitting on the blue-and-white striped sofa in her drawing room and walked to the Savile Club where he sat in a quiet corner, nursing a large Scotch as he contemplated the likely repercussions of the banker getting his way. Eventually, weighing up the pros and cons of the situation and what he knew of George F., he reached what he considered to be the perfect solution.

Decision made he slept soundly, and next morning, he sent out to Fortnum & Mason for a box of hazelnut chocolates. That afternoon he strolled along to Berkeley Square. When Dora informed him her mistress was not receiving, he held on to the chocolates and returned in time for family tea in Bolton Gardens. Despite Grace accepting the chocolates with a certain amount of trepidation, she and the girls finished the box.

A few days later William received a note from Evelyn asking him to call. His journey to Berkeley Square was subdued and an equally subdued Evelyn received him in the drawing room. She was pale and looked as though she had been crying. They sat apart – William on the sofa and Evelyn in a matching armchair. They discussed the arrest of the Russian ambassador – that had been expected. What was unexpected was the way women railway workers had negotiated an equal pay agreement with men. But it was now a fact. Eventually, they ran out of impersonal news.

William, who disliked any form of unpleasantness, broke the mood that had built up between them. 'I've come up with a solution for us.'

'Well, I hope it's good. Papa is not to be turned.'

'For once and all, I'll put a stop to gossip by designing a wedding dress in cloth of gold for Gardenia. And I'll paint her wearing it.'

Evelyn laughed her throaty laugh, 'That, Woppy darlingest, is a near perfect solution. A portrait. One of your most endearing traits is how consistently true to yourself you are.'

William moved his shoulders uneasily. Evelyn had no idea of his life in France. When he returned to the front it would be a matter of getting through each day. True to himself or otherwise. 'Oh, I don't know about that.'

'You should.' Evelyn spoke firmly. 'Your truth is in your paintings. Don't you remember how we forestalled gossip about us by painting my portrait as a birthday gift for Howard?'

All those years ago at the start of their relationship they had nipped in the bud the gossip of Evelyn's circle of elegant friends who lunched in the Ritz, enjoyed afternoon tea in Claridge's and dined in the Dorchester by letting it be known that he was commissioned by Mrs St George to paint her portrait as a gift for her husband. That put a stop to any surmising about the ridiculousness of socially elegant American heiress having an affair with the little Irish artist.

Chapter 23

Spring 1918, Amiens & northeastern France

Back in France and again based in Amiens William wrote to Evelyn: *We never know good things until we want them and can't have them.* The silence from London was deafening, but instead of causing him anxiety as lack of communication from Evelyn frequently did, in this instance his thoughts kept turning to Yvonne. She had the face of an angel, the body of a woman and an innocence that was at variance with the carnage that surrounded him on all sides. A virgin, he would wager. But it was a chance to paint her that he craved more than an opportunity to make love to her.

Her friend Hannah was as different from her as chalk was to cheese. Sturdy and well-built, she was a young lady with a knowing look who had done a bit of living, he'd bet, and given half a chance, he suspected, she would be a lively companion.

Another meal of unidentifiable ingredients finished, he rose from the table and joined Howlett, waiting in the motor parked in front of the restaurant. 'To the hotel, Major?'

'No. First go around by the hospital. I'll just be a few minutes,' William assured him as they drew up at the gloomy building that housed the administrative block.

At the cheerless area that functioned as reception he asked for a pen and writing paper. He wrote a quick note, placed it in the envelope and added two names. 'Make sure to have this delivered first thing in the morning,' he specified, handing the porter some francs.

He watched while Doyle put his envelope on top of a sheaf of correspondence. He couldn't decide if he was being foolish, but having taken action, he felt better and that night he slept soundly.

The following morning after an early breakfast he presented at Doyle's cubbyhole, 'Any messages for Major Orpen?'

The porter gave William what he read as a knowing look, reached up to the top shelf, removed an envelope and handed it to him. In return William gave him another generous tip, thinking, indeed hoping, that he might need his services in the future.

It was an afternoon of crackling ice as Howlett stopped the car at three-thirty outside the gate of the hospital with the sun making an appearance through a bank of clouds. Only Hannah was waiting. Howlett turned back to grin at William.

'Well, you've certainly got the livelier one, Major.'

'Damn you, Howlett, you're too smart for your own good.' William was disappointed. He had addressed his invitation to both girls. The acceptance was a scrawl of time and place with a scribble of a signature that could have been from either or both of them.

When Hannah stepped into the back seat alongside William, he caught the waft of generous usage of too pungent perfume. She settled, fussing with her skirt and fiddling with her purse. 'So where are we going?'

He had not given the outing any thought, except that he had looked forward to seeing Yvonne again. 'Why not into town? The café?'

Hannah shrugged. 'But we've been there. Why not somewhere else? A bit of excitement?' she asked hopefully.

William looked at her with amusement. 'I'm not sure I'm up to excitement.'

'Oh, well.' Hannah accepted a cigarette and settled back against the leather with a resigned sigh. William wondered what he had let himself in for.

The café was crowded. Hannah shrugged and was as non-committal about the coffee and pastries as she was about conversing.

'It's unusual to find an Irish girl nursing here?' William tried.

Hannah moved her shoulders. 'As I told you, it wasn't as though I'd any choice in the matter.' Her voice took on a hardness. 'I don't want to talk about it. What about you? What are you doing in France? You're not a fighting man?'

'I'm not,' William agreed, deciding against mentioning his brief. Instead, he began to tell Hannah about his family and growing up in south Dublin, thinking she would be interested as they were from similar backgrounds, but he eased off the subject when he sensed her disinterest. He wondered how much longer he would have to stretch politeness. Howlett had parked outside the café, and William suspected he gone walking – given any opportunity that was how he spent his free time. After what seemed an age, his driver pushed in the door causing the bell to give a cheery acknowledgement of a new customer. 'Just checking, sir. What time ...?'

William looked at his watch. 'Good lord, I'd quite forgotten. I'm to see the colonel this evening.'

He stood up. Howlett nodded. Hannah asked, 'Are we going?'

'Afraid so.' William pulled on his gloves and waited for her to exit the café in front of him.

William did not want to fall into the trap of entertaining Hannah again. So, he began to plan his courtship of Yvonne with military precision – the more elusive she was, the more determined he was. He asked Doyle to deliver a message to her. Only to her, he stressed. William put thought into the note. At the end of the page, he penned a little ink drawing depicting a sombre man and a woman with flyaway curly hair seated at a table. Yvonne replied within hours. 'Tomorrow. Four-thirty to the left of the gates.'

The following afternoon when the motorcar drew up at the gates of the hospital Howlett stepped out, opened the door and Yvonne sat in beside William. She gave him a considering look. 'You're recovering. You look better than the last time I saw you.'

'I am. I suspect that's nurse-speak.'

She laughed. 'Yes, it is.'

'Now where would you like to go? And how much time do we have?'

'Somewhere away from the war. A place with green fields and blue skies that'll have us back in three hours.'

'Did you hear that, Howlett?'

'I did, Major.'

'And can you oblige?'

'I believe I can.'

Howlett drove the narrow, twisty roads. The trees bordering them were bare, starkly sculptured against the pale sky and the watery sunshine cast long shadows. Through the landscape like a widening blue and silver ribbon, a stream curled and looped, threading its way through fields skirting the distant woods in a glittering detour.

William watched Yvonne's smile as she feasted her eyes on the sights as though she couldn't get enough of the countryside. She said little, merely made an occasional comment about how lovely it all was.

And then they came upon a village with a narrow-cobbled street tucked into a corner on the edge of no-man's-land. Lumpy houses with crooked chimneys were covered in glowing Virginia creeper; old women chatted together in doorways and groups of elderly men wearing berets were bent over chess boards.

Howlett slowed down. 'Shall we stop here, sir?'

William looked to Yvonne whose eyes were shining. 'Yes, please.'

It looked as though the whole village paused its activities as it watched the motor turn a corner and stop – the chess players halted their game; the women stepped out and a gaggle of giggling girls skipped along the pavement with linked arms. There were small children in smocks; babes in arms and young boys, thumbs stuck in trousers, peering out at them from corners being as tough as only young lads can be.

William took Yvonne's elbow as they walked towards the square. They sat on the edge of a granite structure with a gargoyle fountain that looked to be in permanent paroxysms of laughter as it gushed silvery water. William remembered another fountain in a Meuse village – it wasn't that long ago – merely a few months, but in reality, it felt as though it were another lifetime.

They sat for a while without speaking, their puffs of breath mingling in the cold air. William, watching Yvonne's profile, was planning how best to capture her on paper. Some sketches first, he thought, to get the line of her body and the elegance of her neck. His instincts cried out to paint her. As she swung her legs backwards and forwards, he wondered at the shades he would use to paint her hair, curls of it falling across her cheeks. He looked at the bloom of her skin, graceful hands and small pearly nails. He took a small pad and a pencil from his pocket.

'Are you going to draw?'

'Yes, I want to capture the mood of the village.'

'That's hard.' She looked around. 'It must be difficult with a place – easier with people, I suppose?' She waited for his answer.

He prevaricated, not wanting to contradict her. 'Not necessarily so. It rather depends.'

'But it's what you do, isn't it? You paint what you see? It's why you're in France, surely?' She fixed him with an intense look. So, Yvonne had discovered who he was, what he was doing and the importance of his role in France. He couldn't be sure, but he felt that she was unimpressed by the trappings of his success. She leaned back against the parapet and closed her eyes. When next she opened them, William had filled the small page with the village.

'That's amazing. Quite wonderful.'

He tore the page from the sketch pad and handed it to her, 'For you, Yvonne. A memento of this afternoon.'

'I shan't forget it.' She waved an arm. 'Any of it. You bring sensitivity to your drawings.' She looked at him and in a shy way confided. 'My friends call me Eve.'

He was pleased. On two counts: firstly, giving him permission to call her Eve – he was reared on pet names and nicknames and he'd carried the tradition through with his daughters; secondly, was her compliment about his work – he hadn't applied the word 'sensitive' to his painting, but he liked it.

Since coming to France his respect for the fighting man had grown. Despite being detached by rank and status, he engineered encounters, hoping that by being physically close to them he might catch a chance expression, a gesture or an attitude that would allow him to better capture their humanity on canvas.

In Yvonne's company he experienced a wash of ease, the unfamiliar sensation of being in tune with himself. There was something about her – he felt peaceful with her. 'Shall we brave the café, Eve?' She was an Eve, all right: a temptress of the highest order and unaware of her power. But Eve was a bit too similar to Evelyn for him – he'd continue to call her Yvonne.

Her eyes danced, 'Yes, let's. Bet they have real coffee.'

'What makes you say that?'

'This place is so real. They couldn't have anything else.'

Not only did the café serve real coffee, an elderly woman with fine wrinkles around her mouth and deep shadows underneath her eyes added a bottle of brandy and two glasses to their table. William watched Yvonne, noting her reactions, the way she turned her head, how straight she sat, how peacefully her hands rested in her lap. She appeared oblivious of his scrutiny.

A young girl holding a doll sidled up to their table. She had long brown hair tied with a red ribbon. Yvonne spoke to her in French, admiring the doll, asking could she hold it. The child passed it over and smiled. Yvonne held it towards William, and he smiled. Then

the child reclaimed her doll, clasped it to her narrow chest and bobbed a small curtsy. The woman fussed over, scolding the child.

'She's your granddaughter?' asked Yvonne. 'She is lovely, very charming.'

'Yes.' The woman couldn't hide her pride. She spoke in rapid French that Yvonne translated. 'But she mustn't bother our customers.'

'Pardon, Madame, but it is we who bothered her and her doll. Is this your café?'

The woman looked around with the air of a proprietor. 'For three generations. Owned by the family of Bergers. Yes.'

'And the war has not disturbed you?'

Her laugh was a cackle without mirth. 'Not disturbed us? Perhaps not if you don't discount losing a generation of young men.'

As they were leaving, Yvonne doubled back, only to emerge into the early evening holding a mug of steaming coffee that she handed Howlett.

While she was returning the mug, his driver nodded in Yvonne's direction. 'She's special, Major. A kind lady.' As the motorcar pulled away the proprietor, her daughter and several of the elderly men stood at the entrance to the café, smiling and waving.

Yvonne sat back against the upholstery. 'Such a lovely afternoon. Thank you, Billy. It's the nicest time I've spent since leaving Lille.'

'Perhaps we'll do it again when next you're off?'

'But what about you? Your commitments? Don't you have military duties as well as painting?'

'I'm relatively flexible.'

She smiled her acquiescence but was out of the motorcar and gone running towards the hospital before he could make another arrangement with her.

Chapter 24

Spring 1918, Amiens & in the trenches in northern France

William was utterly taken with Yvonne. Evelyn was the only other woman who'd ever had such an effect on him. Dammit. This shouldn't be happening. He was a man of the world – a successful artist and experienced with women. He shouldn't be dithering like a callow youth, hanging around, hoping to catch a glimpse of a girl young enough to be his daughter.

He continued to be relatively healthy, although every now and again he experienced a flash of paralysing nervousness: mostly it was a fleeting sensation. He found it quite terrifying, but he shrugged it off, muttering about mind over matter, straightening his spine and continuing with whatever he was working on.

He frequently went back over his sketchbooks, looking carefully at each page, making pencil annotations on the margins. Overall, he was pleased with his depictions of 'the real men of war', as he thought of the Tommies. He marked up the drawings he had developed into paintings, indicating others to be transferred to canvas, a few were not worth moving beyond the preliminary stage, and he compiled a list of further studies to be carried out – more compositions of the lives of the men in the trenches; the men in action; the men hurtling over the top, tumbling into no-man's-land and on to battle.

He was reluctant to distance himself from Yvonne and the sense of wellbeing he had when he was around her, and so he lingered on in Amiens, until in the end the matter was taken out of his hands. A telephone call from Major Lee firstly expressed what William took to be insincere relief that he was recovered from his 'various

illnesses', as he put it; secondly, he wondered when he could expect the next batch of paintings.

Early morning a few days later William, Howlett and Green were packed up and on their way to the front. William was pleased that his aide, as usual, claiming a backlog of paperwork elected to remain behind.

Locations, men and sketches. Then back to Yvonne.

Rain was coming down in torrents, grey and leaden and the air was chilly – perfect weather, he thought, in which to capture the awfulness of trench life. There was fresh talk of the war coming to an end. Nothing new about that – over the past four years every few months such gossip circulated and then died out. On this occasion William was more optimistic, believing the rumours were rooted in fact, and he wanted to make sure he got these last images while there was still time.

When they reached the network of trenches the noise of shelling folded and unfolded in the distance, occasionally a crack of a shell came nearer, like a blow. William stood on the edge of a trench, his smock draped over his uniform and the straps of his helmet flapping. He fought feelings of repulsion and revulsion as he looked down into the hellhole – his hands clenched and clammy, his breathing shallow and slow. **The squelching mud and oozing smells were hideous, almost beyond imagination. But they were exactly what he needed to capture in paint.**

An officer joined him, wearing the three Bath stars of a captain. He was well protected under a ridiculously large umbrella and sleekly turned out with glossily oiled hair. He introduced himself as Lennox – he reminded William of a music hall comedian. 'I believe you want to take a look at the trenches? They're interesting structures. Well-constructed by the Indian Labour Corps.'

William nodded. His hands were no longer quite as clammy. He was winning his battle for composure. 'Yes, probably

well-constructed, as you say, but from the look of them now, they've deteriorated to little more than drains thick with mud, rubbish, sloshing water and sewage. Anyway, it's the men I'm interested in – not the construction of trenches.'

Lennox nodded in the direction of the shellfire. 'We're expecting an offensive from old Fritz. Any time now. Their artillery and ours'll be whamming shells backwards and forwards. You don't want to be around.

'I'm not afraid,' William fibbed. Damn. He felt the start of tell-tale sweat break out across his back.

The captain warmed to his warning. 'In support trenches, like this, there's always the possibility that a mis-aimed Boche shell will blow us all to smithereens. When the shells land they blow up great fountains of earth and stones. I've even seen bits of animals and men shooting high up in the air. Hanging around here is foolhardy.

Trenches in Thiepval

Dangerous. Are you sure you wouldn't prefer to wait until the shelling finishes?'

'A bit of danger gets the adrenaline moving.' William detested Lennox's attitude. 'We painters have to take chances. Turner lashed himself to the mast of a ship to get the elements of the sea right.'

The captain raised his eyebrows before turning away and picking his route fastidiously along the side of the trench before disappearing from sight.

William jumped down into the trench and stood aghast, gasping in the claggy squelch that climbed halfway up his legs. His nostrils twitched as he identified burnt flesh and a whiff or two of gangrene mixed with vomit and gas, he thought.

He shut his eyes in a bid for guidance – from where it might come, he knew not. He closed his mouth, clamping his lips together to prevent himself from vomiting.

The sight was a Dante's Inferno without the flames – crowds of Tommies, jammed together, standing, leaning or slouching knee-deep in mud – the business of warfare thrusting their bodies between oozing slime and desultory shellfire. The scene was much as he had been told, indeed, been warned, but being informed was not the same as being in the thick of it – seeing, smelling, hearing and feeling. For himself. The majority of men in the trench had the narrow shoulders of the under-nourished, and they looked at him with guarded eyes that had seen too much.

He shook himself together. He had to get on with it. It was why he'd come. 'What's it really like, being here in the trenches?' he asked a forlorn-looking fellow leaning against an inner wall, his hands shoved deep into his pockets and his head jerking from side to side.

The lad stood away from the wall. 'God-awful. If you really want to know.'

'I want to know. Tell me about it.' William met his eyes.

'Well, to get here we'd to march on empty bellies in the rain a good ten miles along a road with stones bigger than duck eggs, greasy

with mud and horse dung and we were splattered with filth from the transport lorries. And now in between being shelled, we're repairing and extending the trenches, rebuilding the parapets. Minding the wounded and trying to cover the dead.'

William wanted to climb from the trench, jump into his motor and get to hell away from this horror. Instead, he moved along the trench, no longer careful of where he put his feet, determinedly absorbing the actions and attitudes of dejected-looking single and equally dejected-looking groups of men packed together like sardines.

A soldier hemmed in by sandbags, with a tattered fluff of greying hair, hummed tunelessly while picking at the torn front of his uniform. He met William's eyes. 'Can't you feel the dead?'

William's breathing came fast and shallow. Yes, he was certain he could feel the dead brushing against his shoulders; whistling tunelessly that miserable dirge about wanting to go home; he saw their ghostly shapes moving along the trench; the smell of death was all around him, and as he tasted their fear, it was his own bile that he vomited up in a yellow gush. Shuddering and swaying, he remembered the raw-boned lad's shamefaced vomit on the troopship crossing the Channel. How little he'd known or understood.

He moved his feet, straightened his shoulders and easing his rucksack he took a few steps forward, then a few more. A group of men joked and laughed as they lined up to have their hair trimmed. Several were scratching at their faces with razors – he'd heard that no matter what was going on around them, Tommies were expected to shave each day. Further along the trench a boy with milk-white skin and red welts across his shoulders was stripped to the waist, washing in a shell-crater; another lad was poking at the seams of his uniform.

'Chasing lice, the buggers,' he grinned at William. William, drowning in the realism he craved, attempted a grin back but suspected it was little more than a deathly rictus.

The anticipated shelling forecast by the captain did not happen and William spent the next few hours moving along the trench, listening to the men as they grizzled about their lot, with an occasional burst of humour. No longer was he dubious of the 'creep', 'burrow', 'crawl' and 'worm' verbs he'd heard used by the ordinary soldier to describe life in the trenches. Such descriptions were true. The men existed in inhuman conditions.

As he sketched, he concentrated on bringing together his skills as a chronicler and his feelings as a man – his eyes, hands, mind and heart in harmony with the sole purpose of capturing the mood of the tableau playing out before him.

Sometime later Captain Lennox wandered back, swinging a swagger stick – the majority of officers carried a stick in place of the traditional sword – and William had heard some were quick to use it. 'Still here?'

'Yes. Before I go, I'd like to see some of the dugouts.' William felt the trenches sucking him dry, but he didn't want to leave without experiencing what the dugouts had to offer.

A swoosh of the stick. 'That's not possible.' The captain gave a little laugh. 'Field officers are only allowed to speculate, you know. They receive orders,

Men in the trenches, near Hendicourt

203

seldom information. Speculation either drives you on or it drives you mad.'

Unexpectedly, the captain smiled and stuck out his hand. They shook hands as though at a social occasion. 'All right. Come on, so. Come with me.' William was sure they were both touched with trench madness.

They squelched through mud for several minutes. The dugout, gouged into the walls of the trench, was about six by eight foot with a table and two chairs. Two fleabags were thrown across what looked like relatively clean, dry straw. The captain removed his gloves and laid them neatly on the table beside a pile of papers. He unfastened the buttons of his coat but did not take it off. He sat down, pulled the coat's dampness close around his legs and closed his eyes.

William murmured his thanks and left. He had seen all he needed to and more.

Buoyed up by the effortless way his latest batch of drawings were transferring to canvas William wrote to Evelyn: *It's now 1 pm and I haven't had a cigarette yet, only two lemon drops!!*

During a quiet evening, he did several sketches of Yvonne from memory. He was pleased with them, pleased that even with a few strokes he had captured her air of innocent sexuality. He itched to paint her luminous skin tones, glorious hair and cornflower blue of her eyes. To do her justice, he wondered, should she be naked? He was ambivalent about nudes. Unsure if a nude could ever turn out well? He considered Rembrandt's seated nude to be a marvel, but not like a woman. Manet's, he thought, was a poor show and that one of Courbet's in the Louvre was a shocker.

The more he sketched Yvonne, the more he yearned to make love to her.

A few days later William visited the hospital – the Nissen huts and tents sat in a sea of mud, the boardwalks were slimy slippery, and the

rain lashed down. His knapsack was filled with supplies of cigarettes, wine, chocolate and whiskey for the patients.

He found Yvonne in one of the recovery tents. She greeted him with a smile. He watched as she went about her work, touched by the careful way she removed bandages, cleansed wounds and re-bandaged injured arms and legs – her interaction with her patients was compassionate and efficient. When he could no longer drag out his time in the tent, he moved towards her. The sister in charge sat at a battered table, her head bent over administrative work.

'And how are you today, Nurse Aupicq?'

'Well, thank you, Major.' Her blush made her prettier.

'Would you allow me to invite you for a drive?' He spoke quietly.

She looked back at Sister, still occupied, and whispered. 'Thursday. Three o'clock.'

'At the gate?'

She nodded.

Sister looked up from her paperwork with a frown.

Before William exited the ward he looked back. Yvonne was attending to a patient with one hand under his head, while her other hand held a glass of water to his lips.

Swearing him to secrecy, William had Howlett organise a hamper of food. He was pleased at his driver's liking for Yvonne.

It rained during the morning, but by afternoon a golden sun was shining from a blameless March sky and as the Rolls drew to a halt by the gate Yvonne moved forward from the shadows.

'Shall we find a quiet bit of countryside? Take a walk?' William asked as she joined him. On his lap he had a small parcel tied with a wide yellow ribbon.

Yvonne's eyes lit up. 'What a perfect idea. Fields and hedges. Perhaps a return to the village?'

A few days previously Howlett had brought William disturbing news. The little village on the edge of no-man's-land with the perfect

coffee had been reduced to a Calvary. Shortly after their visit it was occupied by a dozen or so German soldiers. The villagers were wary, but they fed them as best they could and treated their wounded. When leaving, the soldiers repaid their kindness by setting fire to several of the buildings. 'It makes strategic sense for the Germans to destroy the villages. They know we're likely to be advancing and a burned-out village is of no use to us,' said Howlett in an accepting, matter-of-fact way. 'Pray God the villagers got to safety.'

'It'll be just fields and hedges today,' he told Yvonne.

'Anywhere as long as it's away from the hospital.' She was philosophical.

'What's it like living in the hospital?' William was unable to imagine the circumstances under which the nurses coped.

'If you really want to know … we don't live in the hospital. There are four or five of us in a marquee in a field below the road. At the moment, we have grass growing under our beds, no tarpaulins or boards. I've a tin basin and a length of board resting on two petrol tins for a washstand. But I'm quite comfortable. Sometimes French gunners and infantrymen stray in and sleep on the grass.'

Howlett drove for some miles, in the opposite direction to the front, going deep into the countryside, curving into a series of laneways that looked to be deserted. The breeze was rustling, flirty, gusty and the horizon stretched forever, seemingly limitless. Finally, he pulled into a deep gateway and William and Yvonne climbed out of the motorcar. As she looked around, breathing the sweet smell of recent rain, William handed her a parcel.

She smiled, 'For me? A present?'

'I believe so.'

He watched as she eased back the wrapping paper, inside a sheet tissue paper protected a long silk scarf in yellows and blues and greens. She unfolded its length, held it out from her in admiration. 'Thank you, Billy, this is the most beautiful scarf I've ever seen.' She

wrapped it around her throat smoothing the fringed ends that ran to below her waist.

He was pleased with her delight. He put his hand under her elbow as they walked along the grassy edge of the lane. The air was sharp, like nectar, and for once without the sounds of war. He resisted, turning her towards him so that he could kiss her. She wiggled her elbow free from his hand, closed her eyes and raised her arms as though in adulation.

'This is almost too wonderful to take in. I needed to get away from death and dying and hospital smells to see a bit of countryside. It's hard to believe there's a war going on a few miles away. It's like time suspended. Don't you think, Billy?'

He had never thought of a landscape like that, but it made sense; many things she said made sense.

'What would your wife think of you and me like this?'

'Probably envy us,' he fibbed. 'Walking in the country is a restorative act …'

Yvonne turned towards him and raised her eyebrows. She possessed what his nanny would have described as an old head on young shoulders – Nanny had a great respect for people with old heads on young shoulders.

Thinking of Grace made him uneasy, so to change the subject he asked, 'How is your friend Hannah getting on?'

'She's gone.'

The tone of Yvonne's voice alerted William to the fact that Hannah's going had not been a straightforward matter.

'Where did she go?'

'I'm not sure. I suppose back to Dublin. She should never have been nursing. It's a long story. Poor Hannah.' Yvonne bit on her lower lip and looked upset.

'What happened? The first time I met her I remember being grateful she wasn't nursing me.'

'You'd have been all right. You're not an Englishman.'

The story William teased out of Yvonne was an improbable one of adventure, bravery and romance with Hannah as the unlikely heroine. From the little he knew of the Byrne family his impression of them was one of legal ultra-conservatism. Apparently, Hannah had become involved in the Easter Rising of 1916, participating in the gun battle in St Stephen's Green – so she said – and becoming romantically involved with Tadgh Malone, one of Padraig Pearse's officers. Even with his scant knowledge of Irish politics, William knew that Pearse was one of the leaders of the Rising. When Tadgh ended up on the run with a price on his head, Hannah hid him in the basement of the family home in Rutland Square. Within a few hours of her father becoming aware of his daughter's militaristic and romantic activities, strings were pulled, and she was on her way to France. Before leaving Dublin, she assigned the care of Tadgh to her brother Brian. She was inconsolable to learn from one of Brian's letters that Tadgh had been shot while trying to escape.

Yvonne finished with, 'Hannah was never nice to the English soldiers. After the letter from her brother she was upset, crying all the time. It was hard for her to nurse the English. It's better that she went.'

'You must miss her?'

'I do. But these days I'm in the Resurrection Room, and I've hardly time to think.'

Of one mind they turned back from their walk, and shared with Howlett their picnic of hardboiled eggs, batons of bread and chunks of cheese, washed down with a robust red wine.

'A feast fit for a king,' proclaimed Yvonne, inelegantly brushing crumbs from her jacket. 'We live on boiled mutton twice a day, and in between times, it's tea, bacon, bread and margarine, if we're lucky. Our mess cookhouse is four props and some strips of canvas; the kitchen range is three Dixies, boiling over a heap of slack between empty petrol tins.'

William and Howlett lit up and the three of them sat, watching as the smoke from chimneys in a small village resting on the horizon plumed eastwards. The sky grew full of pillow clouds and towards the west it was bathed apricot-gold in syrupy evening sunshine.

'L'heure bleue,' said Yvonne.

'What's that?' William asked. Yvonne seldom spoke French.

'It's that magical time between day and night when stillness weaves its web, like now.'

As though embarrassed by her sentiment, she plucked a blade of grass, split it with her fingernail, held it between her thumbs and blew through it making a creepy, wailing sound. William put his hand over hers, removed the sliver of grass from her and flicked it away with his thumb and middle finger.

As Howlett cleared off the remains of their picnic, William ran the pad of his index finger along the inside of her wrist, caressing the beat of her pulse. Whereas previously she had given off an image of liveliness, her body full of movement, now she sat immobile, her expression solemn, uncertain sensuality radiating from her. William continued caressing, moving the tip of his finger to her palm, circling the soft skin. She surprised him by reaching out and stroking his cheek, her eyes bright with appeal.

'What a gentle touch you have,' he said.

Killing the moment, she opened her watch, looked at the time, clicked the watch closed, stood up and looked down at him still sprawled on the rug. Her eyes were two gossamer orbs, reflecting his face back at him. 'It's been a wonderful few hours. Thank you, Billy.'

She sat back into the seat she had occupied on the outward journey. William followed her slowly into the motor, certain he was right in his summation of her. She may be inexperienced, but she was ripe for love. This was a love affair that he would savour.

Chapter 25

Spring 1918, Amiens & Beaumerie-sur-mer

After an unappetising meal of yet another unidentifiable stew, William returned to his room. Lips pursed in concentration, he looked over his sketches of Yvonne. Some were done while she was with him, others in her absence. He itched to paint her, to capture her personality in colour. Why not now? He was in the right mood, and as he stood by the window in the milky twilight, he was able to picture her as though she were standing in front of him.

He set a fresh canvas on his easel – measuring thirty-six by thirty inches, well stretched, primed and virginally white; on the small table alongside his easel he placed a box holding several tubes of oil paint and a jar with different sizes and shapes of brushes. He took a deep breath, squeezed a blob of ultramarine onto his palette, added a touch of white spirit, dipped a pointed round brush into the paint and drew his first line. He added line after line until he had an outline of Yvonne to his satisfaction.

Next morning, a pot of coffee by his elbow, he painted in her head and face, applying the paint in layers. Slowly, before his eyes, he brought her alive, capturing the blue-eyed innocence of her expression, the gold glint of her hair and fine tones of her skin. Strategically placed touches of gauze titillated rather than concealed her physical attributes.

When he telephoned Major Lee a few days later after the usual exchange of sniping pleasantries and a discussion on the canvasses he was submitting, William added, 'There's a special painting among the batch.' He suspected he was being foolhardy, but it was as though he couldn't stop himself.

'Aren't all your paintings special? What's different about this one?' Lee sounded impatient and petulant. 'How will I know it?'

'You'll know. It's different to the others – it's called *The Spy*.' The title slid off William's lips spontaneously without thought and without considering the likely consequences of his relationship with Yvonne being discovered. He smiled as he replaced the receiver on its cradle. If he succeeded with this, it would be a sweet moment – his first time to get one over on Lee. Buoyed with his feelings for Yvonne and the beauty of the completed painting, he persuaded himself there was no reason why his prank shouldn't work.

Now that William had sent the painting of Yvonne to Colonel Lee, he had an urgent need to see her, but he didn't want to ask Howlett to deliver a message to her. Instead, sketch pad in hand, he wandered in the direction of the hospital. As he approached, he heard the boom of shelling, sounding nearer than usual.

'What's happened? What's going on?' he asked a running nurse who called back at him, 'Oh my God. There's been terrible fighting, Major. Hundreds of wounded – gangrene and mustard gas as well as mouth, jaw, head, neck, leg and spine injuries. We're expecting an avalanche of stretchers within the next few hours.'

As William made his way towards the terrifyingly named Resurrection Room, the bellow of gunfire grew nearer. An orderly, wearing the remnants of a torn and stained uniform, staggered against the wall, muttering, 'It's awful. 'Orrible. Hundreds of wounded on the sidings. Trains full of 'em. It's hopeless, Major. I tell you, it's hopeless.'

He was a small man with a crumpling face, and he looked as though he was about to cry. William asked if he was all right – a foolish question as he was obviously far from right, but he was unable to think of anything else to say.

'I got onto one of them cattle trucks with a tray of dressings and a pail. Men lyin' on straw. Filthy it was. Been there for several days. In a state they were. Their wounds gone gangrenous.'

'It must have been awful.'

'It was, Major, it was.'

'But you were able to help them.' William had learned the power of positive comment.

The orderly shook his head. 'I dunno that I was. I wasn't much use. Poor blighters. If I found one needin' an amputation or an operation, I called an MO. 'Twas all I could do. I got the dyin' uns off the train.' He wiped a hand across his forehead. 'No one grumbled or made a fuss.'

'They were lucky you were there.' William went to move away, but the orderly followed him.

'Lots of gangrene, Major. Everywhere. It's the pits. A small cut and you're dead.' He was talking himself into an awful state, with his eyes rolling and his hands grasping at nothing.

'It's not always fatal.'

''Tis, Major, 'tis so. It's a killer. I've seen it, and I knows.' He touched the side of his nose with his forefinger. 'Cutting off the leg is the only way of saving life. Amputation they calls it.' He broke the word 'amputation' into syllables, running his tongue across his lips, finishing with, 'and it's always the leg that has to come off.'

William knew the man's beliefs were too entrenched to change.

The Resurrection Room was a large tent divided into sections, with bundles of bloodied bandages piled up against the canvas walls. Stretchers were dropped wherever there was a space, and the medical staff moved among the men, murmuring words of comfort, doing what they could to alleviate suffering. Groans, yelps and curses peppered the air that stank of blood, dirt, bodily fluids and fear. As more stretchers arrived into the already crowded area, William, standing to the side, watched in despair – most of the men were so badly wounded that he thought it unlikely they would recover, but

if by some miracle they did not die, they would live out their lives as crippled wrecks.

His eyes huge and wild, the orderly drew up alongside him. 'It's done on purpose, Major, so it is. These ain't accidents or surgical cases.' He spoke as though enlightened.

'Shush.'

'It's awful to hear injured men comin' over all jolly, ready to have another smack at the Boche.'

A young soldier fell against William. William helped him upright. He was pale and slender, not obviously wounded, but he was whispering, his lips in sizzling motion. As William leaned towards him, he could only make out a little of what he was murmuring, something about an 'officer ordering us to take the trench'. His eyes rolled backwards and continued rolling. 'Oh, my God, the blood. Everywhere. Like strawberry jam, it was. The sides of the trench were falling in and the Germans were using corpses to make a wall, keeping the bodies in place with pikes fixed to the ground.' His head lolled to one side, and he fell tidily to the ground. Dead.

The earth shook as the shellfire drew nearer. William found he was trembling. Afraid he would collapse, he sat down on the floor, jamming his hands into his armpits, tucking his legs tidily out of the way, concentrating on breathing in and out. A surgeon, accompanied by a young nurse, walked briskly between the stretchers, placing tickets on selected chests; other nurses rushed from stretcher to stretcher, starched caps askew, aprons drenched in blood dispensing what comfort they could. William, tucked in against the canvas, watched as volunteers removed soiled bandages from the slumped soldiers; with sloshing bowls of water and indeterminate bits of rags, they washed soldiers' faces and feet.

A small, thin lad, a bloodied stump, where once his arm had been, dropped down beside William, arm and legs sprawling. 'The Germans in the trenches opposite us were a respectable lot of men.'

'Well, I'll never go back,' shouted a Cockney accent from further down the tent. 'Never, ever go back to them trenches again.'

'Me too,' came a chorus of voices.

'Quiet, the lot of you,' shouted the surgeon, pausing for a moment to adjust his blood-saturated apron. He was square-jawed, with a fearless gaze. Seemingly noticing William for the first time, he said, 'Get up. This is no place for you.'

William stood, 'It's no place for anyone.' Emboldened, he asked, 'What percentage of the wounded can be saved?' The surgeon steadied himself against the back of a randomly placed chair.

'Not as many as we'd like, but as best we can, we match the life-saving care we're carrying out here with best patient management. This is triage in operation.' His tone was measured, weary without inflexion.

The Tommy yelled, 'The sound of a bayonet on human flesh is bloody awful.' He rose on an elbow. 'Bloody awful. Dammit. What do the likes of ye lot know about it?' He looked around wildly. 'We're not only choked by the gas, we're blinded by the pepper the goddamn Germans mix with it.'

The surgeon tightened his lips as the soldier continued, 'Brave men fightin' to the end, blabbing for their mothers, givin' up their beds to each other.' He was quiet for a while, as though gathering strength. 'Paradox,' he shouted. 'Know ye all. We're not here to be made well. We're here to be made fit for battle again, so's we can be sent back to the front.'

Later that evening William wrote in his diary: *We heard it was an attack on the Front – explosives and gas. The Allied gunners were temporarily knocked out but soon recovered and gave the Germans hell, which caught their first infantry rush, but they advanced. The doctors and nurses knew the smart of it when the hospital became a front-line casualty clearing station and the arrival of the wreckage began and continued without end – more than a hundred gassed men. Interesting, I hear girl chauffeurs are transporting men in the middle of the night. I wonder what Evelyn would make of that.*

William received a summons to present himself in person to Major Lee a week after he had submitted his latest lot of paintings. He wasn't surprised, suspecting it was about the painting of Yvonne – the more he thought about it the more foolhardy he considered his action. If his suspicions were right, he had much to dread during the coming encounter.

Lee was now stationed in Beaumerie-sur-mer. William arrived early for the meeting and was directed to a hard chair in what passed for a veranda outside a dilapidated-looking hut. He was kept waiting for a good half an hour during which time he chain-smoked and grew more irritated with each passing minute.

Finally, an aide appeared. William straightened his uniform, ran a comb through his hair, replaced his cap and followed him into a basic hut office. Major Lee, as usual, neat as the proverbial pin, sat behind a makeshift desk. The hut was crammed with bundles of papers, wooden boxes of files, several desk lights, two telephones and an antediluvian stove belching out warm smoke. The major made a note on the margin of what looked like a letter before looking up.

Without pleasantries and without inviting William to sit, he came straight to the point. 'As you may know – and if you

Major Lee in his hut office in Beaumerie-sur-mer

don't, you should – the War Office is sensitive about the subject of women spying?'

William nodded.

'You titled that painting of a woman as *The Spy*.'

Unsure of what was to follow, William nodded again – there was still that elusive wisp of familiarity about the major ...

'The publicity surrounding the executions of nurse Edith Cavell and Mata Hari were bad for public morale.'

William was doubtful as to what those women accused of helping Allied soldiers escape from German-occupied Belgium and of spying for Germany had to do with his painting of Yvonne. He was uncertain as to where Lee's moralising was leading.

'Who is the subject of your painting? How did you come across her? And why include her? Your brief is to paint images of the war.'

Images of the war. War images. What a repetitious dolt Lee is, thought William, while again berating his own madness and impetuosity for including the painting of a scantily clad Yvonne and titling it *The Spy*. Perhaps he might get away with pleading ignorance. He threw his hands wide in that dismissive gesture of his and settled his features into what, he hoped, was an expression of puzzlement that might pacify Lee.

'I know little about her. I was led to believe she was a spy. Pertinent to the war, I thought.' He wondered what Yvonne would make of being so described. 'I considered my painting of her to be a war image.'

Lee frowned. 'Is that all the information you have?'

William sought to add a look of contrition to puzzlement. 'Yes, I'm afraid it is.' He hoped that might be the end of the matter.

Lee shook his head. 'You're known for being sparing with information and explanations. But a naked woman?'

'She's not naked.'

'She's as good as. Did she pose for you?'

'No. I painted her more or less from memory.' At least that part was true.

Lee shook his head. 'It's most inappropriate. Although I have to admit, it's a damn fine painting.'

As William waited, wondering where further questioning might land him, Lee said, 'That's all for now.'

William escaped the hut gratefully, hoping the matter was closed, but suspecting Lee would not let go of it that easily.

After thinking the matter through, later that week, he put a blank canvas on his easel – another thirty-six by thirty inches. Again, he painted Yvonne in oils – clothing her modestly in a dark V-neck jumper and a light blue jacket, titling it *The Refugee*. When finished he propped the canvas against the wall, unsure of its future, but feeling all the better for having it in reserve.

The following week he was not too surprised to receive another summons from Lee. On this occasion there was no delay, no sitting around. William was shown into the hut straight away.

Lee's eyes were bloodshot and he looked tired. 'Questions are being asked about that painting you did of the spy.'

'And I've answered them.'

'London is not happy. The War Office has a list of queries. And I hope you can supply satisfactory answers.' He shuffled a bundle of papers and removed a typewritten sheet that he waved in front of William before settling it on his desk, smoothing it down and reading from it. 'Question One – how did you come across her?'

'May I sit?' William asked with a touch of sarcasm to hide his growing feeling of unease.

Lee waved a hand towards the wall; William pulled out an uncomfortable wooden chair and sat down, his mind racing. 'It's a sensitive story from start to finish. The French authorities asked me not to disclose the circumstances. I was brought to see the girl by a friend when I was in Paris – remember, I went to paint one of the Canadian generals? After seeing the girl, I asked permission to do

The Spy and *The Refugee*

some sketches. This was granted with the proviso that I would neither identify her nor the circumstances of her imprisonment. Does that answer your questions?'

Lee frowned; he looked harassed. 'It's the War Office that's looking for answers – not me.' Glancing down at the page again, he asked, 'Was the girl a British or a French capture?'

'French, I'm almost certain.'

'Had she been found guilty when you did the sketches, or was she awaiting trial?'

'I believe guilty.' William sought to keep his tone light.

'Was she shot?'

'I believe so, but I can't confirm it.'

'Where was she shot?'

'I don't know anything more than you already know.'

Lee, elbows on desk, leaned forward, avid with interest. Although William was nervous that there might be further repercussions from the War Office, he was enjoying hoaxing Lee.

'What little do you know?'

William arranged his features into a solemn mask and set his thought process in motion, knowing he had to give an explanation that would stand up to Lee's scrutiny as well as that of the War Office, but that he had to avoid digging a hole for himself with a too-elaborate explanation. And above all, he had to avoid having Yvonne identified.

'It was only afterwards that I heard she was a spy …'

'Who was your informant?'

Damn Lee and his interrogation! 'I never knew his name. Someone on the periphery of a social occasion, I think. I'm not sure.'

'Who was she? The spy? Her name?'

'I never knew. Never knew anything about her. I don't know where she was being held – except that it was some sort of a prison, seemed to be in the outskirts of Paris. She was upset, crying, but not begging for a reprieve.' William bowed his head as he added a touch that he considered to be sheer genius: 'She was praying, holding a set of rosary beads. Her only wish, she said, was to die wearing her own clothes. Later, I heard her maid was allowed to bring her a sable and chinchilla coat and a pair of white satin slippers. She asked that her wrists wouldn't be tied and that she'd be warned before the shots were fired. As the shots were fired, she slipped the coat from her naked body. So I heard.' He shook his head and tightened his lips.

'That's a terrible story,' said Lee.

'That's war,' said William. As he spoke, like pieces of a jigsaw puzzle falling into place, he identified the major. The man before him was the officer who had taken part in the suppression of the Easter Rising in Dublin. He tried to remember what he had heard about him – the words *ruthless*, *determined* and *inflexible* came to mind; *barbaric* too, he thought. Although the Rising had been put down

effectively, the cost in terms of British military casualties was in the region of five hundred dead and several hundred more wounded. The British did not take the rebellion lightly, and Lee was one of the military responsible for arranging the executions of convicted insurgents, many of them known to the Orpen family, including the poet Joseph Mary Plunkett, husband of William's pupil and friend Grace Gifford.

He was up against an indomitable adversary. Only time would tell the outcome of *The Spy*.

William never expected to become the subject of gossip. But he was. The story of the beautiful spy was doing the social rounds in London with news filtering back to France that Lord Beaverbrook was asking questions about it, as well as expressing interest in acquiring the painting. As if that wasn't bad enough, Evelyn's latest letter regaled William about champagne flowing throughout an evening of lavish entertainment in Lord Beaverbrook's company. *He's a powerful man,* she wrote. *Won't let anyone or anything cross him or get in his way. He makes certain that news of Canada's contribution to the war is printed in Canadian as well as British newspapers.*

William decided that he disliked everything about the man.

Chapter 26

Summer 1918, Amiens & London

A few days later as he was finishing the usual meagre breakfast, the porter handed him an envelope. Inside, written in a dashed hand on a single sheet of paper, was a curt missive from Colonel Lee ordering him to remain within easy contact. He crumpled the note and shoved it deep into his pocket. Between Lee, Beaverbrook and Haig, he was demented.

Remain in easy contact, Lee said. It could be worse, he supposed, trying to find a sliver of silver in the cloud of this goddamn war.

At least he had his painting, whereas the medical staff including volunteers were being run ragged with the number of badly injured men arriving on troop trains, with ambulance after ambulance transferring them to hospital. All leave was cancelled and time off was severely restricted. He hadn't seen Yvonne for days. To take his mind off Colonel Lee and the adventures of *The Spy* – as he thought of the painting in wryer moments – he took to visiting the surgical wards.

Until his stay in hospital and seeing doctors and nurses in action, William hadn't considered hospitals to be part of the war experience. How wrong he was. The more he saw, the more he realised the importance of medical input – the ground-breaking research, new drugs, up-to-date ways of carrying out procedures and, of course, the invaluable triage. In their pyjamas soldiers were stripped of uniform, rank and nationality. Social order was based on the severity of injuries.

He became a regular visitor to the surgical wards with matron turning a blind eye to his gifts of whiskey and chocolate for the men. Some of the men were horrifically disfigured, more had brutal injuries. The more he saw the damage of warfare, the more in awe he was

of the ability of the human body to endure, and he took pleasure in watching the men's journeys to recovery.

Up to that afternoon Alex, a young captain from Middlesex, had been making good progress. But now his eyes were closed, his breath rising and falling, and he was muttering an indecipherable jumble of words. Moved by an urge to offer some form of comfort, William rested the palm of his hand on Alex's forehead – his skin was clammy with beads of sweat darkening his blonde hair and pooling in the creases of his neck.

William couldn't make sense of this words. *Father* – he thought and was almost sure the next words were *machine gun* and *shrapnel*, followed by a flood of jumbling sounds. Leaning towards him, William thought he caught a whiff of trench gas, rot and mud. A few more words, perhaps, *lice, beef* and *mud* and something that sounded like *Elizabeth*. Alex opened his eyes – they were a clear intelligent brown. From their first meeting, William had noticed how they lit up when he laughed, something he did a lot as he appeared to be recuperating. 'I'm so glad you could come.' William knew it wasn't him that Alex was seeing.

He stretched out his arm, towards a jug on the bedside locker. William walked around the bed, poured a small amount of water into a glass and held it to Alex's mouth, feeling a rush of pity as he patted with his handkerchief at the dribbles rolling down the smooth chin. Alex's eyes flickered, his facial muscles sagged – William hoped he might be drifting off, floating away from the awfulness of his present; he remained by his bedside, his own body sagging with sadness at Alex's deterioration.

As he was on the point of leaving the ward, William noticed a doctor leaning over the bed of the man he knew as Harry – he too had been making good progress after the removal of a lump of shrapnel in his cheek, the undamaged side of his face attesting to his good looks, but the wounded side was bad – even worse, William thought, since the graft – but Harry was optimistic that the scarring would

improve given time. The doctor was saying, 'That's a bad infection, son. I'm afraid the first thing I'm going to have to do is remove the graft –'

'Remove it? What the hell did you put it on for? The pain of it is bloody awful.'

'I know, old chap, but it hasn't taken. In fact, if we don't remove it, it'll become infected and slough off by itself in a few days.'

'You mean, you've to start again?'

'Afraid so. Things might look a bit worse initially …'

'You keep saying that.'

'I know, I'm sorry.'

William left the ward with a heavy-footed walk, knowing its routine would continue, its relentless caring carried out by the medical team day after day, hour after hour. He was in awe of what the men had gone through and had yet to endure; he was equally in awe of the medical team, the nurses and volunteers. Despite dedicated medical attention, there was no guarantee that any of the men in that ward would recover or be able to live a full life, and there were hundreds of thousands like them.

William was not unduly surprised to receive summons to London. Nothing much surprised him those days. *The Spy* wouldn't go away. He slipped into the city anonymously without alerting Grace or Evelyn and met behind closed doors with a solemn representative from the War Office, a uniformed general and another man in civvies whose purpose William never discovered. The three of them sat behind an expanse of mahogany table, each with a folder and a carafe of water in front of him. There were no introductions, no pleasantries but there were plenty of questions.

'Where did you first meet the subject of the painting you titled *The Spy*?' The general had a narrow face and scant strands of hair brushed across his crown.

'In a cell in a prison.'

'Can you confirm – firstly, the identity of the subject and that you hadn't met the subject previously, and secondly, where the prison was?' The man from the War Office, bald and fat, spoke aggressively and looked belligerent.

'I'd never met her. Didn't know who she was. And I don't know where the prison is.' William thought it likely that the three inquisitors would question him for hours, going backwards and forward over the same non-existent information unless he took the initiative.

'Major Lee took copious notes at our meetings – we had two – specifically about the origins of the painting. I'm surprised he hasn't briefed you.'

'We have his notes, but they don't answer our questions.' The man in civvies was furrow-browed and quietly spoken.

'It's within our powers to withdraw you from France.' It was the general.

'Or you could face the prospect of a court martial.' The belligerent man looked and sounded as though he was enjoying himself.

'I know no more than I've already told Major Lee. I never knew the name of the prisoner. Never knew where she was being held. I was driven there. It was somewhere in the suburbs of Paris. I paid no attention to where I was going. At the time it never crossed my mind that I'd need to know the address of her prison. I painted *The Spy* from memory, as I explained to Colonel Lee. I subsequently painted the subject fully clothed and titled that *The Refugee*. And that, gentleman, in a nutshell is all I know. Now, if you'll excuse me.'

William stood up, slowly easing back his chair, unsure of how his gesture would be taken. He saluted and left, closing the door quietly behind him. The main thing on his mind was to get away from London and back to France as quickly as possible.

His diary entry regarding the meeting was succinct: *I was talked to very severely, in fact, I was in black disgrace. My behaviour could not have been worse, according to Intelligence, or whatever they were then called at GHQ.*

On his return to Amiens William didn't speak of his time in London or what had happened behind Whitehall's closed doors. The worst of the latest bout of fighting appeared to have died down and Amiens was relatively quiet. He had an urgency to see Yvonne and he sent Howlett to the hospital with a note. 'May we meet on your next afternoon off? Leave your answer with the porter.' He added one of his signature pen and ink drawings on the bottom right-hand corner of the notepaper of a small man and a slight woman holding hands.

A few hours later a porter delivered Yvonne's reply to William. She wrote that she was going on leave, returning to visit her father and aunt in Lille.

William felt a sink of his heart. He called Howlett. 'I want you to find out at what time Mademoiselle Aupicq finishes her shift.'

Howlett took the request without batting an eyelid. In an unusual burst of confidence, he confided to William, 'Nurse Aupicq is a good influence on you, Major.'

William was both startled and amused at his driver's insight. 'An influence, in what way?'

'You're healthier and happier since knowing her.'

William didn't probe further.

Half an hour later Howlett returned with the news that Nurse Aupicq was off-duty from twenty hundred hours that evening. 'Should I pick her up, Major?'

'I'll go with you.'

William waited in the motorcar while Howlett fetched Yvonne.

She was smiling, still wearing her uniform, topped by her dark cloak. 'This is a surprise.'

'When are you going to Lille?'

'I am not sure. Perhaps tomorrow? I've yet to send a telegram to Papa.'

'We'll walk for a while,' William told Howlett.

Holding her elbow, they went a short distance along the edge of the side road. After a few yards, he stopped and turned her towards him. 'Will you come with me to Paris, instead of Lille?' William had a general to paint who was due to be in Paris the following week.

Her acceptance was without query, without hesitation. 'Yes, I will.'

It was he who felt the need to give an explanation. 'I've a commission, and afterwards I plan to take a few days enjoying Paris. I'd like to show you around. As well, I'd love to have the opportunity to paint you.'

'I'll write to Tante Jeanne telling her about you, that you're going to paint my portrait and that I'll come home later. I won't say anything about going to Paris with you.'

Chapter 27

Summer 1918, Hazebrouck

The general's visit to Paris was delayed. More red tape complications, William presumed, without minding too much. He accepted that the longer the war went on the more bureaucratic red tape had to be negotiated. He was pleased to have another opportunity to return to the front – he based himself in Hazebrouck situated between Lille and Omer. The small sturdy town intrigued him. It was scene of the April 1918 battle, just a few months previously, when the Germans had opened cracks in the British lines and where Field Marshal Haig issued his famous 'Backs to the Wall' appeal. After fierce fighting and terrible losses on both sides the British and their Allies had routed the Germans.

When he explained the change of location to Yvonne, her acceptance of holing up in a small war-torn town instead of enjoying the glitter of Paris was immediate.

He was in love with her – he was sure of that, his pulse raced when he thought of her, although he couldn't put voice to his feelings. But they were purer, more intense, he thought, than his relationship with his beloved Evelyn; or Grace, maternal and domesticated; Flossie, ever the temptress; giddy Emily who he remembered with a smile, or any of his other light-heated interludes. William knew of nobody else who gave off such an impression of absolute innocence as Yvonne. She was deeply religious and had about her an air of spirituality that he found both calming and endearing. When he was with her his world was a better place. She was good company, uncomplicated and lacking in malice or jealousy. He knew from her gentle smiles and her quiet way of thanking him that she liked their

outings and enjoyed the presents he gave her. But he felt she would be equally happy if he were penniless.

Their relationship was governed by secrecy. He considered it advisable to keep her hidden, primarily due to the web of lies he had woven around her and the two paintings of her that were doing the rounds in London – she was a woman once seen never forgotten. He was relieved that she didn't try to get a pass to visit her father and aunt in Lille. As it was, he had to pour oil on the troubled water of Green's and Howlett's unspoken disapproval of her travelling with him, despite their liking of her. TT never as much as hinted at her existence, and as he remained in Amiens while they were in Hazebrouck, no explanations were needed.

'My *bébé blonde*,' William called Yvonne, assuring her, 'When we get to Paris everything will be different.' He held her close against him in the small hard bed in the small bedroom of the hotel where he had taken rooms. Initially, she was nervous about intimacy, happy enough to kiss and cuddle, but shying from anything more. He was patient and did not rush her – he was in no hurry; time was on their side and she was worth waiting for. When eventually they consummated their relationship, he was amazed to discover that it was not her first time. He drew her close and whispered, 'Was it all right for you? Are you happy?'

When she didn't answer he realised that she was crying quietly, stifling her sobs against his shoulder. He eased back and cupped his hand around her chin, so that he was looking directly at her, but she turned away from him. 'What is it, *ma bébé*? What has you so upset?'

She sat up, her tumble of hair spread around her shoulders and looked at him with wet eyes. 'I don't want to talk about it. I can't. It's better not to.'

She moved to get out of the bed, but he caught at her. 'I've never put pressure on a woman, and I'm not about to start now. I love you and I want to make love to you, but you've to want it too.'

'I do,' she whispered.

'So, what has you so upset?' He was beginning to suspect. 'Did something happen?'

She took a deep breath and closed her eyes. 'Yes, in Lille ...'

William waited while she opened her eyes and looked at him in a way that he read as imploring, as though beseeching him not to ask any more questions. If their relationship was to progress, he had to know what was causing her such upset. He suspected, but he needed to hear it from her. He held her close. 'What happened in Lille ...?' A shudder ran through her body. He tilted her face so that she was looking at him. 'Tell me, *ma bébé*.

'I can't.'

'You can. You must.'

She spoke slowly, hesitantly, and so quietly that he had to strain to hear her words. Between her hiccups and sobs, he pieced together her story. Her father paid a highly recommended artist to come to their apartment to teach her drawing and painting. She loved art and was progressing well. M. Bertraund, for that was his name, was complimentary, praising her improvement.

It began with him putting a hand on her shoulder. She didn't like it as it made her feel uncomfortable. As she wasn't sure of how to handle the situation, she didn't say anything, but when he stroked her hair she stepped away from him and told him not to. He laughed and asked her why. She said it was inappropriate. They got on with the lesson with him being critical of her work in a hurtful way. Yvonne made up her mind to speak to her aunt about the situation.

As he was leaving the apartment M. Bertraund met Tante Jeanne returning from her weekly visit to her sister. He eulogized about Yvonne's artistic progress with the result that Yvonne felt unable to voice her unease. The next lesson started well, until he put his arm around her waist, and when Yvonne slapped it down, he caught hold of her, lifted her skirts, undid his flies, pushed her back on the sofa and ... She was unable to continue.

William held her close as she sobbed as though her heart would break. 'You aren't the first woman to be raped, and you won't be the last.' He thought it cruel to use the word *rape* but knew it was better to call a spade a spade.

'As long as we're together you'll be loved and cared for. Come on. Dry your eyes. And let's go out for breakfast.' He was angry, raging in fact, his hands clenching and unclenching. In the unlikely event that he and M. Bertraund ever met, he would enjoy tearing the man limb from limb.

Seated facing each other across a wrought-iron table with wobbling legs in a small steamy café he was pleased that Yvonne chose to elaborate. 'Afterwards, M. Bertraund thought we'd finish the lesson. As though nothing had happened.' Her voice rose in outrage. 'He even had the nerve to ask for his fee.'

'What did you say?' William was relieved. Yvonne appeared to be regaining her natural confidence.

'I opened the door, pushed him out. Threw his briefcase after him. And told him never to come back. Papa was very cross – more that I'd cancelled the lessons without discussing it with him. Tante Jeanne wanted to know if anything had happened between us.'

'Why didn't you confide in her?'

'Because if I didn't talk about it, I thought I could pretend it never happened. Papa was under a lot of pressure, and Tante Jeanne's sister was ill. But of course that didn't work.' She caught a hold of William's hand. 'Thank you.'

After that Yvonne chatted more openly than previously about her life in Lille, telling how her mother was shot down on the streets during the early days of the war; Tante Jeanne's taking care of her and her father and running the household; her worries about Josephine her best friend, who was in love with a German lieutenant; finishing with how much she was missing her little dog, Kiki.

There was nothing William could do about Yvonne's dog, but he came up with an idea that he thought might please her. 'How about painting you as a nun?'

Until then she had been sober, worried looking, now she burst out laughing. '*Mon chéri*, you are quite daft – is "daft" the right word?'

'Where did you hear that from?'

'Howlett said it of you.'

'Did he indeed? Rather outside the remit of his chauffeuring duties I'd have thought.'

She looked worried. 'Did I do wrong? It's a joke – I think?'

'Yes,' he assured her. 'It's a joke – a good joke. Now, shall we do that painting?'

'It won't change anything,' she almost whispered.

'Perhaps not. But I believe your God will approve.'

Her smile was watery, tremulous.

Yvonne stood modestly against a dark background, wearing all white – habit, coif, wimple and veil – and with a large gold cross hanging around her neck. In keeping with the subject matter, she was demure, taking seriously her portrayal of a nun, with only the smallest murmur of complaint about having to stand still for so long. Without quite knowing why William found the process cathartic.

'What will you call it?' she asked.

He hadn't thought that far but suggested, 'how about *Yvonne as a Nun?*'

'I suppose. Yes, that's what it is.'

When she saw the completed canvas, she went up close, touched the painted lips with a finger, stood back, dropped a curtsy and threw her arms around William. 'You're right. That feels good. Very holy.' She blessed herself and dropped her head for a few seconds – it looked to William as though she was praying. She never ceased to amaze him.

Portrait of Yvonne Aubicq as a Nun

She caused him even more amazement when she stepped out of her habit and left it in a puddle on the floor as she removed the headgear. Naked as the day she was born, she stood before him, childlike and laughing, before jumping onto the bed.

'Now, do me naked. We can call it *Early Morning*.'

She chatted the whole way throughout that painting – keeping her pose, holding her head at the angle William suggested, while sitting naked with no self-consciousness in the rumple of bedclothes.

'Perhaps it might be time for you to start drawing and painting again,' he said as he applied a touch of white to highlight the radiance of her skin.

Dropping her pose, she pulled her knees to her chest and locked her arms around them. 'No, Billy. I shan't ever paint or draw again.'

Early Morning

She had never before spoken about anything in such a definite way. He had not expected such determination from her; he admired her for it and knew better than to try to change her mind.

She took to his lovemaking with an enthusiasm that delighted him, fitting herself around him and drawing him into her. He had not told her the story of his first two paintings of her, nor did he intend to, but when she left their rooms, he was relieved to see that she wore an enveloping cloak and kept her hair covered. He wondered was he becoming paranoid.

On an afternoon when he was whiling away time in the bar, he received a tap on his shoulder. It was a beaming Major Parsons, last seen when he had visited him in hospital. Hearty handshakes were exchanged, another round of drinks ordered, hospital talk and

memories re-visited, and their continuing health toasted. As they raised a glass to war end, Yvonne returned from her daily visit to the church. As she approached, she eased off the hood of her cloak displaying the tumble of her golden hair in all its glory. She was smiling, as always happy to see him.

William sensed Parsons's interest as he introduced them in as perfunctory a manner as politeness allowed. She was neither too familiar nor too distant in acknowledging his visitor, but when it looked as though she might linger, he said, 'I don't wish to delay you. I'll see you later.'

A small frown appeared between her eyebrows, but she gathered her cloak and left the bar.

The major looked after her in appreciative way. 'Is she staying here?'

'I'm not sure.'

'Begad. Not sure? From what I hear that's not like you, Orps.' The major took a generous sip of wine and laughed jovially.

Some weeks later William was cheered by a delightful letter from Major Parsons in London. He was full of compliments, extolling War, the exhibition of William's paintings, officially opened by Lord Beaverbrook, showing at Agnew's Gallery. Although William had done the majority of the paintings during a period that was relatively favourable to the Allies, their showings in London and Manchester was taking place against the backdrop of yet another German offensive.

Parsons commented favourably and knowledgeably on several of the canvasses and finished with: *I enjoyed viewing all of your paintings, particularly* The Refugee. *There was a familiarity about the sitter.*

William responded immediately by post card: *Hush, hush!* Orps.

The paintings on show included the smoky watercolour *Howitzer in Action* and studies of single figures like *After the Fight* and *The Thinker on the Butte de Warlencourt*, this latter created by William when he was in extremis over the deaths of Liam, Paddy and Joe, the

wounded lads he'd met on one of the first forays he'd taken looking for inspiration – the image had been used in several illustrations and was regarded as a visual metaphor for the war. The portraiture was limited to nine paintings of senior officers, two air aces, and *The Refugee* – William had it confirmed from impeccable sources that the rumours about Lord Beaverbrook appropriating *The Spy* for his private collection were true.

The reviews for War were mixed. *The Times* bemoaned: 'His work produced in France adds to our knowledge of himself, but nothing to our knowledge of war.' While the *Daily Telegraph* wrote about the paintings 'vibrating through our hearts'. The poets Owen, Sassoon and Graves were in unison that William's images 'were just what was most needed from a war picture'.

The exhibition was the talk of London. The public flocked to the gallery – during the first four weeks more than nine thousand people visited, and takings were in the region of seven hundred pounds.

William did his best to ignore the subtle and not-so-subtle hints dropped, mainly by officers, about his over-glorification of the fighting men.

One evening he and Major Norton had dined unusually well, enjoying each other's company over a leisurely meal while discussing the state of the trenches, the misery endured by the ordinary soldier and congratulating themselves that, for once, Norton had not been called out to look after some miscreant. But as they were debating finishing with brandies, their attention was drawn to an officer standing at the bar, insisting in a raised voice that 'those paintings are proof that Orpen doesn't understand the magnificence of war and its necessary sacrifices.'

Before Norton could stop him, William was standing alongside the officer. He had not seen him before, and his uniform looked too new to have been anywhere near the front. 'Did you see the paintings in London?' he asked in a conversational way.

The officer turned around. He was plump, pink-faced and bespectacled. 'No, I didn't. I can't be bothered with art.' He turned back to his gin.

Taking a deep breath William sought to control his rising anger. 'How can you have an opinion on what you haven't seen?' William's voice was silkily querying.

'I know enough to know it's a waste of time painting Tommies in the trenches. Who in their right mind wants to look at them?'

William would not be surprised to learn that the opinionated officer was fresh off the boat from Dover. 'Have you been to the front?' He made sure to sound interested rather than aggressive.

'Good God, no. And I've no wish to.'

William knew he should walk away. That if he did not the situation would go from bad to worse, but he was unable to stop himself. 'What are you doing here, so?' Purposely he kept his voice on an even keel. But anyone who knew William would be aware of his rising rage – evident in the narrowing of his eyes and clenched fists. He teetered on the point of exploding. If the officer had an iota of sense, he would back off, but he was in that alcohol-induced, over-confident stage, and quite unaware that he was talking to the artist.

'Observing, dear boy, observing.'

Being addressed as 'dear boy' was the final straw. As the officer turned back to his drink, William's left hook caught him on the chin. He looked surprised, put his hand to his face, staggered and fell back against a table holding several glasses that crashed to the floor, their contents pooling wide.

Norton joined the tableau which at that stage could go either way. He touched William on the shoulder. 'Take it easy,' he urged, wedging himself between William and the officer. He addressed the officer. 'You've had the pleasure of meeting William Orpen, the artist whose work is being hailed as a successful humanitarian record of the war. I suggest you shut up and take your business elsewhere.'

Chapter 28

Summer 1918, London

When the birthday honours list was published in July 1918, William journeyed to London to be made a Knight Commander of the Order of the British Empire for services in connection with the war and Grace became Lady Orpen.

'Are you pleased?' William asked her when they returned to Bolton Gardens after the investiture in Buckingham Palace, an occasion that was further gilded by the recent news of his election to the Royal Academy of Arts. He was delighted and proud. Little Orps from Dublin hobnobbing with the Royal family. What a long way he'd come. He wanted confirmation from his wife. 'Happy, I hope?'

Grace looked at him coldly, her eyes were as flat as stones as finger by finger she removed her cream kid gloves. 'Why would I be happy? I'm a laughing stock. Have been for years. Everyone knows you've a mistress in London and another in France.'

William was unused to vehemence from his wife, who was not in the habit of commenting about his life, much less raising objections about it. He wondered how she was so well informed, wondered too did she know the identities of the women she was dismissing so cuttingly? Who had told her about Evelyn? How had she come to hear about Yvonne? He settled for, 'The title – it's an honour!'

Grace blew a raspberry – never before had he seen her make such a vulgar gesture. How she had changed from the giggly girl in the white dress to a moralising matron. With a toss of her head and her voice newly haughty, she said, 'My title does little more than emphasise the artificiality of our life, although I have persuaded myself to see it as an added personal protection, giving me a certain dignity.'

As he was wondering how to reply to that, Bunnie, Kit and Dickie came hurtling down the stairs and surrounded him with questions, hugs and chattering, breaking the mood between himself and Grace.

At fifteen, Bunnie was a beauty with a mind of her own. 'You'll make some lucky man a great husband,' he told her as she helped him off with his coat.

She turned on him. 'Papa, dearest, I do not plan to marry and end up skivvying for any man.'

He was bemused into asking, 'What will you do?'

'In the long term, I haven't decided. First, I want to attend finishing school in Paris.'

He gave a little laugh. 'That's not possible. Don't you know there's a war on?'

'The finishing schools are still open, and everyone says the war will be over in a few months.'

'That's been said since it began.'

'One way or another I plan to finish in Paris. And then I'll see.' Bunnie flounced off with the fearlessness of the young, leaving William wondering.

Kit, who was twelve years of age, came bouncing forward, wrapping her arms around him and snuggling her head into his belly. 'Come on, dearest Papa, I've been brushing up on my ping-pong. And I shall most certainly beat you.'

Young as she was, Dickie, the baby of the family, was well able to whinge about unfairness. She had grown up under the strain of war's separation and saw her father as an infrequent visitor.

'You're never home,' was her frequent complaint to him.

William suspected she was mimicking Grace – little as he knew about children, he didn't consider that a four-year old, no matter how bright, could reach such a conclusion on her own.

Whenever Grace spoke about the end of the war, she made it clear that she expected him to return to live *en famille* in Chelsea, emphasising that it was his duty to do so. The idea horrified him. He

wished it didn't; wished he could settle back into family life, as so many of the men he came across at the front talked about longingly. He could not imagine his life without the war, nor could he imagine being able to adjust to family life.

A few mornings after the investiture, as he stood in front of the long mirror in the marital bedroom struggling to neaten his bow tie, he turned and watched as Grace eased out of bed. She looked fragile, her movements were sluggish, devoid of the vitality that had been one of her most endearing traits. There was never going to be a right time to do what had to be done – he was skilled at avoiding the type of discussions that made him uneasy and at distancing himself from emotional scenes, but this had to be done and he supposed now was as good an opportunity as any to inform her of his decision.

'When this is all over,' – a wave of his arm specified the war – 'I'll be a wanderer for a year to two. You must accept that.' He spoke quietly but firmly, knowing that his decision would add to the deterioration of their relationship.

Grace's expression was so cold and shuttered that William saw little point in explaining his reasons.

'Your wanderings take second place to my health?'

'What's wrong?' His tie remained askance.

'I'm seeing a doctor in Harley Street this afternoon.'

She primmed her lips, turned her back to him and huddled into the chair by the window. He dithered, moving from one foot to the other, uncertain as to how to handle the situation. At least she wasn't crying – he could never handle tears. His bowtie knotted to his satisfaction, he put on his jacket, took one look at her immobile back and with a small sigh left their bedroom.

He spent another fortnight in London, playing at family life, knowing he was not succeeding. When Grace refused to speak of her visit to Harley Street, William snapped, 'You're so angry, there can't be much wrong with you.'

When he called on Evelyn in Berkeley Square, she was courteous but did not allow his presence to impinge on the social life she had built during his absence – in her company he felt the lurking presence of George F. Baker's threat of cutting her out of his will.

He was relieved to leave behind the complications of Grace and Evelyn and to return to Yvonne, who never made demands on him.

Chapter 29

Winter 1918, Amiens & Paris

Autumn drifted into winter. Bare trees stretched sideways around the drab landscape, the earth was brown, almost luminous with lying water and the faraway mountains were merely a darker grey than the clouds.

Distance had William worrying about Grace. He wrote frequently, the idea that she might be ill gnawed at him: *I would like the Doctor to write and tell me exactly what is wrong with you – but I suppose this is too much to expect – anyway be careful.* He signed the letter: *My love to you all, Billom.*

On 11 November 1918 the war ended with the Kaiser's abdication.

Once again, William was unwell.

'Nothing specific,' he assured Green, 'and I don't want any fussing.'

'You look very sick, Major. How do you feel?'

'I'm all right. A bit of a headache, a bit of a cough and a bit of a sore throat.'

'As well as running a temperature. Look at how you're sweating.'

Green disappeared, likely to confer with Howlett. While the coast was clear William, well muffled up in scarves and a woolly hat, ventured onto the streets of Amiens – he couldn't bear the thought of missing out on the experience of being part of the end of the war. As well as history being made, he had a fondness and respect for the city and all it had been through. The news that the war was over rolled down the main streets, lingered along the side streets and was

whispered about in buildings, the words clambering up the steps of the railway station and bouncing off the pebbles of courtyards.

The final bombardments were shattering, resulting in sturdy buildings crumbling to the ground, throwing up mushroom clouds of dust that had him gagging for breath. The carnage and devastation was like some huge climatic underworld orgy. To add to the confusion, celebratory live shells exploded all over the town. Leaning against a corner building at the end of the street, he felt only numbness as he watched the hideousness of the celebrations – against a backdrop of shattered sights and sounds children holding hands, jumping up and down; soberly dressed women dancing with abandon and elderly men with tears running down faces that looked as though they had been carved from granite.

Back in his room he wrote in his journal: *On this day looked forward to for years, I must admit that, studying people, I found something wrong – perhaps, like all great moments expected, something is sure to fall short of expectations. Peace was too great a thing to think about, the longing for it was too real, too intense. For four years the fighting men had thought of nothing except that great moment of achievement: now it has come, the great thing had ceased, the war was won and over. The fighting man – that marvellous thing that I had worshipped all the time I had been in France – had ceased actively to exist. I realised then, almost as much as I do now, that he was lost, forgotten.*

As the weather turned even colder William felt the chill of illness seep into his bones, and within days he was unable to get out of bed. He thought it might be the blood poisoning flaring up again. Yvonne confirmed the likelihood. She also diagnosed a dose of the dreaded Spanish influenza.

When she was not on duty at the hospital she was with William. He overheard Green and Howlett wondering how she was managing to nurse him, and seemingly with the blessing of matron, although much of the time he was too out of it to know what was happening.

After a few days of high temperatures and sweating nights, of her own volition, Yvonne organised a doctor to visit.

The young man who arrived at the hotel looked to be on the point of collapse. He reeked of stale perspiration, his linen was grubby and his frockcoat stained. After looking around at the chaos of the room, he examined William in a perfunctory manner, wiped his hands down the side of his trousers and gave a self-conscious laugh. 'Why don't you give up the brandy and try drinking two litres of milk and a litre and half of Vichy water each day. Perhaps that'll have you better.'

William must have drifted into sleep because his next memory is of opening his eyes and seeing Yvonne bending over him.

'Are you all right? You've been out for two days.'

He was in a lather of sweat – the wetness of his nightshirt clung to his back, small beads of sweat crept out from under his hair and trickled down his face. She placed a cool hand on his forehead.

'Don't fuss.'

She ignored him, slipping her hand under his head, lifting it and sliding in two extra pillows. He eased his body upwards in the bed, reached out to the locker and his cigarette case. Awkwardly, he lit a cigarette, drawing the nicotine deep into his lungs, watching the smoke scribble across the room as he sipped on the bitter black coffee that Yvonne handed him. During the following days he was not sure whether he was asleep or awake, but he was aware of Green, Howlett and Yvonne coming and going, changing bed linen, clearing the debris of his illness, urging bowls of soup and sips of water on him until he yelled at them, 'Get out, all of you.' He felt he might well die – his head was hammering with pain, as well as full to bursting point with worrying thoughts about how he'd cope with life in the aftermath of war; fretting about his family and worrying about Evelyn and Yvonne.

As he had told Grace, he would wander for a few years when the war ended. He could not return to family life – Grace and his

daughters would remain in their home in Chelsea; he was in contact with them with frequent letters and humorous notes. In all likelihood, Evelyn and Vivien would continue to divide their time between Berkeley Square and Coombe House in Surrey; while he and Evelyn were no longer in the throes of a passionate affair, their commitment to each other was enduring. Yvonne's caring presence and nursing skills were a comfort, but he had flashes of guilt at prising her from her father, aunt and the life she knew in Lille.

Now that he was no longer able to hide behind his easel at the front and fill his hours with painting, he felt like a juggler as he tried to sort out ways of keeping those three relationships going – silently he reproached himself at the ineptitude of his juggling.

His batman recognised that he was disturbed and depressed by the aftermath of the war and, leaning against the wall of the bedroom, he would listen, without comment, to William's rolling thoughts about how little progress civilization had made throughout the centuries; his grieving that surely if he cared enough, he could shoulder some of the weight of the world. Perhaps if he'd tried harder, he'd berate himself, he could have done more. He'd read somewhere that the twentieth century was the era of war and the motorcar, and yet when he looked back over the past two decades the humanity of those who had dreamed up both was non-existent. 'The human race,' he finished miserably, 'has scarcely advanced in a thousand years.'

When Yvonne called that afternoon, she had news that did little to dispel William's mood. 'The Madonna has fallen from the cathedral in Albert.'

He edged upwards on his elbow. 'What happened?'

'The statue fell from the belfry – the pieces are scattered all over the place. The locals see it as fulfilling the prophecy of guarding the people of the town until the end of war.'

'I'm not sure how good a job it did.'

Yvonne was horrified. 'That's blasphemous, Billy.'

Lying in bed, he had too much time to think. He thought about how officers and politicians had betrayed their fighting men. His curiosity and fascination for the ordinary soldier was enduring – the optimistic vulnerability of Liam and his diary; the lad whose mother lent out her pig's head to the neighbours; the boy who watched the squirrels. The more he knew of their day-to-day life in and out of the trenches, the more ironclad was his certainty that they had been sold out.

William was so locked into ill health and agonised by swirling thoughts that when TT visited, he was scarcely able to raise his head from the pillow. His aide was his usual immaculate figure. He looked down at William and landed a bombshell in his dry way. 'You'd want to pull yourself together.' William wondered why the hell he should bother to pull himself together. 'I thought you should know you're tipped to paint the Peace Conference.'

This was different. A spark at last. William raised himself on a shaky elbow – ill as he was, he was aware of the heaviness of the air and untidiness of the room, anathema to a man like TT who was an advocate of fresh air and the epitome of fastidious tidiness.

'I doubt it. Sure, I wasn't even invited aboard Foch's train to paint the signing of the Armistice.' William had raged at his exclusion from the Armistice of 11 November 1918 that had ended the fighting on land, sea and air between the Allies and Germany.

'Don't be ridiculous,' Aikman advised. 'You couldn't possibly have gone. You were in no fit condition – hardly able to get out of the bed much less travel to Le Francport. I'd advise you not to complain. Keep quiet until you receive official notification of the commission.'

Thanks to the burst of excitement at TT's news and Yvonne's nursing, William's health improved. Playing down his worries, he wrote to Grace in flighty style: *I was even a bit anxious about myself – blood poisoning and inflammation of the bladder, bowels, liver, groins, glands, nerves and all the other middle parts.*

Eventually he pronounced himself ready, willing and able to fulfil the various official and social engagements and celebrations marking the end of war. Still smarting from the Foch affair, and determined not to be sidelined again, on learning that King George V was visiting the city, he put in for a window seat along the route being taken by the king. His request was granted, as were the official passes to work in a variety of cities in Belgium and Germany.

Eventually Prime Minister Lloyd George gave the official go-ahead for William to paint a commemoration of the Peace Conference at Versailles in 1919. The picture was to include all the leaders attending the conference.

Since the end of the war the cost of living had rocketed in Paris, but despite feeling the financial pinch – while in France, William had lived on his major's salary – he did not stint when he and Yvonne arrived in Paris. He took long-term accommodation at the Hotel Majestic, booked studio space in the Hotel Astoria and rented rooms in a nearby apartment block, primarily for Charles Grover-Williams, the chauffeur who had replaced Howlett when he and Green were returned to England at the end of the war.

Grover-Williams was the son of an English horse breeder. He was born in Monaco, educated in the UK and lived for motorcars. As William's days were occupied with meetings and the work of being an artist, and his evenings were frequently taken up with socialising, Yvonne lived much of the time in the apartment.

William was aware that it was an honour to be commissioned to paint the Peace Conference, and he celebrated by whooping it up in Fouquet's, buying champagne all around. Next morning, he sobered up quickly when he realised the amount of work involved in the painting – the size alone was off-putting.

He was relieved at how well Yvonne took to Paris – it took the pressure off him. She regaled him with tales of lingering along the banks of the Seine, walking through little parks, wandering the wide boulevards, fascinated by the tramway cars, taxis and heavily laden

drays that competed for space, admiring the high buildings with their stylish wrought-iron balconies and appreciating the beauty of the fine silks and satins on display in the boutiques. Other times, she told him, she walked the narrow streets that Zeppelins had targeted relentlessly, where the only things left standing were the iron bases of the streetlamps and where peaky, small boys scooted in delight in and out among the debris carrying whatever they managed to salvage.

Her one adventure had her almost bursting with excitement. 'There I was, Billy, on a lovely sunny morning looking at a damaged house with the end wall gone, wondering about the people who'd lived there, imaging their lives now and feeling sad for them, when I saw a puppy curled up on a brass bed. As I'm wondering what to do, a boy appeared out of the ruins. He'd a torn shirt and scabbed knees. I offered him a few francs if he'd fetch it. He climbed like a monkey. When he reached the bed, he waved down at me, scooped up a puppy and stuffed it under his jersey. It whimpered as it snuggled into my arms. I'd found another Kiki.'

She was radiant with delight, and he was pleased for her. He knew he neglected her, took her for granted. Now that the war was officially over, she dropped occasional, delicately worded hints about their future. He never rose to her bait, and she knew enough not to push him.

A few mornings later when Yvonne arrived at the Majestic, William stepped towards her, bowler hat in hand and bowed from the waist.

'Billy, you look so handsome.'

He wore one of his English three-piece suits, an elegant shirt and a jazzy bowtie. He enjoyed spending time with Yvonne, wandering the streets and boulevards, seeing the city through her eyes. It was a day of fragile brilliance. Below them stretched the pavements of the lower quay, glistening white in patches of hoar frost and the cool smoothness of the grey-green Seine. Down the promenade, a boy

watered horses and a lavender seller plied her wares. In the middle of the river a commuter boat chugged past a barge, coloured posters gleamed on the *bateau-mouche*'s square roof.

While they waited for the next boat at the small jetty at Pont Neuf, Yvonne drew his attention to a child selling *boutonnières* from a heavy shoulder tray. Since the end of the war children working at a variety of simple jobs had sprung up throughout the city. 'Look, Billy, that little one is so young.'

William's face tightened. He called the child over, and in English, in a voice boding no argument, that Yvonne translated, he bought the contents of the tray of small white roses, their petals adhering to each other.

'Give the remainder away,' he urged. Yvonne explained his wishes. The girl rewarded them with a puzzled smile that didn't quite reach her eyes. 'Go now and come back to me when it's done.' With a pat on her arm, he sent her on her way.

William pinned three of the buds on Yvonne's shoulder. They watched silently as the child did his bidding, curtseying gracefully to each of the surprised recipients before, they presumed, explaining the situation in an outburst of language, with a nod back in William's direction. When she returned with the empty tray and a tentative smile, he gave her a few more coins. 'Buy yourself a meal and go home for the remainder of the day.' His voice was back to stern, and she looked confused.

Yvonne dropped to the girl's height and repeated slowly what William had said. The child frowned, looking from him to her and back up the quays.

William mimicked the actions of eating and resting. As Yvonne translated the girl looked at them with wide-eyed incredulity.

'Why, Billy?' Yvonne asked as the girl scampered off, the shoulder tray thumping against her scrawny body.

He sighed. 'War. Its long-term effects are disastrous – of necessity, too many children end up educated in the ways of the world

before their time. We do what we can, but invariably, it's too little, too late. Doubtless that little one will be back tomorrow with another tray of roses, and eventually, she'll be on the streets without the roses. Regretfully, she's pretty enough to make her living without flowers.'

As he spoke, he was struck by Yvonne's innocence, how she appeared to glide through the world, untouched by its atrocities.

William was tucked into a corner in the bar of the Majestic holding a letter from Grace when he looked up to find his aide looking down at him. 'I was hoping to catch you.'

'What's up? As Aikman was a man surrounded with problems, William anticipated that something must be amiss.

'I wanted to let you know I've been recalled to London.'

'You're pleased?'

'Yes, I am. Very pleased. It'll be good to get back to the family. And you?' His aide gestured to the letter. 'Good news, I hope?'

Despite selecting TT as his aide, throughout his time in France William's dealings with him had been on a professional rather than a personal level. Now that he thought of it, he didn't remember the two of them ever having a convivial drink or talking about their families.

'Mary, my eldest daughter is here. Attending finishing school. Mlle. Arbel's – have you heard of it?' Even as he asked, William knew TT would not, but he had an unexpected hunger to acknowledge his family.

'No. But I'm sure it's excellent. From what I hear Paris is the city where young ladies wish to be finished.' He gave him a quick look. 'It'll be good for you to have family around. It's lonely on your own. She must find you quite the hero.'

'Quite the opposite. My family do not favour me.' The comment was without rancour.

'Nonsense. You're officially endorsed as the painter of realistic war scenes and the public sees you as our nation's leading artistic

commentator. You paint with forthrightness and courage that frequently gets you into trouble, but you're true to yourself and what you see as truth. The public love you for it. You're the most famous artist of the day, a hero with diplomatic status. You're seen as working on behalf of Britain and the Empire – right at the centre of what's happening.'

William had never heard his aide speak at such length or so volubly. He was touched. He didn't consider himself in those terms. Evelyn had spoken in a similar vein. He was pleased, so inordinately pleased with TT's words that they invited confidence. 'During my time in France I encountered the strangest and most diverting collection of puppets and puppet-masters. I'm painting them as I see them, human limitations and all.'

As soon as he had spoken, he regretted it.

TT stood up, rested a hand on his shoulder. 'Our war is over, William, let it go. Thank God we've survived, and now it's time to return to our families and peace.'

Chapter 30

1919, Paris

William struck up an unlikely friendship with Sidney Dark, the *Daily Express* special correspondent, and George Adam from *The Times*, both stationed in Paris to cover the Peace Conference. They were journalists to their fingertips, cynical and world-weary. William found refreshing their light-hearted banter and irreligious attitudes towards establishment figures. The three of them socialised between the Majestic and the Astoria hotels; they drank at Fouquet's and usually lunched at Hotel Chatham, where William, to the delight of the chef-in-residence, painted his portrait that he titled *The Chef*.

'You seem out of sorts.' Sidney Dark, looked up from his newspaper as William sat in beside him on a dark winter evening. He was a lean man in his forties with a booming voice and a beaming smile.

William sighed deeply. 'So would you if you were on the receiving end of bureaucratic messing about. Little Orps is tired, so tired.'

'My, dear chap, we reporters know all about being tired, being slaves to bureaucracy and being treated abominably by our editors. Ask George.'

George Adam joined them, sitting down with a grunt. He was running to fat and inclined towards baldness.

'So, what's news? What's up? William, you look as though you've swallowed a lemon.'

'Nothing to do with a lemon, George. A change of plan. What started as a single painting has become three. Those "frocks" have me demented.'

'Frocks?'

'The bureaucrats and conference delegates who think they're God.'

'You'll have to put up with them. You'll get no pity from us,' Sidney laughed. 'Bet you're being well remunerated?'

'Suppose I am. But I've a lot of commitments and little money. I could face financial ruin.'

George threw back his head and laughed. 'Pull the other one. You're the most successful, the best known and the wealthiest portrait painter in the whole of Britain.'

'Before the war I may have been, but I've had to exist on a major's salary for the past two years.'

'I hear there's talk of a fee of six thousand to do those paintings.'

'Hell, George, where do you get your information?'

'By keeping my ear close to the ground.'

William grimaced.

'I also hear that Singer Sargent is only getting a few hundred for *Gassed*. And that's a huge canvas.'

'Seriously, Sir William, you're coming across as champion of the ordinary soldier and displaying a visceral disgust at the way the politicians are carving up the post-war world.' Sidney's expression was grave.

'Right on the second point. Listening to the politicians going on, trying to score points off each other, is both terrifying and depressing. But the thought of all that painting and what it represents weighs heavily on me. I wonder what I've let myself in for. Wonder too how many more changes I'll have to make.'

William was aware of the warning glance George shot Sidney. From their earliest get-togethers he realised they could and did read his moods. Those moods could fluctuate at the drop of a hat from optimism to pessimism. He supposed such an ability as theirs went a long way towards making them excellent newspapermen.

'I hear your painting of that refugee girl is of continuing interest in London.' Sidney beamed widely and leaned forwards, avid for

information, daringly changing the subject to what was still a matter of lively conjecture on both sides of the Channel.

William looked fondly at the pair of them – they were without censure, generous to a fault, true drinking friends and offering unstinting companionship.

Drawing on his cigarette Sidney continued, 'Rumours are flying around about the girl.' He ignored a warning frown from George who was more inclined to veer on the side of caution. 'Duff Cooper is claiming to be in the know, to have the true story. But as I say to anyone who brings up the subject, Sir William is the only one who knows the truth, the whole truth and nothing but the truth and he's not talking. Am I not right?'

William burst out laughing. 'All right. All right. You're right.' He threw up his hands. 'Scout's honour, you never heard from me any of what I'm going to tell you.'

'This deserves another bottle.' George called over a waiter.

There was no stopping Sidney. 'In my opinion your painting of *The Refugee* is the perfect symbol of this war – the destruction of the innocent. It's having a profound influence on the public – Lady Diana Manners is busy, busy conveying her opinions to anyone who'll listen.'

'Daily that story grows legs – so much so that it's passed into the folklore of war,' announced George. 'I believe there's talk of Lord Beaverbrook's interest.'

'Yes, I heard the lovely refugee in the guise of a spy has so taken the Lord's fancy that he has acquired the painting. Go on, William,' Sidney urged, 'tell us the truth that lies behind the story doing the rounds.'

The journalists had full glasses and looks of high expectation.

William tapped at the side of his nose with his index finger. 'This much I'll tell you.' He spoke in a jocose Irish accent. 'The sitter's name is Yvonne Aupicq. She's from Lille where her father is a powerful, highly thought of administrator – I understand he was almost

single-handedly responsible for keeping the town relatively peaceful during the German Occupation. I met her while I was in hospital. She was a nurse, a volunteer, and now she's with me in Paris. End of story.'

'So, the bit about her being a Belgian spy is fiction? As I presume is the story about her being a refugee?'

'Yes, Sidney, I admit they are.'

'So where does *The Refugee* come in?' William wished George was not so curious – he was a devil for detail. But he supposed that was an aspect of what made him a good journalist.

'The first painting I did of Yvonne was titled *The Spy* – in it she's scantily clothed. In *The Refugee* she's modestly dressed.'

George laughed, 'So Beaverbrook has *The Spy* – trust him. And *The Refugee* is being exhibited. I reckon yours isn't the first bit of fiction to emerge from this war, but it's certainly one of the best.'

Sidney jumped in, 'And I believe in certain esteemed circles there was talk of the artist being court-martialled? Major Lee is far from enamoured at being publicly hoodwinked.'

George and Sidney were a probing double act.

'So I heard,' William's eyes twinkled.

'How do you get away with it, Sir William?'

'Hard neck,' said Sidney.

'And friends in the right places,' added George.

With the journalists sworn to secrecy, the matter was closed.

Before settling down for the night William wrote in his diary: *All the people who made the peace conference possible are being forgotten, the frocks reign supreme.*

William lost count of how many of the 140 formal and informal meetings of the Paris Peace Conference he attended. Day after day he sat to the side in the over-crowded chamber sketching those 'frocks'. Much of what was being debated by the delegates washed over him,

but vague as his grasp was, he was singularly unimpressed at the solutions being put forward to guarantee continuing world peace.

Between January and the following July by his count he completed portraits of nearly every political leader attending the conference and many of their advisers, as well as portraits of the military figures he had not got around to during the war.

The conference was dominated by what was being called The Big Four – the leaders of Britain, France, the United States and Italy. Germany and the losing nations had little voice. William found the sessions tiring, each evening he was exhausted.

'Not surprising,' Yvonne said, 'as you're not fully recovered from your last illness.'

He was in agreement with her until she added, 'You'd be better off having an early night rather than drinking with those journalists.'

He walked off in search of Sidney and George, who he found in their usual corner in the bar of the Majestic.

'We're talking about you,' George greeted. 'Reckoning politicians must be difficult to paint?'

William nodded. He was designing his compositions to emphasise the grandeur of the Louis XIV's surroundings, rather than the importance of the politicians. 'It's difficult trying to pander to political personalities.'

'Too large a bite spoils the mouth.' Sidney had a stock of sayings.

'I know. I wish we could have a peace with good will instead of a peace with mutual hate.' George shook his head sadly.

'As bad as that, George?' William did not doubt George's assessment of the peace process.

'Sadly, I think so.'

'Yet, you'd no trouble with Churchill,' Sidney stated in his categorical way. 'No pandering there – you captured the inner man, and no one could be more political.'

'He was genuine. From what I've seen the "frocks" aren't authentic. They reign supreme, full of self-importance. And the fighting men have been all but forgotten.'

Invariably, as the evenings progressed the three of them ended up grizzling about editors, bureaucrats and top brass military.

Late one night William wrote to Evelyn: *Dog tired. My health is fine but my mind is scattered. Going to Cannes on Sunday and back by motor.*

Finally, two of the Peace paintings were completed. *A Peace Conference at the Quai d'Orsay* depicted the Council of Ten, comprising two delegates each from Britain, France, the United States, Italy and Japan. William filled more than three-quarters of the forty by forty-nine-inch canvas with the cream, yellow and gold décor of the chamber. He showed the delegates either sitting or standing – each figure isolated in assertion of its own importance.

As the title implied, *The Signing of Peace in the Hall of Mirrors* (sixty by fifty inches) was set in the ornate Palace of Versailles. Again, the background took up more than three-quarters of the canvas, resulting in a cluster of minute-sized delegates.

That there was yet a third canvas to paint hung over him, albatross-like. His brief for that was to include a group of soldiers and statesmen, about forty figures in all, most in military uniform to be set in the Hall of Mirrors at Versailles. He wrote to Grace: *The picture is a great difficulty ... a mass of Khaki is a dreadful thing to manage.*

As William started on the painting, he was haunted by images of soldiers in the trenches – the waterlogged conditions, sleet cutting into their bare hands, patrolling gangs of rats, short rations, trench foot and exposure to screeching shells and blinding mustard gas. So many had lost their lives – nearly three thousand fighting men had died on the last day of war, and their bodies would remain in France forever. They were the hard facts; they were also the realities being ignored by the 'frocks' and that were haunting him to the point of creative impotency.

A Peace Conference at the Quai d'Orsay

His head was throbbing. As he suspected, and as Yvonne confirmed, his fever was on the rise again.

'Billy, you must rest,' she urged. 'Stop working for a few days, stay in bed. Rest. And don't drink.' But he ignored her, continuing to

The Signing of Peace in the Hall of Mirrors

put in long hours at the conference and in his studio in the Astoria. He skimped on meals, slept little and smoked and drank too much.

Black pen held delicately like a surgical instrument between his fingers, he wrote to Grace: *Alas the picture has lost its glamour – its real*

bad time is on us now – and I've got the black dog – a what am I all about sort of feeling. Hands too cold to write.

As his headaches continued their pounding and his fevers became more feverish the many images that haunted him resolved into one.

A conversation he had some months previously with a young gunner played over and over in his mind. He was a handsome, long-limbed boy with expressive brown eyes who spoke in a matter-of-fact way about the death of his friend. 'I wrote to Archie's mother telling her that I held him in my arms to the end, and when he died, I closed his eyes and kissed him twice – on the brow – one kiss for her and one for me.'

Next day William had learned that the gunner had been killed. He repaired to his room and sat, head bent, crying, grieving that he had not even known the lad's name. Yvonne came on him, cross that he was ignoring her advice and she let loose a rare torrent of French with the word *erratique* featuring over and over.

Later that evening, he wrote again to Grace complaining: *I haven't enough shirts to do the rounds.*

Celebrations acknowledging the end of war continued with William's name on every guest list. He was uneasy at many of the merriments. While the war was in full spate, he knew where he stood – now that the war was officially over and festivities were in full swing he was unsure of where he fitted in.

When he arrived late of an evening at Fouquet's, the restaurant was full of military, naval and air force officers, the majority on the point of returning to England. Their celebrations were loud and alcoholic. William ignored several raised arms – the last thing he wanted was to be involved in a discussion on peace. He found George and Sidney tucked into a corner of the bar, heads bent over a newspaper, laughing.

When George saw William, he called him over. 'You'll have a good laugh at this – it'll appeal to your Irish sense of humour.'

Of recent times William had found little to laugh about. George passed over the *Daily Mirror*, pointing towards the end of the right-hand side page. 'Pip, Squeak and Wilfred,' he spluttered. 'Three of the campaign medals – the 1914 Star, British War Medal and Victory Medal are so nicknamed.'

William wasn't amused. 'That's trashy.'

'Where's your sense of humour?' asked Sidney. 'This afternoon I came across a soldier who'd swopped a medal for a bottle of red wine.'

'Why did he do that?' George's voice rose querulously.

'Said he was thirsty.'

'Disgraceful.' George clapped his knee, laughing. 'But this is the best cartoon strip I've seen in an age. It's what we need to combat the misery of the peace process. What does our artist think?'

William shrugged. 'I've a lot on my mind, George. It would take more than a cartoon, no matter how humorous to have me laughing.'

The two reporters stood up. 'Come on, William, let's eat. Nobody can function on an empty belly.'

While they dined relatively well on a dish of beef bourguignon, William picked at his food. Eventually, with head throbbing and thoughts swirling, he pushed aside his plate. 'I'd value your opinion on something.'

He had no one except these newspapermen to turn to. It was their business to be on constant alert for a story, and he was what was known as 'newsworthy'. Despite their friendship, he was as dubious about them as he was about the several journalists who came sniffing around, angling for a story. He always insisted he was not the news and directed them towards the fighting soldiers.

His private life was private, out of bounds, never up for discussion. George and Sidney knew he was married with a family in London; that one of his daughters was attending school in Paris – when they came across them lunching, his introduction of Mary to them was perfunctory; they knew of Yvonne too. While they talked out their

stories in garrulous detail, William held most of the events in his life close to his chest.

Until that evening.

'You remember I ended up with a commission to paint three canvasses?'

They nodded in unison.

'The last one is proving problematic.' William shook his head from side to side as though trying to rattle the solution into place.

'All the "khakis",' you said.

'Right, Sidney. I've rubbed them out – the "khakis" are all gone.' He gave a most un-Orpen like giggle. 'Probably cooked my goose, in the process.'

Their reaction was neutral. 'What will the "frocks" say about that?' George leaned in towards William.

'Don't know. Don't care. So far you're the only people I've told.'

William clicked his fingers at a waiter. 'A bottle of brandy.' He turned to his friends. 'And now I hope you'll join me while I get piss-Irish drunk.'

Sidney laughed. 'Might as well. We won't be able to justify carousing for much longer. The war is over and we're malingering here instead of being back in London.'

William watched while the waiter poured the brandy, then lifted the balloon-shaped glass and raised it in turn to George and Sidney. 'I can't bear the thought of the war being over.'

Chapter 31

1919, Paris & London

William must have found his room that night. He must have climbed into bed, and drifted into sleep because his next memory was of opening his eyes and seeing Yvonne bending over him. He closed his eyes quickly against the burn of daylight.

'Billy.' There was urgency in her voice as she shook him. 'You must wake up. You drank too much last night.'

He was in a lather of sweat as he raised himself on one elbow with no idea of where he was, why he was where he was, or what day of the week it was. He dropped his head back onto the pillow, glowered at the windows pewtered with the reflection of the grey sky. Of course! He was in Paris painting the Peace Conference, and he was in bed in his suite on the second floor of the Hotel Majestic on avenue Kléber in the Sixteenth Arrondissement. He was relieved to identify his location.

In an instant the worry about the 'khakis' engulfed him. He sat up, knowing he needed to be alone, to gather his wits, as his nanny would have said. Yvonne, keeping a wary eye on him, was picking up his soiled clothing from the floor. He was in no mood for her kindness.

'I'm not drunk.'

She raised her head in a way that he recognised as the beginning of an argument.

'Go on back to the apartment. Perhaps I'll see you later.'

Her look changed to one of bewildered anger. With a glare at him she threw the bundle of shirts and trousers onto a chair. As she

left the room with a firm bang of the door he settled back against the pillows, thoughts scrambling around his head.

With his every action from the day he first set foot in France he had sought to capture truthfully the war's agony, its anguish and its death toll by painting the shattered lives of soldiers and civilians in the desolate landscapes of the front. His was the art of blood and sacrifice. His vision contained a mockery of the generals and politicians, many of whom, he considered, had made a mess of handling the war, and were continuing to do so with the signings of the Treaty of Versailles.

Now that there was peace, he wondered what the years of killings and desolation had been for. He doubted himself. Running his fingers through his hair, he fretted should he have left his family and gone to the war? Yes, his Boy's Own style adventure had turned out to be the right decision. He had made a difference. By painting the untarnished truth of what he had seen, he had been in a position to present the reality of war. England had made him the artist he was, and the War Artists' Scheme had come at the right time for him.

His thoughts rambled backwards and forwards. He had set out to capture the war on canvas as an adventure, throwing himself into it with enthusiasm and light-headed abandon that had him viewing the painting of it as exotic – a continuation of the gilded view of the Western Front being force-fed to the British public by the war machine and the propagandist press.

It had taken him a while to get into his stride, but once he had flexed his conscientious muscles with *Ready to Start*, there was no stopping him as he painted the truth and only the truth; yet on occasion he'd a sneaking suspicion that he was becoming another cog in the wheels of the war's publicity machine, particularly since falling into Lord Beaverbrook's clutches. He wondered could his interpretation of war have been more balanced? Had he been truthful in his representation of the fighting men? No and yes were the answers. War could not be classified as black and white – it was mostly greyish. He had used detail-drenched images like *The Thinker on the Butte*

de Warlencourt to convey the agony of war. And, nothing to do with him, it had become one of the iconic images of the war.

His rubbed-out painting of the 'khakis' loomed ghost-like before him. Nothing about it had been an honest or truthful interpretation of what he knew and what he had experienced. It had to be changed. But he did not know how to set about righting his original wrong, and he suspected that altering it could be detrimental to his career.

He ordered up a pot of black coffee, and after downing two cups, he ran a hot bath and, in an effort to obliterate the alcohol exuding through his pores, he scrubbed at his skin until it reddened. He dressed in fresh clothes, finished the coffee, and as he walked to his studio in the Astoria, he came up with a solution that had him dancing a few jig steps on the pavement – resolving the matter of the 'khakis' had him light-headed with relief.

Standing before his easel he felt the hand of fate guiding him. Raw inspiration urging him onwards. In the centre of the canvas, he painted in a coffin draped with the Union Jack flag – that was better, but not enough. He stood back, index finger on chin, appraising. Now he had it. With a fine pointed brush, he added two emaciated soldiers chained to the sides of the coffin – above the coffin he floated a pair of cherubs holding green and gold garlands. Once again, he stood back from the canvas, evaluating, somewhat unsure about the cherubs but he would leave them for the present. He heaved a sigh of relief – he had created a fitting memorial to the soldiers who had lost their lives during the war.

To the Unknown British Soldier in France raised controversy with society and the military holding forth on the pros and cons in much the same way as they had during the debacle of *The Spy* versus *The Refugee*. That third Peace painting became the subject of heated dinner-party discussions, with some hailing it a powerful interpretation of war, while others considered it a blasphemous disgrace.

The Spectator wrote that the colour was unpleasant and the design weak, while the Imperial War Museum labelled it the only symbolic picture in its collections.

'Do you mind?' Evelyn asked a few weeks later when he was back in London. As they were discussing the painting, William realised how much he'd missed her company, her plain speaking and unsentimental common sense. Seated with her on the blue-striped sofa in her Mayfair drawing room, he never wanted to leave. He'd forgotten the magnificence of her beauty – mature now, but just as alluring to him as all those years ago. He'd never forgotten her, but he'd allowed his feelings for her to become blurred. He saw anew – her porcelain skin, casually coiffed hair, those ropes of pearls and her outfit of cream and white silk with the added warmth of a fringed shawl thrown over her shoulders.

He would tumble into bed with her in an instant, but she showed no interest in resuming intimacy.

'Do you mind, Woppy?' Evelyn repeated.

'Mind what?' William shrugged away his wandering thoughts.

'The controversy about your Unknown Soldier?'

Did he mind? He did. He minded so much about that painting that his stomach tightened whenever he thought about it. But there were a great many other things to mind about too. Since coming back to London he had felt unappreciated and rootless – wrangling with the War Office about money; wondering how to thaw Grace's frosty demeanour that had him staying in the Savile Club; missing the easy companionship of Paris; and Evelyn's attitude that left him in no doubt that the intimacy of their relationship was over.

'Yes, I do mind. Of course, I mind. You of all people shouldn't have to ask.'

'Woppy, I'm worried about you. You're nothing but skin and bones, and you seem so sad. Depressed, dare I say.'

To the Unknown British Soldier in France (original version)

'And don't forget, "and drinking too much".' For the last four words he adopted a falsetto voice, making a joke that in the past would have had Evelyn laughing.

Dora interrupted whatever Evelyn might have said, pushing open the door and entering with a trolley of tea things. William cast a glance of longing at the consul table holding cut glass decanters

reassuringly filled with whiskies, brandies and gins. With Evelyn's mood and the ambience of the afternoon, he knew better than to suggest a drink.

She poured her favourite Earl Grey tea, put two fingers of shortbread on a side plate and set a small table in front of him. She touched his shoulder. 'Don't make light of your health, our relationship, but especially your exceptional talent.' She took his hand in hers. 'Your paintings explain the reality of war with your visceral images, but words are important too – they give life an understanding. You protect your feelings with jokes and a casual manner. You don't speak about how you suffered throughout your time in France – coping with orders, negotiating authority, rank, hierarchy, stupidity and endangering your health while all you wanted was to be free to paint images that surrounded you.'

She knew him so well – she'd put his thoughts and feelings into words, in a way that he couldn't.

'But it has all taken a terrible toll on you.' Her words were calming and her hand resting on his soothing. 'You need to do something about that painting first and then look after your health.'

'What do you suggest?' William's voice was low, hopeful. He took a sip of tea and a bite of shortbread. He was remembering her previous support, her knack of getting to the kernel of problems, of coming up with solutions, promoting his work, her way of getting the right people to see her point of view and how frequently it had reflected his.

She sat back, shook her head. 'Dearest Woppy. You couldn't possibly know.'

He registered the return of her term of affection. 'Couldn't know what?'

'Everyone wants to forget the war – it is the first great trauma of this century. We want to pretend it never happened and get on with living. Could we, who are supposedly civilized not have moved

from a world of kaisers, kings and archdukes to a fully enfranchised democratic continent without so many millions of deaths?'

It was a question he could not answer, but she continued. 'Your painting is too powerful, too stark a reminder. It has made its point. And a powerful point it is. Suppose you offer to paint out the ghosts, the cherubs and the garlands and present the painting as a memorial to Earl Haig – like him or not he's hero of the hour.'

William listened transfixed. He had forgotten how voluble and passionate Evelyn could be. He spoke quietly. 'I'm not in the habit of painting over.'

'I know you're not, but can't you see it depends on *how* you paint over, how much you conceal and the way you conceal it.' She waved an airy arm. 'After all, you're regarded as being technically peerless.' The solution floated in the air as she bent over and kissed the top of his head.

He left Berkeley Square with a heavy heart and Evelyn's words urging him to 'take care of yourself' ringing in his ears. For reasons he couldn't fathom, her solution to his problem with the painting left him with a sense of loss. He adjourned to his club for drinks and mourning ruminations. Sitting in a quiet corner, smoking, he thought through what Evelyn had said. Out of the chaos hers was the only solution that made sense. But not in a million years would he have thought of it. If it worked, perhaps he could emerge from this with his reputation intact.

The painting-over was a job that deserved an attitude of funereal pomp and ceremony. William arrived at the War Museum dressed in his immaculate khaki uniform with his palette, brushes and paints as well as a flask of Dewar's. He was shown to a small square-shaped room blessed with good northern light. After setting the canvas at a slant, as he had done on many nights in his hotel room in Amiens, he prowled around the painting, viewing it from all angles, standing

To the Unknown British Soldier in France

back from it, pausing in front of it, getting the feel of it until a silent conversation ensued between him and it.

He apologised to the scantily clad soldiers as he painted them out, first removing their guns before starting on them, beginning at their feet and working upwards. He said a final goodbye as his paint obliterated their heads and features.

He paused before removing the cherubs, recalling with a pang of nostalgia the cherub gushing silvery water fountain from the fountain in that picturesque village. How many lifetimes ago was that? The garlanded flowers he saluted with his paintbrush before consigning them to oblivion. In the end, he found the act of painting-out to be surprisingly cathartic – the canvas accepted the smooth skim of paint, as though waiting for it. His decisiveness acted like an intoxicant filling his brain with confidence. He enjoyed a generous slug of whiskey as he looked over his work, intrigued at how the faint, ghostly outline of the half-naked soldiers, holding their rifles diagonally across their bodies, would not be denied. Looking closer he saw that the obliterated 'khakis' still lurked as a shadowy presence. He went up to the painting, touched his fingers to his lips and transferred his kiss to the canvas. Truth would not be denied.

He breathed a sigh of relief. He was finished with the third Peace painting. It was done. And he breathed more relief when his offer to present it as a memorial to Earl Haig was accepted. What could have been a humiliation turned to a celebration.

Chapter 32

1920, Paris

Back in Paris. Seated in a corner of the lounge in the Majestic with *The Shadow of Crime*. William had nearly finished the book and from what he remembered of the beginning it was a good story. As he ordered a whiskey and soda he was looking forward to a relaxing, undisturbed hour or two.

The sight of his driver negotiating the afternoon tea tables as he came towards him put paid to that. 'May I have a few words with you, Major?'

William nodded and gestured to the opposite chair. Grover-Williams sat down and cleared his throat. 'It's about Yvonne.'

'What about her?'

'She's unhappy. Unsure of what the future holds for her?'

'And how does that concern you?'

'I thought you should know.'

'Now I know. And if that's all you may leave. I'll contact you when I require the motor.' William took out his cigarette case and slowly withdrew a Gold Flake. By the time it was lit, Charles was gone, and he settled back again, uneasy at the unplanned interruption.

It could not have been more than half an hour later that he looked up to see Yvonne approaching, with Kiki tucked under her arm. How young she was. Her happiness at seeing him never wavered. Her blue eyes sparkled, and her face was one large smile. 'There you are, Billy. I'm so glad you're here. I thought I might have to go the Astoria?'

'What's so urgent?' There was little warmth in his voice. He had accepted the shakiness of his future with Grace, acquiesced to the fact that he and Evelyn had moved to a changed relationship,

and now had to deal with Yvonne who was bubbling with delight at having him back in Paris.

She sat in beside him, tucking a tail-wagging Kiki between them. 'I'd a letter from Tante Jeanne. Papa has invited us – you as well – to spend a few days with them in Lille. How nice is that?'

That was the last straw. Biding time, he tickled behind Kiki's ear – he had been thinking about easing away from Yvonne; perhaps finishing with her, if it came to that. He was unsure of what his future held but sure enough to know that long term she would not be part of it. Her enthusiasm about the invitation reinforced her lack of worldly experience – Evelyn would never put him in such a situation.

'I won't be going to Lille with you.' He didn't look at her as he spoke.

She turned towards him. 'That's all right.'

He breathed easier. 'What have you been doing?'

'Walking Kiki mostly.' She looked around. 'Shall we have tea?'

He knew her well enough to know she wanted to stretch time. 'Not this afternoon.' The halcyon days of their early relationship were long past. Silence hung heavily between them until William said, 'I'm looking forward to seeing my daughters again – they're all pretty, talented and competitive. I was reared to be competitive too.'

'Will you go back to your wife?'

He was taken aback with her question. To cover his discomfiture, he lit a cigarette.

He did not expect her to pursue it. 'Will you?' she repeated.

'I never left my wife and I've no plans to. Never had.' His words were harsh with emphasis.

She cleared her throat. 'Will you be a portrait painter again?'

This was going from bad to worse. The lounge of the Majestic hotel, full of affluent middle-aged Parisians, was not the place for an emotional showdown that he felt could be imminent.

He stroked the little dog's head. 'I've always enjoyed painting portraits.' He spoke slowly, emphasising each word.

'Remember the stories you told me about donkeys and funny hats?' She placed her hand on his.

'No. I don't.' He removed his hand from under hers.

She twisted around until she was looking him full in the face. 'You said painting portraits was a good way of life. I could be with you. Keep house, take care of you.'

'The war has changed life in London. It's not the same as it was – probably never will be again.'

'Charles says the whole world is changed for ever.'

'Charles is right.' William made a production of pulling out his watch from its pocket. It was time to end this charade. He stood up. 'I've an appointment. I've to leave.' He moved briskly to the lobby. He didn't look back. He could not bear to see Yvonne's look of disappointed bewilderment. He would take her out to breakfast, deal with the matter then. He sent a note around to Grover-Williams.

William had no idea of day or time when, from the depths of sleep, he heard a voice calling, 'Billy, Billy.' He opened his eyes slowly – the curtains were still drawn over and the main shutters closed. The sole glimmer of light was from a small rectangular window that showed the bedroom with its regular mess of scattered clothes, bottles, glasses, books, cigarette packets and overflowing ashtrays.

Emerging from his tangle of sheets, he saw the blurred figure of Yvonne moving towards him. It couldn't be morning already? As he came to, slowly gathering his wits, realising it must be morning, he was aware of a figure rising up in the bed beside him. The figure sat upright, gave a sharp intake of breath and pulled at the sheets to cover her nakedness.

He wanted to burrow back under the bedclothes, and never come up, but he stayed lying motionless on his side of the bed, his eyes open, watching flickers of dim light dance across the walls.

Yvonne was standing immobile by his side of the bed; fleetingly, he wondered would she say anything. But no. She gave a strangled

gasp, gulped, let out a giant sob and fled, the door of the bedroom closing soundlessly behind her.

William got out of bed slowly, reluctantly placing his feet carefully on the floor. He turned to his companion who was as still as though carved from stone.

'You may leave.' When she looked at him in puzzlement, he spoke more firmly. 'Go. Now.'

He did not as much as glance at her as she rose, gathered her clothes and went into the bathroom. She exited, fully dressed, a few minutes later. He kept his back turned, looking out the window as she opened the door leading to the corridor.

He lit a cigarette and inhaled deeply, his belly cramping. He did not look forward to what had to be done.

The older he got the more he dreaded emotional scenes – and the war had escalated that dread – unless, of course, the emotion involved the passion of lovemaking. He disliked discussions about the future, analysis of relationships and he was unable to handle tears. But he had never wanted to distress Yvonne.

It was unfortunate that he'd slept in. Instead of meeting Yvonne in the lobby and taking her for breakfast where he planned to break the news to her that he'd be returning alone to England, he'd ended up in this mess.

He had the ability to blithely ignore the consequences of the body in his bed – a young dancer he'd been seeing on and off for some weeks. It was foolish to bring her back to his hotel, he knew that, but last night he hadn't wanted to be alone, and she was more than willing.

Lighting a cigarette, he tried to think through the situation, getting nowhere but managing to console himself that he'd never made a commitment to Yvonne. She must have suspected that their relationship was coming to an end. Women had good instincts about such things. Hadn't they? He ran a rumpling hand through his hair and went into the bathroom.

A short time later he emerged, showered, shaved, wrapped in a towelling robe, and feeling more positive about the whole sorry mess. The matter would have to be cleared up sooner rather than later. He disliked the feeling of unfinished business hanging over him almost as much as he disliked confrontation. He sent a message to Grover-Williams to come to the hotel at five o'clock.

On the dot of five William, immaculately dressed and uncharacteristically nervous, waited in the lounge of the hotel. Two glasses, a bottle of whiskey and a soda siphon were on the table in front of him. He'd had all day to think about how he would say what had to be said.

His driver was equally punctual. He stood before him, cap in hands. His lips were a thin line and his eyes wary.

'Sit down, have a drink.'

Charles sat opposite William but refused a drink.

William poured a generous measure of whiskey and added a small squirt of soda water to his glass. 'Thank you for coming.' He wasn't in the habit of thanking those he employed for the services they were paid to render, although Grover-Williams was more than an employee – he was a gentleman, well educated, good company, an exemplary driver and a trained expert in the mechanics of Rolls-Royce automobiles.

William was nervous and his driver's shuttered, disapproving attitude didn't help. He cleared his throat. 'I called you here to let you know that I'm returning to London.' Seeing he was about to speak William raised his hand. 'Hear me out without interrupting. The apartment is paid up for three months and I'll settle a generous sum on you. I've observed that you're fond of Yvonne and she of you, I believe. You have my blessing there – I'm leaving her the Rolls and will be settling a sum of money on her. That's all. We'll not meet again. My solicitor will be in touch with the details.'

Shaking his head, Grover-Williams looked across the table at him. 'Yvonne deserves better than this, sir. She gave up everything for you. The least she deserves ...'

'That is all. The matter is closed.' William cleared his throat again, busied himself lighting a cigarette and taking a deep swallow of whiskey. He wouldn't meet Charles's eyes, be inveigled into a discussion, or listen to recriminations. But he need not have worried.

Grover-Williams stood up and looking down at William he spoke slowly and deliberately. 'I see. And so, Major, your war is finally over.'

As William watched him exit, the dryness in his throat was an ache that could not be swallowed. There could be no more lingering. Finally, he knew, his war *was* over.

Epilogue

The 1920s was a hedonistic time of a superficial mix of cynicism and sentimentality – William divided his time between Paris, where his home remained the Hotel Majestic, and London, where he stayed at the Savile Club. Grace became legally responsible for their daughters. He saw little of Evelyn St George.

His drinking, jocular bonhomie, self-mockery and carefully constructed personality became the image of the man. He was the leading society portrait painter of the age, commanding huge fees.

He was the last of a dying breed of portrait painters soon to be extinguished by changing fashions and economic upheaval. His role as Britain's principal war artist and painter of the Peace Conference precluded him from returning to Ireland during the uncertain political climate that followed Independence. His drinking accelerated and his health deteriorated. He died in 1931 on September 29. He was fifty-three years old.

He is buried at Putney Cemetery and was forgotten until in 2001 his portrait titled *Gardenia St George with Riding Crop* sold at Sotheby's for nearly two million pounds, making it the then most expensive Irish painting sold at auction. From that time, his reputation and the prices commanded by his paintings have been on the rise.

Despite the way their relationship ended, Yvonne and William met up on several occasions in Paris and Dieppe. She and Charles married in 1929. Charles worked for Bugatti Automobiles, racing on the Paris circuits and winning the Monaco Grand Prix. Yvonne was an active member of the French Club for Scottish Terriers. They belonged to the Anglo-French set in Paris. During the Second World War, they were part of the Resistance.

Charles was code-named Sebastian and Yvonne worked as a courier. Charles was captured, tortured and shot in Sachsenhausen. Yvonne was arrested and imprisoned for a time at Fresnes and then released. She settled in Normandy where she ran dog kennels, becoming an expert on the Scottish terriers and judging at Crufts. She died in 1973.

Older Again 'Orpsie Boy'

Bibliography

Books

Arnold, Bruce (1981) *Orpen: Mirror from an Age*, London: Jonathan Cape

Arnold, Bruce (1991) *William Orpen (Lives of Irish Painters)*, Dublin: National Gallery of Ireland

Barker, Pat (1996) *The Regeneration Trilogy*, London: Viking Books

Barker, Pat (2012) *Toby's Room*, London: Hamish Hamilton

Bunbury, Turtle (2014) *The Glorious Madness*, Dublin: Gill &Macmillan

Dark, Sidney and Komody, P.G (1932), *Sir William Orpen: Artist &Man*, London: Seeley Service & Co.

Dedio, Florian and Gunnar, *The Great War Diaries*, London: BBC Books

Harrison, Gerry (editor) (2015) *To Fight Alongside Friends: The First World War Diaries of Charlie May*, London: William Collins

Hemingway, Ernest (1929) *A Farewell to Arms*, New York: Charles Scribner's Sons

Horne, John (editor) (2010) *A Companion to World War I*, Chichester: Wiley-Blackwell

Johnston, Jennifer (1974) *How Many Miles to Babylon?* London: Hamish Hamilton

Orpen, William (2008) *An Onlooker in France, 1917-191*, London: re-published Paul Holberton Publishing

Thompson, Jenny (2006) *My Hut: A Memoir of a YMCA Volunteer in WWI*, London: iUniverse

Online and Other Resources

1914-1918 Encyclopaedia on line
https://www.edwardianpromenade.com
https://www.longlongtrail.co.uk
https://sirwilliamorpen.com
https://www.tcd.ie/warstudies/
Imperial War Museum, London, online features
RTÉ –World War 1: 100 years on from the start of the Great War
Tate Gallery: 'Canvas and its Preparation in Early 20th century British Paintings' by Sarah Morgan, Joyce H. Townsend, Stephen Hackney and Roy Perry
World War I Exhibition at National Library of Ireland

Acknowledgements

Peter O'Reilly, the first reader
Susanne O'Reilly, marketing supremo
National Library, Dublin – Ciara Stewart, Archivist, and Ela Von Monschaw
National Gallery, Dublin – Donna Rose Andrew Moore
Imperial War Museum, London
Domnic Lee who manages the Orpen Research Archives and www.sirwilliamorpen.com
Richard Ryan for sharing his contacts
Derville Murphy, for her early read and insight into the artistic mind
M.K. Tod, for her suggestions
Military History Society of Ireland – Col. D. Bigger and Dr. Pat McCarthy
Rolls-Royce magazine – Philip Hall & John Gallop
Claridge's Hotel, London – Brona Kelly, sales and marketing
Bernadette Whelan for info on nursing during WWI
UCD's Lifelong Learning students past and present
And most of all, thanks to my family who put up with my endless research, writing, editing and talking.

Picture Credits

Page	Title	Image courtesy of:
vi	*William Orpen Self Portrait*	www.sirwilliamorpen.com
2	*Douglas Haig at GHQ, France, 1917*	www.sirwilliamorpen.com
4	*Mrs St George, 1906*	Wiki Commons, private collection
9	*Lieutenant-Colonel Arthur Lee, Censor in France of Paintings and Drawings by Artists at the Front*	Wiki Commons, Imperial War Museum (IWM) collection
12	*Winston Churchill, 1916*	www.sirwilliamorpen.com
16	*A man with a cigarette, 1917*	Wiki Commons, IWM collection
18	*A man in a trench, April, 1917, two miles from the Hinderberg Line*	www.sirwilliamorpen.com
25	*The Mirror, 1900*	Wiki Commons, Tate Britain collection
27	*Grace Reading at Howth Bay*	www.sirwilliamorpen.com
28	*Portrait of Grace, 1907*	Wiki Commons, Mildura Arts collection
31	*Portrait of the Artist's Parents*	Wiki Commons, National Gallery of Ireland collection
38	*Ready to Start. Self-portrait, 1917*	Wiki Commons, IWM collection
40	*Royal Irish Fusiliers, 'Just come from the chemical works, Roeux', 1917*	Wiki Commons, IWM collection
45	*The Manchesters, Arras, 'Just out of the trenches.' 1917*	Wiki Commons, IWM collection
47	*A Grenadier Guardsmen in full kit, 1917*	www.sirwilliamorpen.com
50	*Bringing in a wounded Tommy, 1917*	www.sirwilliamorpen.com
55	*A Bloomsbury Family, 1907*	Wiki Commons, National Gallery of Scotland collection

63	*Interior at Clonsilla with Mrs St George, 1908*	Wiki Commons, private collection
69	*Avenal St George, 1915*	www.sirwilliamorpen.com
73	*Frozen Feet – Fleurs, 1917*	Wiki Commons, IWM collection
74	*Poilu and Tommy, 1917*	Wiki Commons, IWM collection
75	*Howitzer in Action, 1917*	Wiki Commons, IWM collection
76	*Soldier after a fight, 1917*	Wiki Commons, IWM collection
84	*K.o.s.b – 'just away from the Chemical Works', Roeux, 1917*	Wiki Commons, IWM collection
91	*Café Royal, 1912*	www.sirwilliamorpen.com
103	*The Thinker on the Butte de Warlencourt, 1917*	Wiki Commons, IWM collection
124	*German prisoners POW camp, France, 1917*	www.sirwilliamorpen.com
127	*Adam and Eve at Péronne, 1918*	Wiki Commons, IWM collection
128	*The Madwoman of Douai, 1918*	Wiki Commons, IWM collection
136	*The gas mask, Stretcher-bearer Ramc near Arras, 1917*	Wiki Commons, IWM collection
137	*A tank in Pozieres, 1917*	Wiki Commons, IWM collection
144	*Portrait of Gardenia St George with Riding Crop*	Wiki Commons private collection
155	*Midday on the Beach, 1910*	www.sirwilliamorpen.com
168	*The Receiving Room, the 42nd Stationary Hospital, 1917*	Wiki Commons, IWM collection
200	*Trenches in Thiepal, 1917*	Wiki Commons, IWM collection
203	*Men in the trenches, near Hendicourt, 1917*	Wiki Commons, IWM collection
215	*Major Lee in his hut office in Beaumerie-sur-mer, 1917*	www.sirwilliamorpen.com
218	*The Spy and The Refugee, 1918*	Wiki Commons, IWM collection
232	*Portrait of Yvonne Aubicq as a Nun*	www.sirwilliamorpen.com
233	*Early Morning*	www.sirwilliamorpen.com
257	*A Peace Conference at the Quai d'Orsay, 1919*	www.sirwilliamorpen.com
258	*The Signing of Peace in the Hall of Mirrors, 1919*	www.sirwilliamorpen.com
266	*To the Unknown British Soldier (original version), 1923*	www.sirwilliamorpen.com
271	*To the Unknown British Soldier, 1927*	www.sirwilliamorpen.com
280	*Older Again 'Orpsie Boy', 1926*	www.sirwilliamorpen.com